Graphis Inc. is committed to celebrating exceptional work in Design, Advertising, Photography, & Art/Illustration internationally.

Published by **Graphis** | Publisher & Creative Director: **B. Martin Pedersen**
Chief Visionary Officer: **Patti Judd** | Design Director: **Hee Ra Kim** | Designer: **Hie Won Sohn** | Associate Editor: **Colleen Boyd**
Account/Production: **Bianca Barnes** | Intern: **Katie Bailey**

Graphis Poster Annual 2022

Published by:
Graphis Inc.
389 Fifth Avenue, Suite 1105
New York, NY 10016
Phone: 212-532-9387
www.graphis.com
help@graphis.com

Distributed by:
National Book Networks, Inc.
15200 NBN Way
Blue Ridge Summit, PA 17214
Toll Free (U.S.): 800-462-6420
Toll Free Fax (U.S.): 800-338-4550
Email orders or inquiries:
customercare@nbnbooks.com

ISBN 13: 978-1-931241-12-0

We extend our heartfelt thanks to
the international contributors
who have made it possible to publish
a wide spectrum of the best work
in Design, Advertising, Photography,
and Art/Illustration.
Anyone is welcome to submit
work at www.graphis.com.

Printed by The Foundry.

Contents

THE AMERICAS

Art Institute of Chicago
www.artic.edu
111 S. Michigan Ave.
Chicago, IL 60603
United States
Tel +1 312 443 3600

**Center for the Study of
Political Graphics**
www.politicalgraphics.org
3916 Sepulveda Blvd., Suite 103
Culver City, CA 90230
United States
Tel +1 310 397 3100

Chicago Design Museum
www.chidm.com
Block Thirty Seven
108 N. State St., Third Floor
Chicago, IL 60602
United States
Tel +1 312 894 6263

Chisholm Larsson Gallery
www.chisholm-poster.com
145 Eighth Ave.
New York, NY 10011
United States
Tel +1 212 741 1703

**Cooper Hewitt Smithsonian
Design Museum**
www.cooperhewitt.org
2 E. 91st St.
New York, NY 10128
United States
Tel +1 212 849 8400

Dallas Museum of Art
www.dma.org
1717 N. Harwood
Dallas, TX 75201
United States
Tel +1 214 922 1200

Delaware Art Museum
www.delart.org
2301 Kentmere Parkway
Wilmington, DE 19806
United States
Tel +1 302 571 9590

Denver Art Museum
www.denverartmuseum.org
100 W 14th Ave. Parkway
Denver, CO 80204
United States
Tel +1 720 865 5000

International Poster Gallery
www.internationalposter.com
460C Harrison Ave., Suite C20
Boston, MA 02118
United States
Tel +1 617 375 0076

J. Paul Getty Museum
www.getty.edu
1200 Getty Center Drive
Los Angeles, CA 90049
United States
Tel +1 310 440 7330

The Metropolitan Museum of Art
www.metmuseum.org
1000 Fifth Ave.
New York, NY 10028
United States
Tel +1 212 535 7710

Minneapolis Museum of Art
www.new.artsmia.org
2400 Third Ave. S.
Minneapolis, MN 55404
United States
Tel +1 612 870 3000

**MUMEDI - Museo Mexicano
del Diseño**
www.mumedi.mx
Avenida Fransicsco I. Madero 74
Centro, Cuauhtémoc
06000 Ciudad de México, D.F.
Mexico
Tel +52 55 5510 8609

Museum of Arts and Design
www.madmuseum.org
Jerome and Simona Chazen Building
2 Columbus Circle
New York, NY 10019
United States
Tel +1 212 299 7777

Museum of the City of New York
www.mcny.org
1220 Fifth Avenue (at 103rd St.)
New York, NY 10029
United States
Tel +1 212 534 1672

**National Gallery of Art,
Washington D.C**
www.nga.gov
Constitution Ave., NW
Washington, DC 20565
United States
Tel +1 202 737 4215

Oakland Museum of California
www.museumca.org
1000 Oak St.
Oakland, CA 94607
United States
Tel +1 510 318 8400

Poster House
www.posterhouse.org
119 W. 23rd St.
New York, NY 10011
United States
Tel +1 917 722 2439

**Posteritati Movie
Poster Gallery**
www.posteritati.com
239 Centre St., Fourth Floor
New York, NY 10013
United States
Tel +1 212 226 2207

The Poster Museum
www.postermuseum.com
122 Chambers St.
New York, NY 10007
United States
Tel +1 212 513 0313

Rennert's Gallery
www.rennertsgallery.com
26 W. 17th St.
New York, NY 10011
United States
Tel +1 212 787 4000

**San Francisco Museum of
Modern Art**
www.sfmoma.org
151 Third St.
San Francisco, CA 94103
United States
Tel +1 415 317 4000

San Jose Museum of Art
www.sjmusart.org
110 S. Market St.
San Jose, CA 95113
United States
Tel +1 408 271 6840

The Seattle Art Museum
www.seattleartmuseum.org
1300 First Ave.
Seattle, WA 98101
United States
Tel +1 206 654 3100

Solomon R. Guggenheim Museum
www.guggenheim.org
1071 Fifth Ave.
New York, NY 10128
United States
Tel +1 212 423 3575

Speed Art Museum
www.speedmuseum.org
2035 S. Third St.
Louisville, KY 40208
United States
Tel +1 502 634 2700

Spencer Weisz Galleries
www.antiqueposters.com
3720 S. Dixie Highway #3
West Palm Beach, FL 33405
United States
Tel +1 312 527 9420

St. Louis Art Museum
www.slam.org
One Fine Arts Drive
Forest Park
St. Louis, MO 63110
United States
Tel +1 314 721 0072

Swann Galleries
www.swanngalleries.com
104 E. 25th St.
New York, NY 10010
United States
Tel +1 212 254 4710

**Whitney Museum of
American Art**
www.whitney.org
99 Gansevoort St.
New York, NY 10014
United States
Tel +1 212 570 3600

EUROPE & AFRICA

Artifiche Swiss Poster Gallery
www.artifiche.com
Stockerstrasse 38
8002 Zürich
Switzerland
Tel +41 44 387 40 44

**Bauhaus Archives
(Bauhaus-Archiv)**
www.bauhaus.de
Knesebeckstraße 1-2
10623 Berlin-Charlottenburg
Germany
Tel +49 30 2540020

The Berardo Collection Museum
www.berardocollection.com
Praça do Império
1449-003 Lisboa
Portugal
Tel +351 21 361 2878

Dansk Plakatmuseum
www.plakatmuseum.dk
Viborgvej 2
8000 Aarhus
Denmark
Tel +45 86 15 33 45

Designmuseum Danmark
www.designmuseum.dk
Bredgade 68
1260 Kobenhavn
Denmark
Tel +45 33 18 56 56

Design Museum
www.designmuseum.org
224-238 Kensington High St.
Kensington, London W8 6AG
United Kingdom
Tel +44 20 3862 5900

Die Neue Sammlung
www.dnstdm.de
Barerstrasse 40
80333 München
Germany
Tel +49 89 2727250

**Galeria Plakatu -
Cracow Poster Gallery**
www.cracowpostergallery.com
Stolarska 8
31-043 Kraków
Poland
Tel +48 12 421 26 40

Galerie Maeght
www.maeght.com
42 Rue du Bac
75007 Paris
France
Tel +33 1 45 48 45 15

Kunstmuseum Den Haag
www.gemeentemuseum.nl
Stadhouderslaan 41
2517 HV Den Haag
Netherlands
Tel +31 70 338 1111

Kunsthalle Basel
www.kunsthallebasel.ch
Steinenberg 7
4001 Basel
Switzerland
Tel +41 61 206 99 00

Kunsthaus Zürich
www.kunsthaus.ch
Heimplatz 1
CH-8001 Zürich
Switzerland
Tel +41 44 253 84 84

MAK Austrian Museum of Applied Arts/Contemporary Art
www.mak.at
Stubenring 5
1010 Wien
Austria
Tel +43 1 711 360

Moscow Design Museum
www.moscowdesignmuseum.ru
The New Tretyakov Gallery, West Wing
10 Krymsky Val, Moscow
Russia
Tel +7 495 957 07 27

MUSAC - Museo de Arte Contemporáneo de Castilla y Léon
www.musac.es
Av. de los Reyes Leoneses, 24
24008 Léon
Spain
Tel +34 987 09 00 00

Museum Fur Gestaltung
www.museum-gestaltung.ch
Pfingstweidstrasse 96
8005 Zürich
Switzerland
Tel +41 43 446 67 67

Museum Haus Konstruktiv
www.hauskonstruktiv.ch
Selnaustrasse 25
8001 Zürich
Switzerland
Tel +41 44 217 70 80

Pinakothek Der Moderne
www.pinakothek.de
Barer Str. 40
80333 München
Germany
Tel +49 89 23805360

Stedelijk Museum Amsterdam
www.stedelijk.nl
Museumplein 10
1071 DJ Amsterdam
Netherlands
Tel +31 20 573 2911

Stedelijk Museum Breda
www.stedelijkmuseumbreda.nl
Boschstraat 22
4811 GH Breda
Netherlands
Tel +31 76 529 9900

Tate Modern (London)
www.tate.org.uk
Bankside
London SE1 9TG
United Kingdom
Tel +44 20 7887 8888

Tel Aviv Museum of Art
www.tamuseum.org.il/en/
The Golda Meir Cultural and Art Center
Sderot Sha'ul HaMelech 27,
Tel Aviv-Yafo
Israel
Tel +972 3 6077020

Triennale di Milano
www.triennale.org
Viale Emilio Alemagna, 6
20121 Milano MI
Italy
Tel +39 02 724341

ASIA & OCEANIA

Art Gallery of New South Wales
www.artgallery.nsw.gov.au
Art Gallery Road
Sydney NSW 2000
Australia
Tel +61 2 9225 1700

Art Gallery of South Australia
www.agsa.sa.gov.au
North Terrace
Adelaide SA 5000
Australia
Tel +61 8 8207 7000

Auckland Art Gallery Toi o Tāmaki
www.aucklandartgallery.com
Wellesley St. E.
Auckland, 1010
New Zealand
Tel +64 9 379 1349

Australian Centre for Contemporary Art
www.acca.melbourne
111 Sturt St.
Southbank VIC 3006
Australia
Tel +61 3 9697 9999

Chi-Mei Museum
www.chimeimuseum.org
No. 66, Sec. 2, Wenhua Road
Rende District, Tainan City, 71755
Taiwan
Tel +886 0 6226 0808

Fukuoka Art Museum
www.fukuoka-art-museum.jp
1-6 Ohorikoen, Chuo Ward
Fukuoka, 810-0051
Japan
Tel +81 92 714 6051

Hong-Gah Museum
www.hong-gah.org.tw
11F., No.166 Daye Road,
Beitou District
Taipei City, 11268
Taiwan
Tel +886 2 2894 2272

Lotte Museum of Art
www.lottemuseum.com
LOTTE WORLD TOWER (7F)
300, Olympic-ro, Songpa-gu
Seoul
South Korea
Tel +82 1544 7744

Metropolitan Museum of Manila
www.metmuseum.ph
BSP Complex, Roxas Blvd.
Malate, Manila, Metro Manila
Philippines
Tel +63 63 250 5271

Museum MACAN (Modern and Contemporary Art in Nusantara)
www.museummacan.org
AKR Tower Level M
Jalan Panjang No. 5 Kebon Jeruk
Jakarta Barat 11530
Indonesia
Tel +62 21 2212 1888

Museum of Art Seoul National University
www.snumoa.org
1 Gwanak-ro, Gwanak-Gu
Seoul 08826
South Korea
Tel +82 2 800 9504

Museum of Contemporary Art, Australia
www.mca.com.au
140 George St.
The Rocks, NSW 2000
Australia
Tel +61 2 9245 2400

Museum of Contemporary Art, Shanghai
www.mocashanghai.org
Gate 7, People's Park
231 W. Nanjing Road, Shanghai
China
Tel +86 21 6327 9900

National Art Gallery
www.artgallery.gov.my
Lembaga Pembangunan Seni Visual
Negara
No. 2, Jalan Temerloh, Off Jalan Tun
Razak
53200 Kuala Lumpur
Malaysia
Tel +60 3 4026 7000

National Gallery of Armenia
www.gallery.am/hy
1 Aram St.
Yerevan, 0010
Armenia
Tel +374 10 567472

National Gallery of Australia
www.nga.gov.au
Parkes Place
Parkes ACT 2600
Australia
Tel +61 2 6240 6411

National Gallery of Victoria
www.ngv.vic.gov.au
180 St. Kilda Road
Melbourne VIC 3006
Australia
Tel +61 3 8620 2222

National Gallery Singapore
www.nationalgallery.sg
1 St. Andrew's Road
Singapore, 178957
Singapore
Tel +65 6271 7000

National Museum of Modern and Contemporary Art - Seoul
www.mmca.go.kr
30 Samcheong-ro, Sogyeok-dong
Jongno-gu, Seoul 03062
South Korea
Tel +82 2 3701 9500

Queensland Art Gallery and Gallery of Modern Art (QAGOMA)
www.qagoma.qld.gov.au
Stanley Place
South Brisbane QLD 4101
Australia
Tel +61 07 3840 7303

Seoul Museum of Art
www.sema.seoul.go.kr
61 Deoksugung-gil, Jung-gu
Seoul 04515
South Korea
Tel +82 2 2124 8800

Shanghai Propaganda Poster Art Center
www.shanghaipropagandaart.com
Room K, 7F East Tower
Hua Min Han Zhen International
726 Yan An Xi Rd., Shanghai
China
Tel +86 21 6211 1845

Taipei Fine Arts Museum
www.tfam.museum
No. 181, Section 3
Zhongshan N. Road
Zhongshan District, Taipei City 10461
Taiwan
Tel +886 2 2595 7656

Additional Museums:
If you are a museum that collects posters and are not listed above, please contact us for inclusion in our next Annual at help@graphis.com.

10 PLATINUM WINNERS IN 2012

Andrea Castelletti

Kasai Noriyuki

Mike Barker Design

Naughtyfish

Palio

SenseTeam

Skolos-Wedell

Venti Caratteruzzi

Visual Dialogue

Zubi Advertising

The birth and the death are one and indivisible.

AUSTRALIAN
NATIONAL
ACADEMY
OF MUSIC

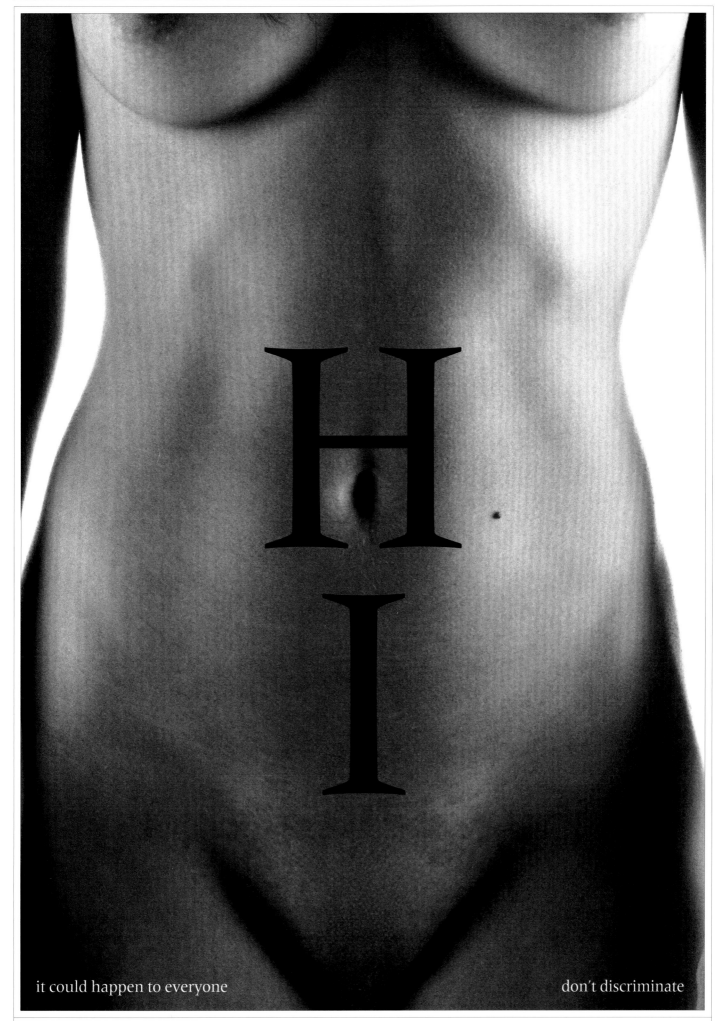

it could happen to everyone

don't discriminate

Title: Places | Client: Ford Dealer/Gus Machado | Design Firm: Zubi Advertising Images 1 of 3

Coppélia

TEATRO MASSIMO

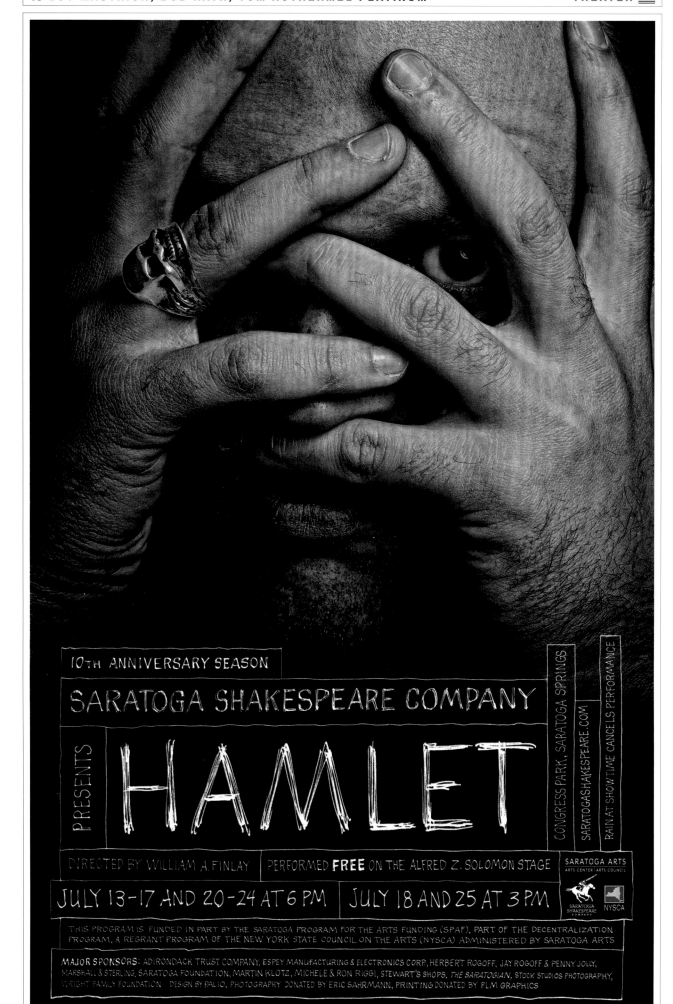

10TH ANNIVERSARY SEASON

SARATOGA SHAKESPEARE COMPANY

PRESENTS

HAMLET

CONGRESS PARK, SARATOGA SPRINGS

SARATOGASHAKESPEARE.COM

RAIN AT SHOWTIME CANCELS PERFORMANCE

DIRECTED BY WILLIAM A. FINLAY PERFORMED **FREE** ON THE ALFRED Z. SOLOMON STAGE

SARATOGA ARTS
ARTS CENTER | ARTS COUNCIL

SARATOGA SHAKESPEARE COMPANY NYSCA

JULY 13–17 AND 20–24 AT 6 PM JULY 18 AND 25 AT 3 PM

THIS PROGRAM IS FUNDED IN PART BY THE SARATOGA PROGRAM FOR THE ARTS FUNDING (SPAF), PART OF THE DECENTRALIZATION PROGRAM, A REGRANT PROGRAM OF THE NEW YORK STATE COUNCIL ON THE ARTS (NYSCA) ADMINISTERED BY SARATOGA ARTS

MAJOR SPONSORS: ADIRONDACK TRUST COMPANY, ESPEY MANUFACTURING & ELECTRONICS CORP, HERBERT ROGOFF, JAY ROGOFF & PENNY JOLLY, MARSHALL & STERLING, SARATOGA FOUNDATION, MARTIN KLOTZ, MICHELE & RON RIGGI, STEWART'S SHOPS, *THE SARATOGIAN*, STOCK STUDIOS PHOTOGRAPHY, WRIGHT FAMILY FOUNDATION DESIGN BY PALIO, PHOTOGRAPHY DONATED BY ERIC SAHRMANN, PRINTING DONATED BY FLM GRAPHICS

Graphis Judges

Stephan Bundi | Lead Designer | **Atelier Bundi AG**

Biography: Stephan Bundi is a graduate of the Bern School of Design (University of the Arts). He later studied book design and illustration at the State Academy of Art and Design in Stuttgart before going into business for himself. As a designer and art director for film producers, concert promoters, museums, theaters, and publishers, he combines unconventional ideas with practical Swiss tradition. He has taught at several universities, held lectures and workshops around the world, and was a professor at Bern University of the Arts (1999–2013). Bundi won first prizes in Chicago, Mexico, Mons (Belgium), New York, Sofia, Vienna, the ICOGRADA Excellence Award in Warsaw, and the Swiss Poster Gold Award several times. His posters are part of public collections worldwide.

Commentary: The poster is still an important means of advertising and information. Thanks to new printing technologies, posters can also be produced inexpensively in high quality in small print runs. This means that today the poster is not only produced as an advertising medium, but also as a self-promotion, as a graphic work. This possibility expands the spectrum in the creative and communicative area enormously, making a new visual language independent of the client possible.

Randy Clark | Graphic Design Professor | **Wenzhou Kean University**

Biography: Mr. Clark is an assistant professor teaching graphic design at Wenzhou-Kean University in the Peoples' Republic of China. His work has been featured in Communication Arts, HOW, Creative Quarterly, the Taiwan Annual Invitation Poster Exhibition, the University & College Designers Association, and the Dallas Society of Visual Communications, and recently received Platinum from Graphis. Past client work includes Warner Brothers, the Utah Jazz, PEP Boys, Wal Mart, the Utah Symphony, and many others. Mr. Clark received a BFA from the University of Utah, and an MFA from Utah State University. He credits his wife, Tamralynn, and professors Calvin Sumsion, Ray Morales, and Robert Winward for his success.

Commentary: Graphis has always been the standard for graphic design. While other journals mirror design culture, Graphis defines it. It is the great repository of design that archives, communicates, and celebrates the best of our profession. As a long-time aficionado of Graphis, it has been 'go-to' journal as both a student and professional.

Michael Hester | Principal & Creative Director | **Pavement**

Biography: Michael Hester is the principal and creative director of Pavement, an award-winning San Francisco-based design and branding studio. Pavement is passionate about crafting strategic packaging and brand identities for wine, spirits, food, and luxury goods. Notable clients of Pavement include E & J Gallo Winery, Whole Foods Markets, Peet's Coffee & Tea, Williams-Sonoma, Fetzer Vineyards, Dollar Shave Club, Target, and Bloom Farms. Prior to founding Pavement in 2014, Michael had a diverse career in creative spanning over two decades. His background includes packaging, branding, art direction, creative advertising, and editorial design. Michael graduated from the University of Arizona with a BFA in visual communications.

Commentary: I think overall the quality of the work seemed to lack something to be desired. I didn't see many examples of anything innovative or fresh. The most interesting category for me was the television section. There were a few quality examples there. I would have liked to see examples that push the boundaries of typography more or posters that had more of a "hook" to them.

Chemi Montes | Designer & Professor | **American University — Katzen Arts Center**

Biography: Chemi Montes was born and raised in Spain, where he studied fine arts and graphic design. He later completed his MFA in the United States. His design career includes an ongoing professional practice and a long-term focus on design education. He currently works in the Graphic Design Department at American University in Washington DC. His design work has been recognized and published in numerous venues, including Graphis, Communication Arts, How, and various books and publications, as well as the Colorado International Invitational Poster Exhibition. He has also published and presented about visual semiotics in design and advertising.

Commentary: Whether it is through a metaphorical tap on the shoulder to a punch in the gut, a poster's mission is to engage the viewer's attention, to provoke, to intrigue, to emote, to outrage … a poster that does not elicit a reaction becomes visual noise before it can become a message. Posters ought to be an expression of visual wit. Images, alone or in combination with a typographic expression of the verbal content, face that challenge. An uninteresting, unmemorable poster is something else, a notice, a one-sided brochure, a meme. The posters I have admired in this year's competition embrace image-making, the exploration of cognitive dissonance between the visual and the verbal, or a typography that becomes an image through sheer effort, acknowledging the space it inhabits and aware of the content it presents. Copywriting, the worthiness of a cause or message, is inherent to the poster but cannot and does not sustain it as such. At their best, posters are witnesses of the time in which they come into being: they are both mirrors and documents of culture. There is an understandable apprehension that accompanies considering posters as an either nostalgic or progressively obsolete medium, an apprehension reinforced by the progressive shrinkage of all print media's territory. But the value of the poster as a medium does not reside on its scale, placement, means of production, or distribution; posters are an exercise in visual rhetoric, and as such they embody the essence of visual messaging, regardless of what platform or media they may move to inhabit.

Nancy Skolos | Professor & Partner at Skolos Wedell | **Skolos-Wedell**

Biography: Nancy Skolos is a partner in Skolos-Wedell, a practice that works to diminish the boundaries between graphic design and photography by creating collaged, three-dimensional images influenced by modern painting, technology, and architecture. She is also a professor of graphic design at the Rhode Island School of Design. Skolos-Wedell's work has received numerous awards and has been widely published and exhibited. Their posters are included in the graphic design collections of the Museum of Modern Art, the Metropolitan Museum of Art, and many others. Skolos is an AIGA Medalist, AIGA Fellow, and a member of AGI.

Commentary: As was the case for most of the art and entertainment world, the pandemic impacted poster production. Fewer events — music, theater, conferences, sports, festivals — diminished designers' opportunities for making captivating and enjoyable posters. COVID-19 did generate a new genre of public health posters, but most were unavoidably joyless. Overall, this year's challenges led to less innovation both conceptually and visually. Still, some sparkling examples endured.

Rene Steiner | Lead Designer | **Steiner Graphics**

Biography: René V. Steiner, a Swiss-Canadian, established Steiner Graphics in 2000 and since then has provided design services to a truly global client base. Prior to returning to Canada in 2014, Steiner lived and worked in Boston, Zurich, and Geneva, and was a member of Swiss Graphic Designers (SGD) for the better part of a decade. Much of his work now focuses on the dynamics of the forces of globalization and how these affect human interaction locally, nationally, and internationally. Born of an Iranian mother and a Swiss father, his perspectives on these issues are reflected in his design work.

Commentary: The past year has represented a collective reckoning of sorts for humanity. The pandemic, which has touched every aspect of our lives, was very much in evidence in many of the posters submitted to this year's competition. If art is a reflection of our common human experience, posters represent a graphic distillation of many of the themes that bind us together as a species — everything from climate change to current trends in environmental design and commerce. Just as a well-designed chair can communicate much about our shared aesthetic values and cultural views, a well-designed poster can reflect the essence of a theme like few other things can. We respond to posters viscerally — and so the challenge for the designer is to create something that transcends language and conveys its message visually with a punch. True to form, many of the posters in this year's competition lived up to the challenge.

As judges Stephan Bundi and Randy Clarki were also entrants and winners, special care was taken to insure that they did not judge their own work.

Title: Otello | **Client:** Self-initated | **Design Firm:** Atelier Bundi AG

Open to all students at
South Dakota State University

2016 Annual SDSU Juried Student
Art and Graphic Design Competition

Entries Accepted April 11–13
Ritz Gallery, Grove Hall
For more information 605.688.4103
sdsu.schoolofdesign@sdstate.edu

Title: Mona Student Jury Show | Client: School of Design/South Dakota State University | Design Firm: Randy Clark

海洋正在死去

Title: OMG | **Client:** Taiwan Poster Design Association International Poster Invitation Exhibition | **Design Firm:** Randy Clark

Title: El Paso Distillery Vodka | **Client:** El Paso Distillery & Spirits | **Design Firm:** Pavement

Title: Cooper's Classic American Whiskey | **Client:** Cooperstown Distillery | **Design Firm:** Pavement

✝THE CRUCIBLE

PLAY BY **ARTHUR MILLER**

DIRECTED BY **KARL KIPPOLA** THE CRUCIBLE IS PRESENTED BY SPECIAL ARRANGEMENT WITH DRAMATISTS PLAY SERVICE, INC., NEW YORK.

STUDIO THEATRE | KATZEN ARTS CENTER
OCTOBER 4 & 5 AT **8**PM
OCTOBER 6 AT **2**PM & **8**PM

TICKETS: $15 REGULAR ADMISSION | $10 AU COMMUNITY AND SENIORS
202-885-ARTS AMERICAN.EDU/AUARTS

COLLEGE *of*
ARTS & SCIENCES

Title: The Crucible | **Client:** AU Department of Performing Arts | **Design Firm:** Chemi Montes Design

American University
Jazz Workshop
Jazz Orchestra

Dr. Noah Getz, director
with special guest Erik Spangler

Joshua Bayer, director
with special guest Paul Carr

then and now

COLLEGE of
ARTS & SCIENCES

Tickets: $10 regular admission, $5 AU community
and seniors. For tickets and more information,
please call 202-885-ARTS or visit us online at
www.american.edu/auarts.

Saturday, April 14, 2012, at 8 p.m.
Abramson Family Recital Hall, Katzen Arts Center
4400 Massachusetts Ave. NW, Washington, DC

Title: Montes_Poster_Jazz_201204 | **Client:** AU Performing Arts | **Design Firm:** Chemi Montes Design

Title: Honoring Matthew Carter | **Client:** AIGA Boston | **Design Firm:** Skolos-Wedell

Title: Languages Matter! | **Client:** Design 21/Unesco Poster Competition | **Design Firm:** Skolos-Wedell

Title: Crucifixion | **Client:** Self-initiated | **Design Firm:** Steiner Graphics

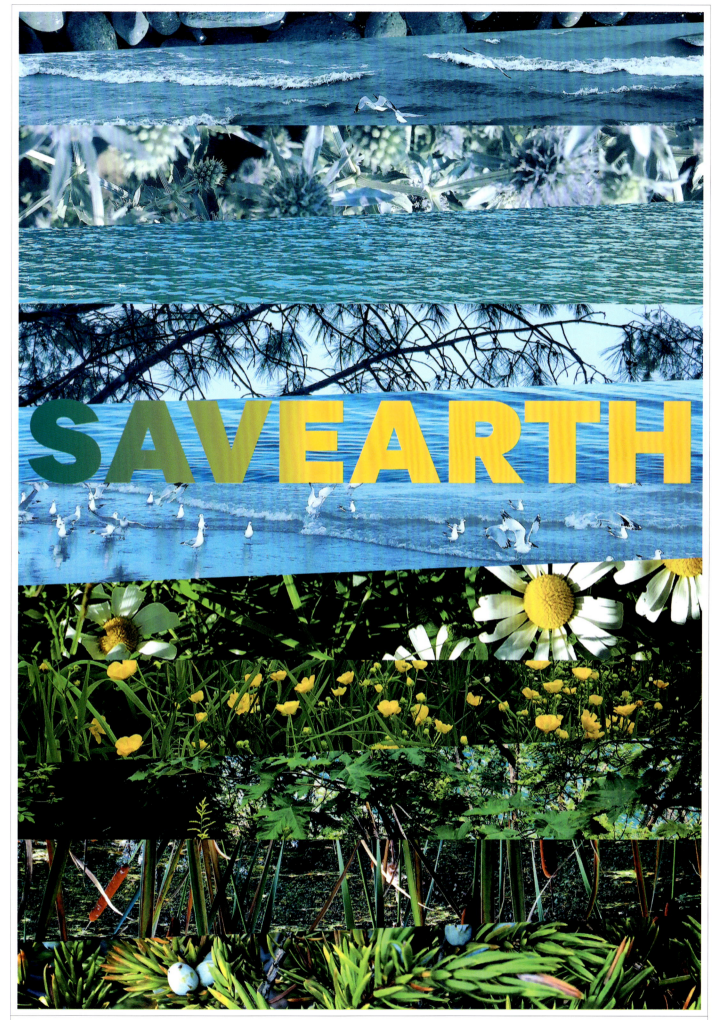

Title: Save Earth | **Client:** Self-initiated | **Design Firm:** Steiner Graphics

Katarzyna Zapart | **Katarzyna Zapart** | Freelance Graphic Designer | Page: 38 | www.behance.net/kazapart
Biography: Katarzyna Zapart is a Polish graphic and poster designer. She is a graduate of professor Piotr Kunce's Poster Studio at the Academy of Fine Arts in Krakow. She has been a part of many poster exhibitions and publications from Japan to the Americas. Katarzyna is a Graphis New Talent and Typography winner. She creates logos, websites, and other designs on a daily basis as a freelancer, but her favorite creative work remains the poster, especially cultural ones, which seems to be the most artistic. Her favorite part of the creative process is turning a story or information into a visual metaphor.

Kiyoung An | **KINDAI University** | Professor & Graphic Designer | Page: 39 | www.facebook.com/ANkiyoung
Biography: Born in South Korea, Kiyoung An moved to Japan in 2000 where he graduated from the Tokyo University of the Arts after studying a doctoral course in design. He is now a professor at KINDAI University and is part of the Department of the Arts. He is also an established designer and was a judge for the Korea Design Exhibition Award (KIDP). Other competitions he has won include the Daegu City C.I Design, the Daedong Bank C.I Design, the Miyazaki National University Logo Design, the Etajima City Logo Design, and the Presidential Education Community Logo Design.

Yin Zhongjun | **Dalian RYCX Advertising Co., Ltd.** | Founder, Creative Director, & Graphic Designer | Page: 40 | www.rycxcn.com
Biography: Zhongjun Yin is the founder and creative director of the RYCX advertising company, and also works as a graphic designer. His main work involves branding, graphics, and posters, and he focuses on conceptual independence, whether in culture, branding, or the public domain. Idea innovation requires creativity and courage, and curiosity is the beginning of everything. Zhongjun Yin is good at finding the graphical dialogue between reality and idealism, as well as exploring the unknown and possibilities through philosophical thinking. He has won Graphis Platinum and Gold Awards, the China International Poster Biennale, the Shenzhen International Poster Festival Gold Award, and more.

João Machado | **João Machado Design** | Founder & Graphic Designer | Page: 41 | www.joaomachado.com
Biography: Born in Coimbra, João studied sculpture at the Porto School of Fine Arts, where he later became a professor of graphic design. He opened his own studio in 1981. His work has been featured in solo exhibitions that have brought him several national and international awards, such as the Icograda Excellence Award as well as his appointment as a Graphis Design Master and a AGI member. While he has created many works, the poster is his piece of choice. Color and shapes are his hallmarks; his posters are characterized by bright colors and well-defined geometric elements. He also works in editorial design in the areas of illustration, marked by an identity that has been persistently built.

Sanja Planinic | **MA'AM** | Design Director | Page: 42 | www.sanjaplaninic.com
Biography: Originally from Bosnia and Herzegovina, Sanja is an internationally recognized, award-winning art director. She co-founded the SOS Design Festival, the first of its kind in Bosnia, to advance the development of creative industries in southeastern Europe. She is an active participant in international projects and exhibitions, bringing an innovative perspective to the world of graphic design. Sanja is currently the design director at MA'AM, living and working in New York Coty. She studied graphic design at the Academy of Fine Arts in Sarajevo.

Woody Pirtle | **Pirtle Design** | Founder & Graphic Designer | Page: 43 | www.pirtledesign.com
Biography: Woody established Pirtle Design in 1978, and after great success, joined Pentagram in 1988. He became an equity partner, and moved to New York. For almost eighteen years, he helped build the New York office into the powerhouse it is today. Woody's work has been exhibited worldwide, and is in the permanent collections of many museums, including MOMA, the Cooper-Hewitt, and the Victoria & Albert. He has taught at many art schools and lectured extensively. In 2003, Woody received the AIGA Medal for his distinguished contributions to the design profession. In 2015, he was awarded the Rome Prize from the American Academy in Rome. In 2016, he became a Fellow of the Academy.

Ariane Spanier | **Ariane Spanier Design** | Founder & Graphic Designer | Pages: 44, 45 | www.arianespanier.com
Biography: Ariane Spanier is a Berlin-based graphic designer. Born in Weimar, she studied visual communication at the Art Academy Berlin-Weißensee. Ariane works primarily with clients from the cultural sphere. Her studio designs everything from printed matter to identities, animations, and illustrations. Since 2006, she has been the creative director and co-editor of Fukt, an annual magazine for contemporary drawing. She has won many awards, like the TDC New York and Tokyo, D & AD, ADC New York, 100 Best Posters Germany/Austria/Switzerland, and many more. Her work has been published in numerous magazines and design publications. She is a member of the international graphic design organization Alliance Graphique Internationale (AGI).

Fons Hickmann | **Fons Hickmann m23** | **Graphic Designer & Founder of Fons Hickmann m23** | **Page: 46** | **www.m23.de**
Biography: Fons Hickmann studied design, photography, and philosophy, and is the founder of the design studio Fons Hickmann m23. He has taught at several universities, held lectures and workshops around the world, and is a professor at the Berlin University of the Arts. He is a member of the TDC New York, the Alliance Graphique International, and Borussia Dortmund. He is a winner of more than 200 design awards. The studio is focused on corporate design for cultural events, theater, and opera, such as Semper-Oper, State Opera Munich, and the Vienna State Opera House. Since 2018 he has been the president of the 100 Beste Plakate Association (100 Best Posters of Austria, Germany, Switzerland). He has published a few books about design and football. Currently he lives with his kids and a kitten in Berlin.

Rikke Hansen | **Rikke Hansen** | **Graphic Designer & Educator** | **Page: 47** | **www.wheelsandwaves.dk**
Biography: Rikke Hansen is a graphic designer and educator. For several years, she has been working with product development, branding, and consulting. She works on and researches design development projects and has her own design studio doing print and digital design. She also owns a letterpress workshop. Rikke is vice chairman at The Danish Book Craft Society and a board member of the Bienal del Cartel Bolivia (BICeBé). She is also a member of the China International Design Educator Association (C-IDEA) and the China Europe International Design and Culture Association (CEIDA). She is an advisory board member for Odisha Design Council (ODC). She has been exhibiting and giving lectures and workshops internationally in Asia, the Middle East, and South and North America. See her work and find more information at www.wheelsandwaves.dk.

Hajime Tsushima | **Tsushima Design** | **Art Director & Graphic Designer** | **Page: 48** | **www.tsushima-design.com**
Biography: Hajime Tsushima has been a representative at Tsushima Design since 1995. He is an art director and a graphic designer. He is also an associate professor at the Osaka University of the Arts, where he teaches graphic design. He's won many major awards, including the China International Poster Biennale Grand Prix, ONE SHOW Gold prize, HKDA Global Design Awards Gold prize, Design for Asia Awards Gold prize, and the A' DESIGN AWARD Gold prize. In addition, he has won many international poster design competitions. His main work is branding and corporate CI and VI.

Coco Cerrella | **Coco Cerrella** | **Graphic Designer & Professor at Buenos Aires University** | **Page: 49** | **www.coco.com.ar**
Biography: Coco Cerrella is a designer and graphic activist who graduated in 2001 from Buenos Aires University, where he has been teaching since 2007. He teaches workshops in prisons and in the private sphere. He specializes in social design. His posters on human rights have been exhibited in thirty-nine countries and have been included in the book "The Design of Dissent" by Milton Glaser and Mirko Illic. He has coordinated the Dept. of Communication of Engineering Without Borders Argentina, whose visual identity has been distinguished by Hiiibrand Japan, Flexibility Brand Awards China, and the Metropolitan Design Centre of Buenos Aires. Coco has been on juries in international design competitions and has spoken at TEDx, Forum Art & Branding Russia, Ibero-American Design Biennial Madrid, and several design events.

FX Networks | **FX Networks/Arsonal/Icon Arts Creative/Eclipse Advertising/LA** | **Pages: 50, 51** | **www.fxnetworks.com**
Biography: The FX Networks Print Design Department, part of FX Marketing, creates original and unparalleled print advertising for all of FX Networks' original programming. The team aims to push the boundaries of entertainment advertising and commercial art. In years past, FX Networks Print Design has created award-winning campaigns for shows like "Legion", "American Horror Story", "Sons of Anarchy", "Pose", "Atlanta", "Taboo", and "Fargo", among numerous others. The FX Marketing team is the winner of the Clio Key Art Awards' "Network of the Year" and Promax/BDA's "Marketing Team of the Year" several years running.

Graphis has always been the standard for graphic design. While other journals mirror design culture, Graphis defines it.

Randy Clark, *Graphic Design Professor, Wenzhou Kean University*

Visit our Credits & Commentary section in the back of the book to read the full assignments, approaches, and results from this year's Platinum Winners.

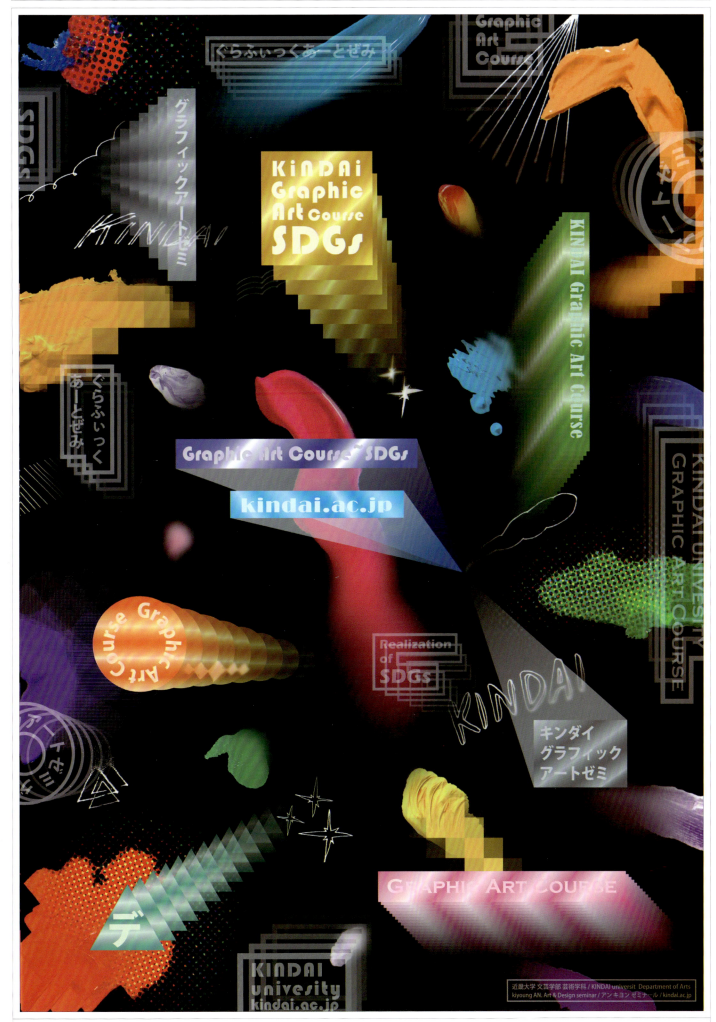

P216: Credit & Commentary　　**Title:** KINDAI Graphic Art Course | **Client:** Self-initiated | **Design Firm:** KINDAI University, Graphic Art course

BIODIVERSITY

© 2020 Design / JOÃO MACHADO to UnknownDesign

Title: Process | Client: PDP Conference | Design Firm: Sanja Planinic

LA STRADA

P217: C&C **Title:** LIGHT & SHADOW | **Client:** Japan Graphic Designers Assoc. Hiroshima | **Design Firm:** Tsushima Design

LE CORBUSIER

P217: Credit & Commentary

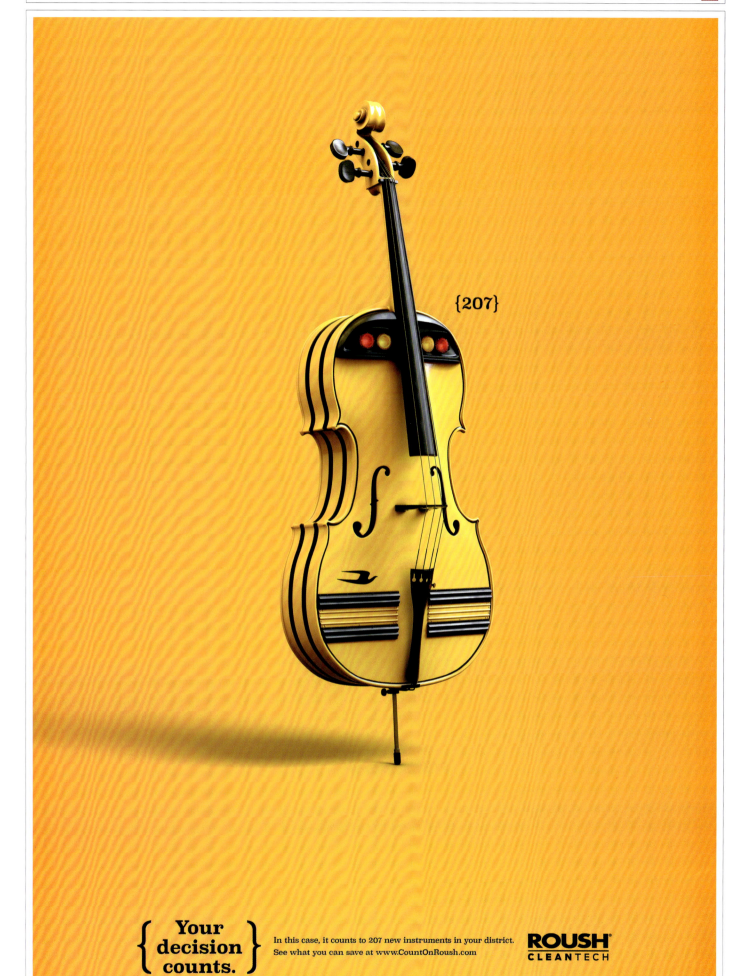

{207}

{ Your decision counts. }

In this case, it counts to 207 new instruments in your district.
See what you can save at www.CountOnRoush.com

ROUSH
CLEANTECH

Good health and good wishes to you for the
Year of the Ox 2021 from John Gravdahl

INFORMED AND DELIGHTED

One of a few true geniuses of graphic design in the 20th Century. The first graphic designer to receive the National Medal of Arts. Milton Glaser redefined design at a time when modernism was the definitive graphic voice.

Glaser, along with Push Pin founder Seymour Chwast embraced historical styles and influences. "We were excited by the very idea that we could use anything in the visual history of humankind as influence."

Often simply identified as the creator of the "I Heart NY," illustrator of his emblematic Bob Dylan poster and cofounder of New York magazine, Glaser was also an author, scholar, educator, entrepreneur and children's book illustrator. His seven- decade career spanned the spectrum of commerce and art. His work did indeed, inform and delight.

John Gravdahl/USA

From Hiroshima to the World

Read More.
Top 10 Books Read in 2019.

1 Lost Children Archive
 Valeria Luiselli
2 The Fire Next Time
 James Baldwin
3 Bonhoeffer: Pastor, Martyr, Prophet
 Eric Metaxas
4 What You Have Heard Is True
 Carolyn Forché
5 El Boxeador Polaco
 Eduardo Halfon
6 Las Tierras Arrasadas
 Emiliano Monge
7 Sacred Economics
 Charles Eisenstein
8 The New Jim Crow
 Michelle Alexander
9 White Fragility
 Robin DiAngelo
10 Death of the Liberal Class
 Chris Hedges

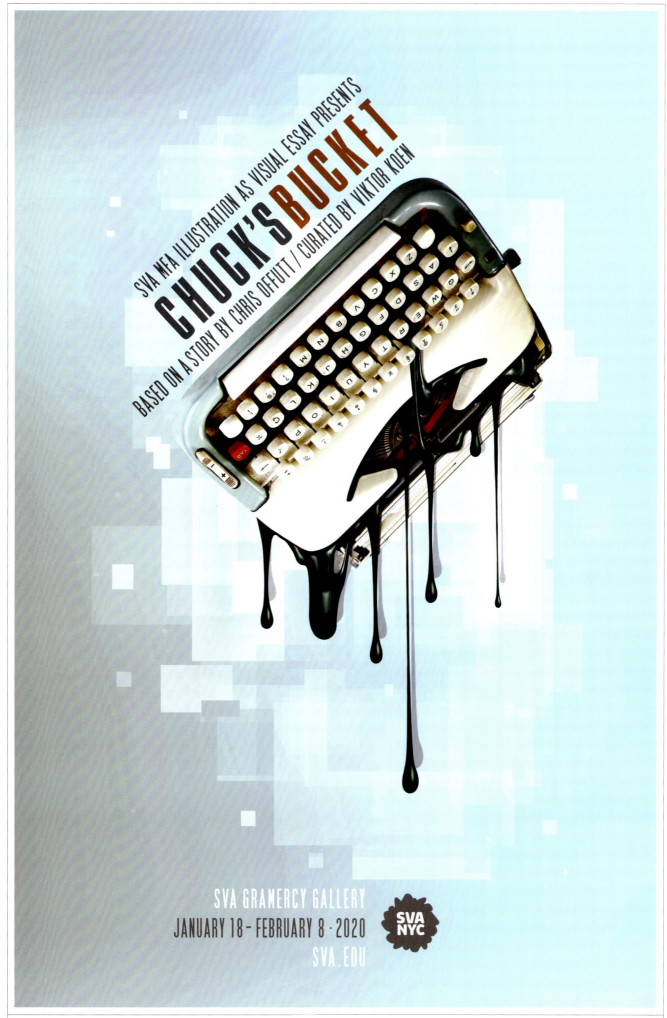

P217: Credit & Commentary **Title:** SVA/MFA Illustration Exhibition | **Client:** School of Visual Arts | **Design Firm:** Attic Child Press

P217: Credit & Commentary **Title:** Halloween Snackmix | **Client:** Wenzhou Kean University | **Design Firm:** Randy Clark

P217: Credit & Commentary **Title:** Dune Poster | **Client:** Intended as a licensed product | **Design Firm:** Stark Designs, LLC

Title: X | Client: Self-initiated | Design Firm: Marlena Buczek Smith

BIODIVERSITY

BIOPHILIA

© 2020 Design / JOÃO MACHADO

VIII INTERNATIONAL TRIENNIAL OF ECOLOGICAL POSTER THE 4th BLOCK

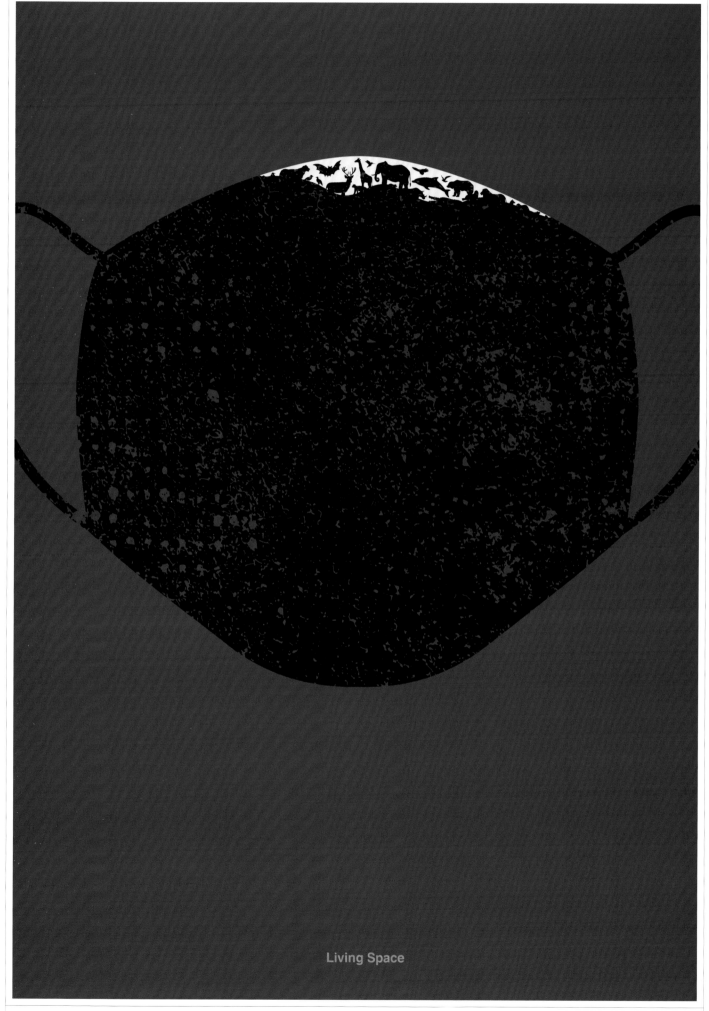

Living Space

P218: Credit & Commentary **Title:** Living Space | **Client:** Qian Yifeng Gallery | **Design Firm:** Wuhan Yanzhanglian Design Consultant

DIALOGUE
WITH NATURE

HOPE of EARTH

Life and death have been repeated countless times since the birth of the earth. There is hope for our future, which has learned the hearts of those who seek peace from the mistakes of the past due to war.

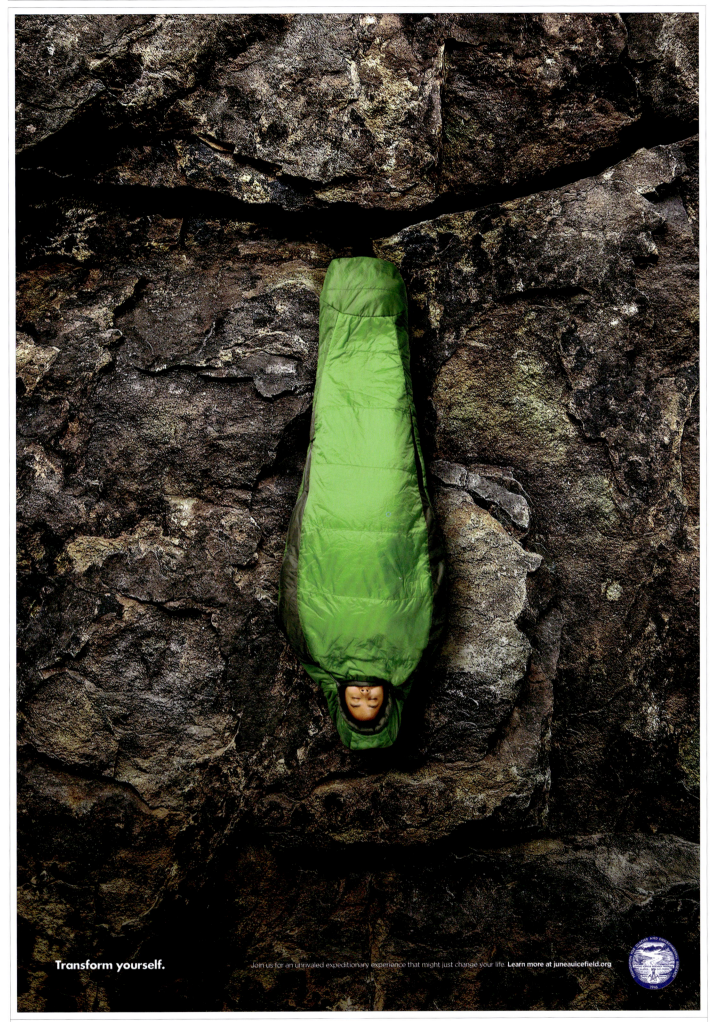

Transform yourself.

Join us for an unrivaled expeditionary experience that might just change your life. **Learn more at juneauicefield.org**

California wildfires burned over 4 million acres in 2020

21xdesign.com

our legacy their future

BIO

JAN RAJLICH 1920 2016

the
vagina
exhibit

photoworks
by
bianca
de
loreno

april 6
thru
may 3

gallery
of
photography

2525
michigan
ave

santa
monica
ca
90404

P219: Credit & Commentary **Title:** Bauhaus 100 | **Client:** Golden Bee 14 Moscow | **Design Firm:** Namseoul University

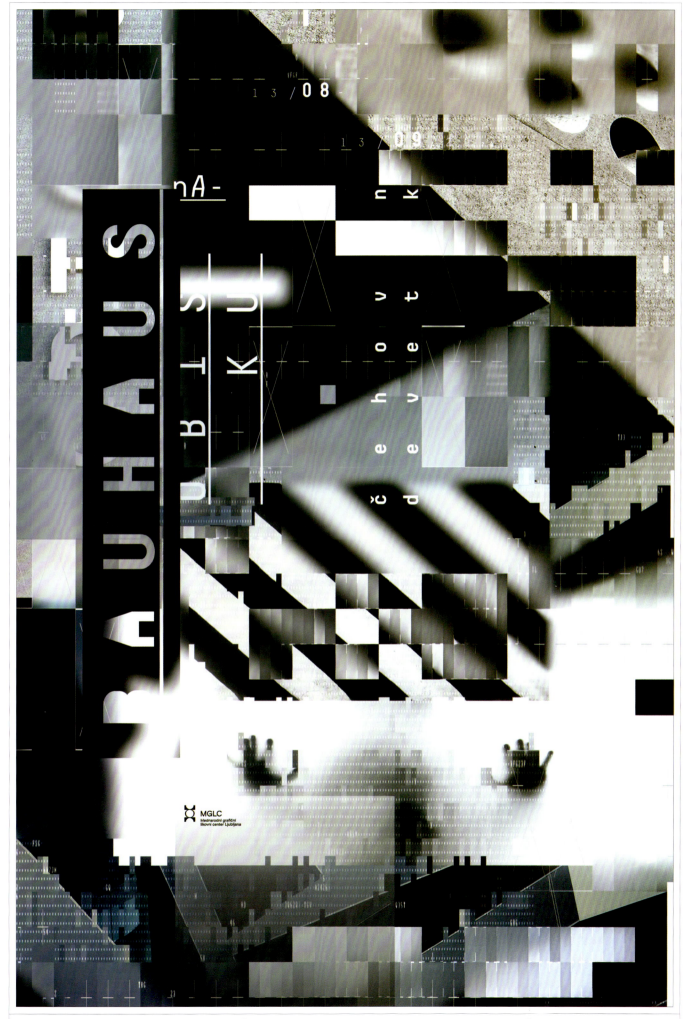

Yossi Lemel

The Last Chassid of Radomsko in La Paz

האדמו״יר האחרון מראדומסק

El último Hasid de Radomsko
Exposición de Yossi Lemel
en La Paz, Bolivia
Espacio Simón I. Patiño
Av. Ecuador esq.
Rosendo Gutiérrez

18.11.2019–10.01.2020

BIENAL
DEL **CARTEL**
BOLIVIA
BICeBé.

FUNDACIÓN ÁUREA
PARA LAS ARTES VISUALES
Y EL DISEÑO

DISEÑADORES
GRÁFICOS
BOLIVIA.

BICeBé 2019
10 YEARS

FUNDACIÓN SIMÓN I. PATIÑO

The Artist Gallery at the Virginia Beach Arts center

The Illustrated Art of dGwaltney

P219: Credit & Commentary **Title:** Emperor and the Lionfish | **Client:** Self-initiated | **Design Firm:** dGwaltneyArt

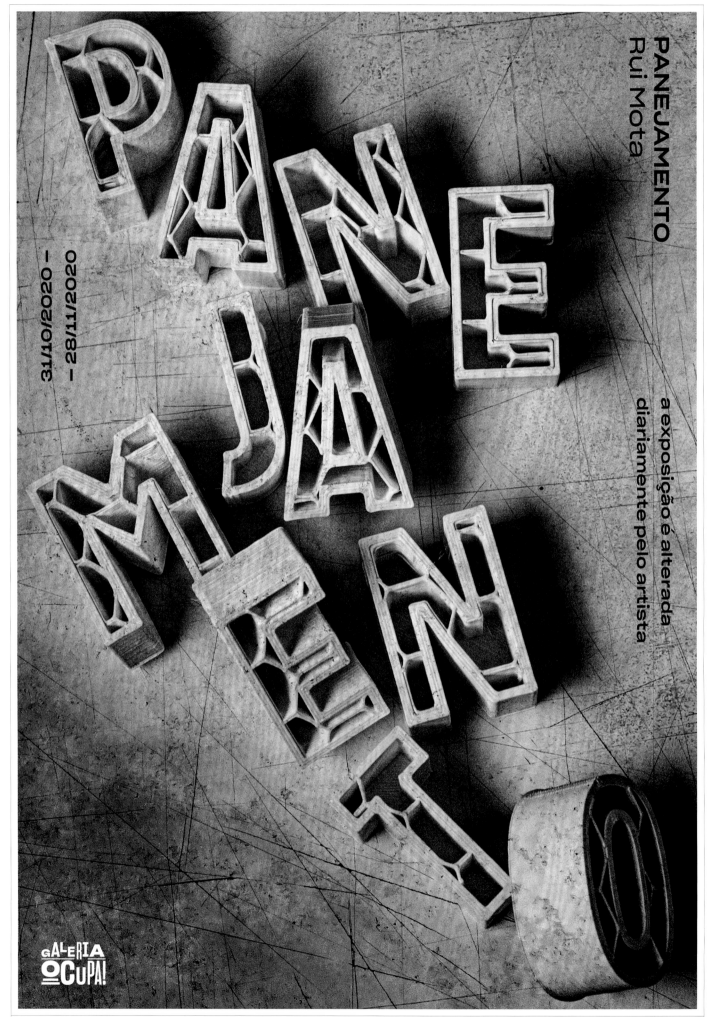

P219: Credit & Commentary **Title:** Panejamento | **Client:** Galeria Ocupa! | **Design Firm:** 1/4 studio

H O P E
IN PEOPLE THAT LIVE AND LET LIVE

3RD ANNUAL 2020
AUGUST 14-16

WOMEN
TEXAS
FILM
FESTIVAL

P219: Credit & Commentary **Title:** Frames of Mind | **Client:** Coronado Island Film Festival | **Design Firm:** Judd Brand Media

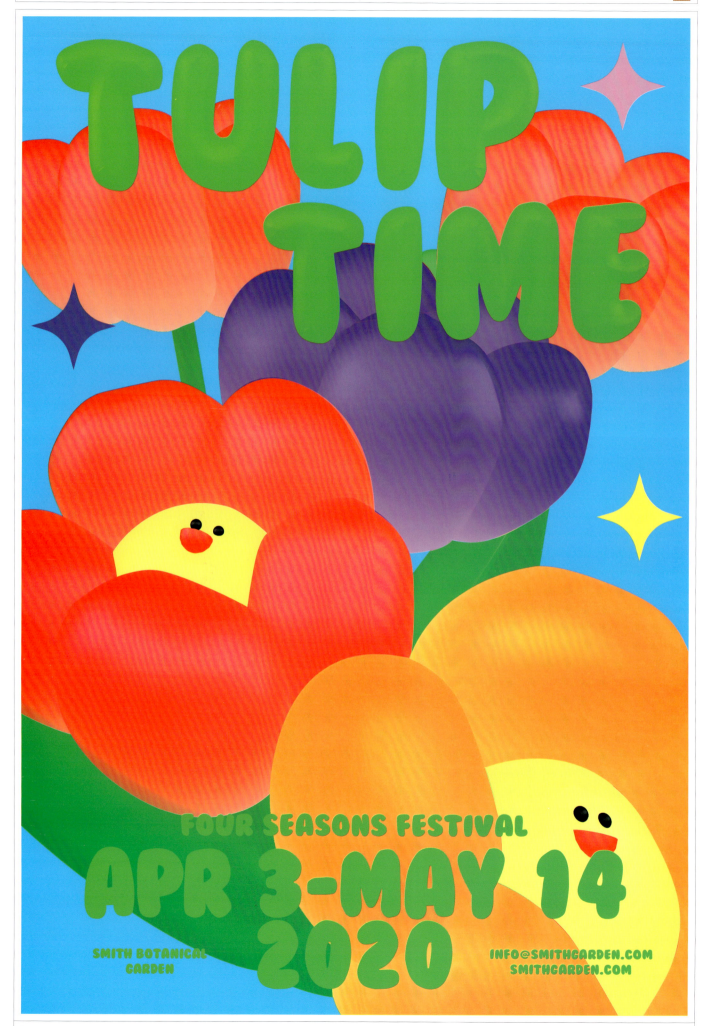

P220: Credit & Commentary **Title:** Four Seasons Festival | **Client:** Self-initiated | **Design Firm:** Maryland Institute College of Art

ARTISAN GUITAR SHOW CONCERT SERIES

The general admission concert series includes 12 great concert performances by internationally acclaimed performing artists. Our luthier partners have selected and will host some exciting and respected players who will showcase their instruments. The general admission concert series is included in the price of general admission.

• INVITATIONAL LUTHIER SHOWCASE

• MASTERCLASS WORKSHOPS • CONCERT SERIES PROGRAM •

P220: C & C **Title:** Artisan Guitar Show Posters | **Client:** John Detrick, Artisan Guitar Show | **Design Firm:** Fallano Faulkner & Associates Img. 1-3 of 4

A FILM BY
**FEDERICO
FELLINI**

LA
DOLCE
VITA

FELLINI
1920•2020

LET THERE BE THUNDER

250
BEETHOVEN

CHAMBER

PLAYERS

Title: "Even the Darkest Night Will End and the Sun Will Rise" from Chamber Music Players of Tokyo

P221: Credit & Commentary **Client:** Chamber Music Players of Tokyo | **Design Firm:** AYA KAWABATA DESIGN Images 1 of 3

MUSIC

OF TOKYO

Title: "Even the Darkest Night Will End and the Sun Will Rise" from Chamber Music Players of Tokyo

P221: Credit & Commentary **Client:** Chamber Music Players of Tokyo | **Design Firm:** AYA KAWABATA DESIGN Images 2 of 3

TRIBUTE TO JOE LOVANO
JAZZHUS MONTMARTRE
STORE REGNEGADE 19
COPENHAGEN DENMARK

TRIBUTE TO STEVE GADD
JAZZHUS MONTMARTRE
STORE REGNEGADE 19
COPENHAGEN·DENMARK

UN BALLO IN MASCHERA

GIUSEPPE VERDI

WOLFGANG AMADEUS MOZART

LA FINTA
GIARDINIERA

PALAU DE **LES ARTS**

GIOVANNI BATTISTA PERGOLESI

LA SERVA PADRONA

STABAT MATER

Patronatsverein

Mit freundlicher Unterstützung

Rambow 2020

Frankfurter Erstaufführung:
Sonntag, 18. Okt 2020
Alle Termine und Infos:
www.oper-frankfurt.de

}Oper Frankfurt

Stay smart

We're always listening, learning and looking ahead to make sure we're at the sharp edge of the industry. We make smart decisions based on science, data and intelligence, not intuition. We seek out new ideas, technologies and methodologies to give our clients an unfair advantage.

THE KITE FACTORY

Get involved

We speak up with passion and give space for fresh ideas. We get stuck-in and support each other with team spirit. And we go further to understand our clients world and work from the inside, out. Because the best results come from collaborating on the front lines, not watching quietly from the sidelines.

THE KITE FACTORY

Think freely

Because we're independent, we're not tied down to one way of doing things. Instead, we're free to explore, experiment and embrace innovative ways to help clients hit new heights. Collectively, we think more creatively; bigger, braver and without boundaries.

THE KITE FACTORY

Aim Higher

We continuously push ourselves beyond comfort zones, client expectations, and traditional job titles. We don't just take briefs, we help make them, then exceed them. We hold ourselves accountable for excellence in every area. We keep going until we're all proud of the effort, work and results we've delivered.

THE KITE FACTORY

BIBLIOTECA PALERMO

Frankenstein
by Mary Shelley

CLASSICS MADE MODERN

CHICAGO
PUBLIC
LIBRARY

Same stories, now in digital formats.
Access all our collections on the Chicago Public Library app.

P222: Credit & Commentary Title: Take Care | Client: Self-initiated | Design Firm: Craig Frazier Studio

Boris Ljubicic / CROATIA

TOLERANCE

HOUSEBOUND

Design: Osborne Ross **Print:** Boss

IRENE SOLÀ

Canto yo y la montaña baila

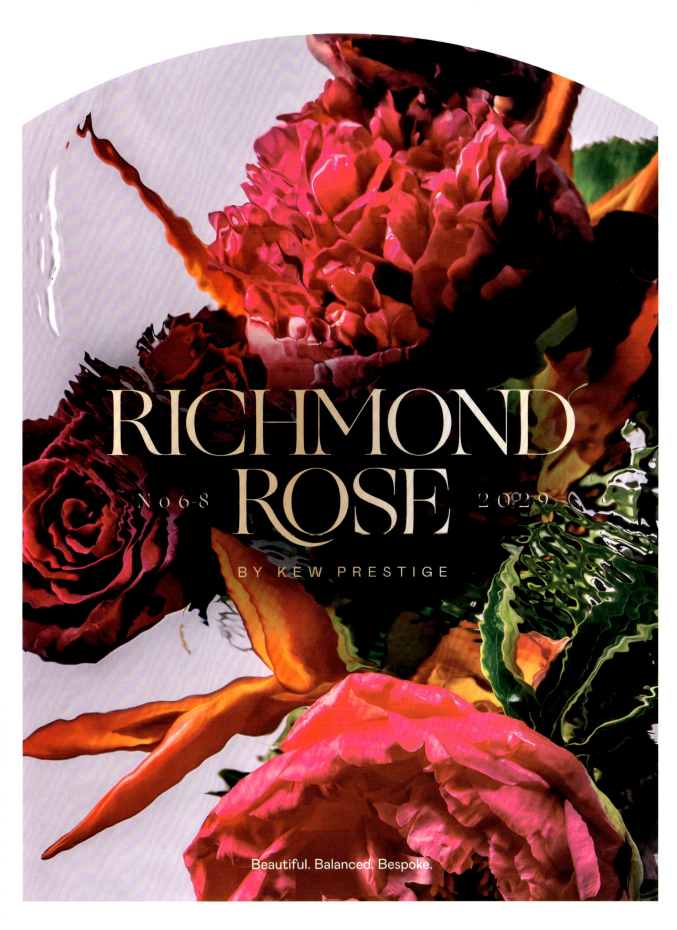

RICHMOND ROSE

No 6-8 · 2029

BY KEW PRESTIGE

Beautiful. Balanced. Bespoke.

richmondrose.com.au

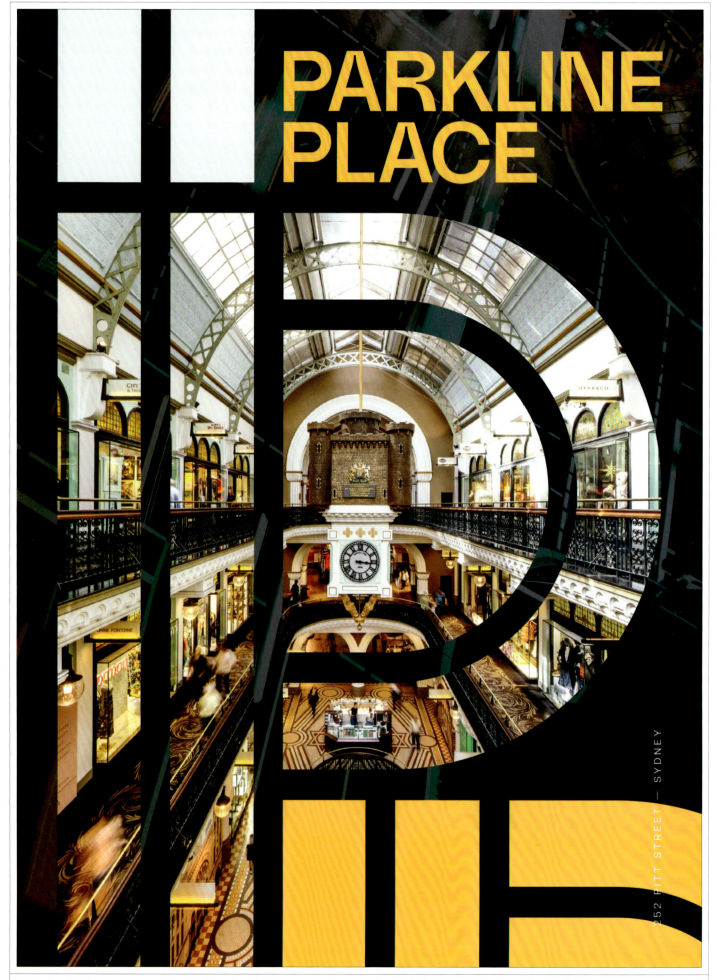

PARKLINE
PLACE

252 PITT STREET — SYDNEY

FILLMORE
MIAMI BEACH
DAY 1

Matt Spangler
Chief Brand &
Communications Officer
Panel Moderator

COMPASS

Kristen Ankerbrandt
Chief Financial Officer
Speaker, Panelist

Rob Lehman
Chief Business Officer
Panelist

Robert Reffkin
Founder & CEO
Speaker, Panelist

SPEAKERS

Peter Jonas
President, West Region
Panelist

Joseph Sirosh
Chief Technology Officer
Panelist

Neda Navab
President, East Region
Panelist

Chloe Drew
President, Philanthropy &
Community Impact
Speaker

11
–
13

PEACE BE WITH YOU!

Golden Bee Moscow Rambow 2019

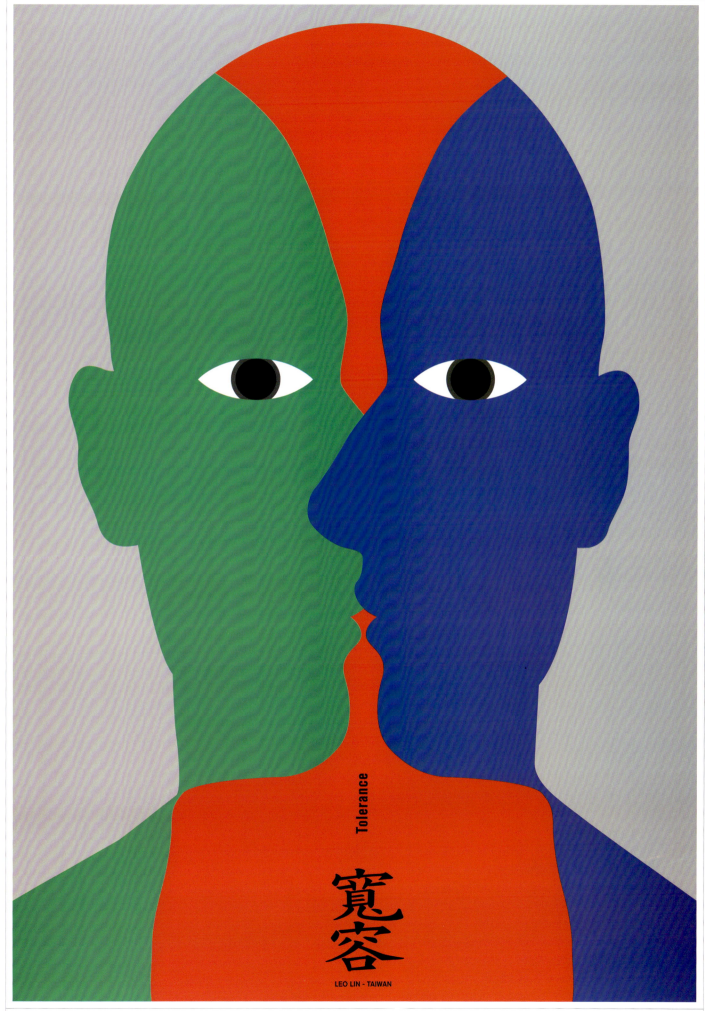

Tolerance

寬容

LEO LIN - TAIWAN

Title: Tolerance | **Client:** Mirko Ilic Corp. | **Design Firm:** Leo Lin Design

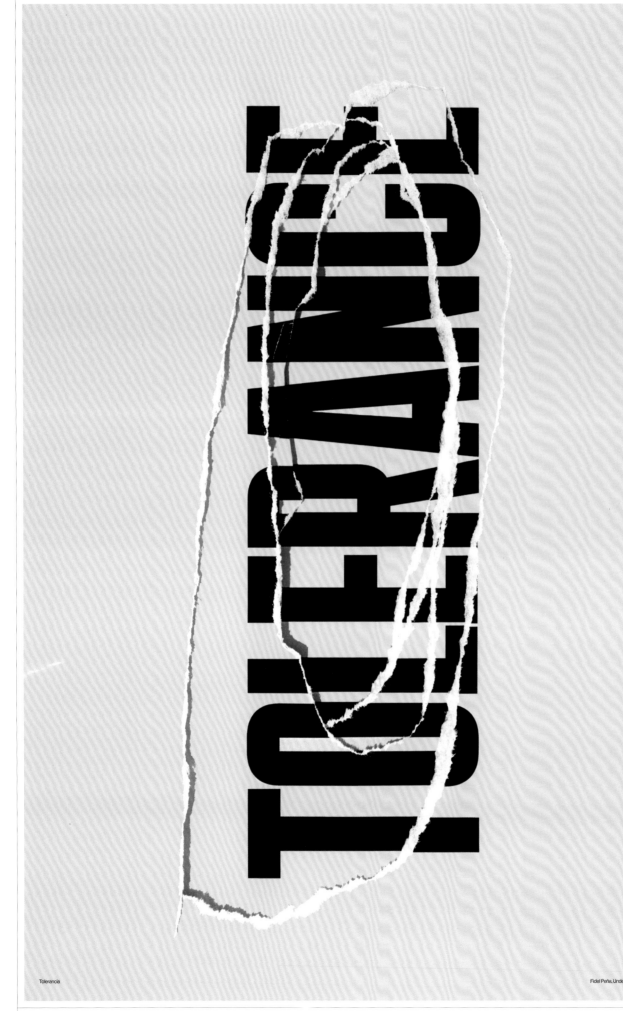

Tolerancia

Fidel Peña, Underline Studio — El Salvador/Canada

Title: Tolerance | **Client:** Mirko Ilić | **Design Firm:** Underline Studio

TRUST **KOREA'S FIGHT AGAINST COVID19**

STAY
H O
M E

STAY
S A
F E

P223: Credit & Commentary **Title:** STAY HOME, STAY SAFE | **Client:** Ministry of Health and Welfare | **Design Firm:** Woosuk University

DIGITAL REALITY AND MENTAL HEALTH

CO WORLD WIDE CASES COVID-19

FROM 01.2020 TO 01.2021

02.20　03.20　04.20　05.20　06.20　07.20　08.20　09.20　10.20　11.20　12.20　01.2

02.20　03.20　04.20　05.20　06.20　07.20　08.20　09.20　10.20　11.20　12.20　01.2

Concept & Design Franziska Stetter, 2021

The denial of the realities during the pandemic led to suffering and death. Denial and death are shown as cause and consequence of the same equation, visualized as a graph. This project shows the world-wide cumulative covid cases from January 2020 to January 2021 using related news headlines.

The objective was to represent the contrast between the denial and misinformation and it's real world impact. The result is an info graphic, a collage, of hundreds of headlines related to Covid misinformation and denial around the world. The lighter colored headlines in the background are arranged by date showing that the articles increased drastically from October to January. The exponential curve, visualized by darker colored headlines for contrast, show the gruesome toll of the disease, month by month and a more rapid increase the closer it gets to January 2021.

„Death and Denial" illustrates the fascinating absurdity of denying the existence of major self-evident crisis, though a cacophony of lies, deception and rage.

Sources: OWD;ECDC @ statista 2020, Fast Company, New York Times, Zeit Online, Washington Post, Los Angeles Times, Berkley News, The Indian Express, Desmog, Merkur, Augsburger Allgemeine, the Guardian, The Berlin Spectator, The Sun, global News, RND, RBB, DW, Der Tagesspiegel, MSNBC, NBC, billboard, Rolling Stone, The Sun, ZDF, Nova, The Intercept, Poynter, WION, Berliner Morgenpost, The Independent, Npr, National Post, Idaho Statesman, T-online, The Hill Times, Merkur, The Jakarta Post , Apa, News.com.au, Trip Advisor, Very well mind, El Pais, Business insider, CIPD Community, Evening Standard, Nursing Times, Chanel 4, Abc news, The Hindu, euro news, CNN, Presse Portal, Coventry Live, The Sydney Morning Herald, E & G news, The Atlantic, Ruptly, The City Herald, SRF, Deutschlandfunk, the Northern Times, RTL, NHS, The Milli chronicle, Vanity Fair, RN 24.

Yossi Lemel 2020

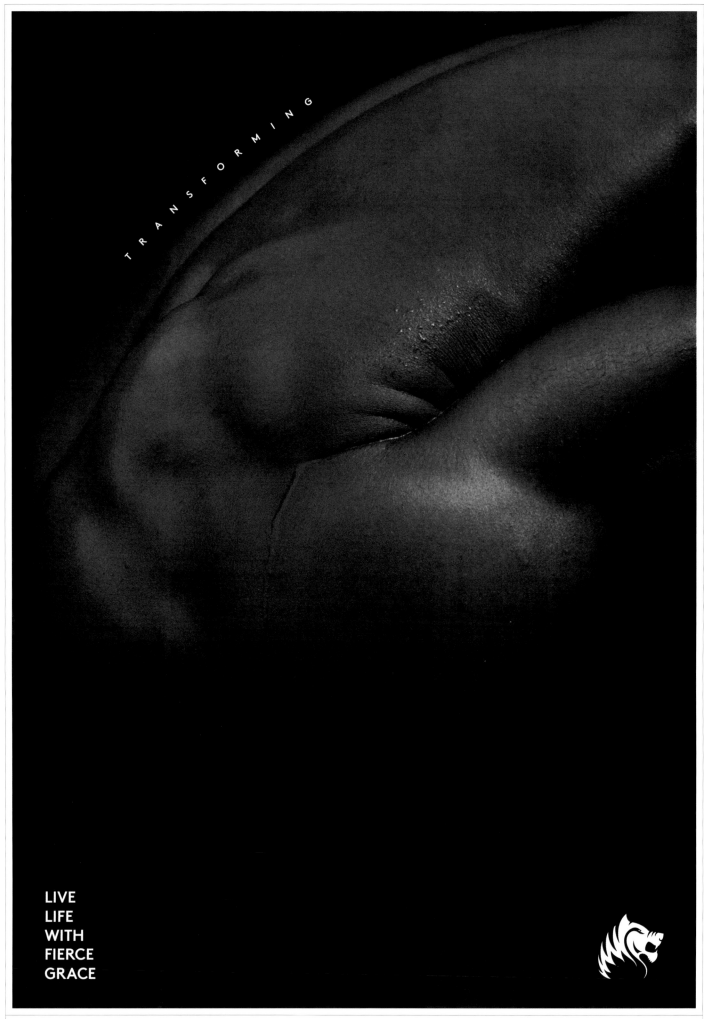

TRANSFORMING

LIVE
LIFE
WITH
FIERCE
GRACE

BLACK NARCISSUS

11.23 **FX**

FRIEDRICH DÜRRENMATT
DIE PANNE
THEATER SOLOTHURN AB 28|08|2020
THEATRE BIEL BIENNE AB/DÈS 23|09|2020
SURTITRÉ EN FRANÇAIS À BIENNE
www.TOBS.CH

P223: Credit & Commentary **Title:** Die Panne | **Client:** Theater Orchester Biel Solothurn | **Design Firm:** Atelier Bundi AG

P223: Credit & Commentary **Title:** The Visitor | **Client:** Robert Allan Ackerman | **Design Firm:** Ron Taft Design

CEREN CALISKAN

Title: Interdisciplinary Studio | **Client:** Istanbul Arel University
Design Firm: Atelier Ceren Caliskan

EDUARDO DAVIT

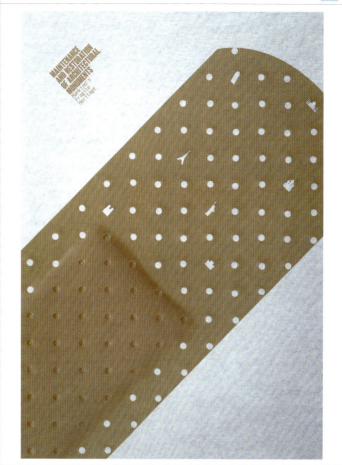

Title: Band Aid | **Client:** Mankind's Fragile Heritage
Design Firm: Eduardo Davit

KRISTINA KARLEN

Title: Frankimpact | **Client:** Snap-on Tools
Design Firm: Traction Factory

JEAN-BENOIT LEVY, MARTIN VENEZKY

Title: First Step on the Moon / 50 Years | **Client:** Self-initiated
Design Firm: Studio AND

SCOTT LASEROW

Title: Silk Rivers | **Client:** International Charity Poster Design Invitational Exhibition | **Design Firm:** Scott Laserow Posters

KARI PIIPPO

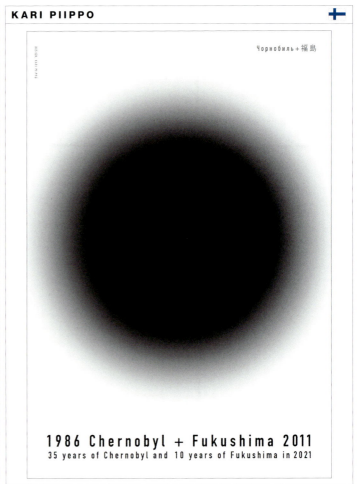

Title: 1986 Chernobyl + Fukushima 2011 | **Client:** 4th Block Biennale
Design Firm: Kari Piippo

JOHN GRAVDAHL

Title: Campanile di Fellini | **Client:** The Fellini Project
Design Firm: Gravdahl Design

HUI PAN, DAWANG SUN

Title: Milton Glaser 1929-2020 | **Client:** Self-initiated
Design Firm: T9 Brand

XOSE TEIGA

**Title: Tribute to Milton Glaser | Client: Self-initiated
Design Firm: teiga, studio.**

JEAN-PAUL KRAMMER

**Title: Max Frisch and Friedrich Dürrenmath | Client: Self-initiated
Design Firm: Krammer Atelier**

JOHN GRAVDAHL

Title: Beethoven 250 | Client: Negra40 | Design Firm: Gravdahl Design

CURIOUS

Title: Zyte Poster Series | Client: Zyte | Design Firm: CURIOUS

HOWARD SCHATZ

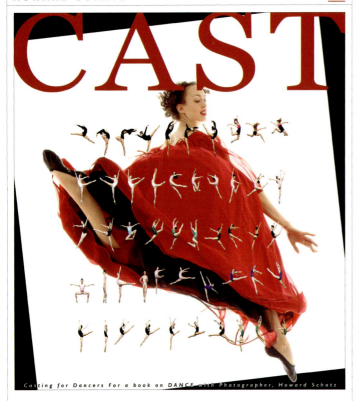

Title: Dance Study 1436 | **Client:** Self-initiated
Design Firm: Schatz/Ornstein Studio

HOWARD SCHATZ

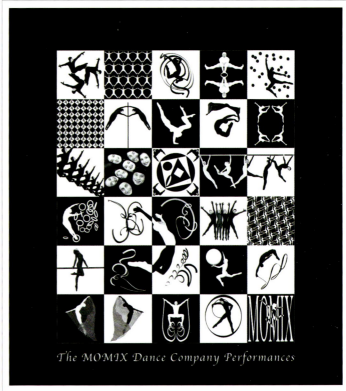

Title: Momix Dance Company | **Client:** Momix
Design Firm: Schatz/Ornstein Studio

TAKASHI AKIYAMA

Title: Earthquake Japan 2019 | **Client:** The Earthquake Poster Project
at Tama Art University | **Design Firm:** Takashi Akiyama Studio

HYUNGJOO A. KIM

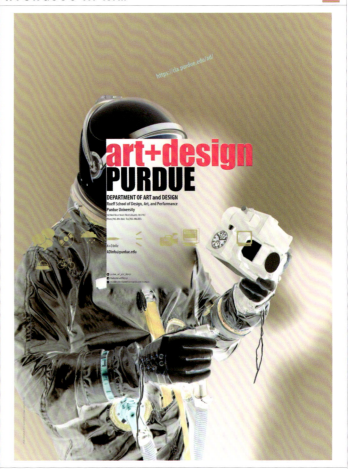

Title: art+design PURDUE | **Client:** Dept. of Art and Design
Design Firm: hyungjookimdesignlab

TAKASHI AKIYAMA

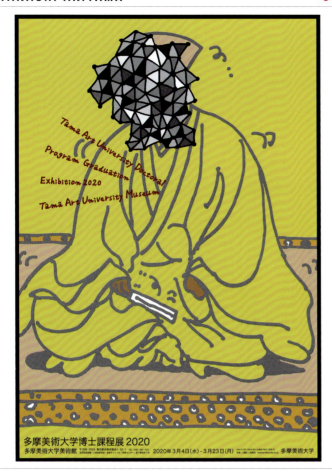

Title: **Tama Art University Doctoral Program Graduation Exhibition 2020**
Client: **Tama Art University** | Design Firm: **Takashi Akiyama Studio**

DANIELLE FOUSHÉE

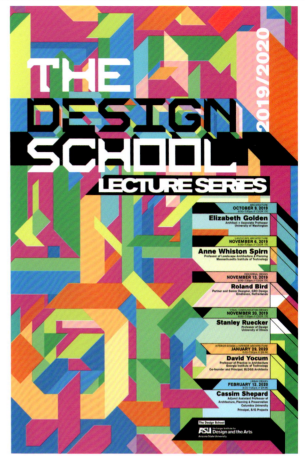

Title: **ASU Design School Lecture Series** | Client: **ASU Design School**
Design Firm: **Danielle Foushée**

FA-HSIANG HU

Title: **AART's Imagine** | Client: **FU-JEN Catholic University**
Design Firm: **hufax arts**

TRAVIS TATUM

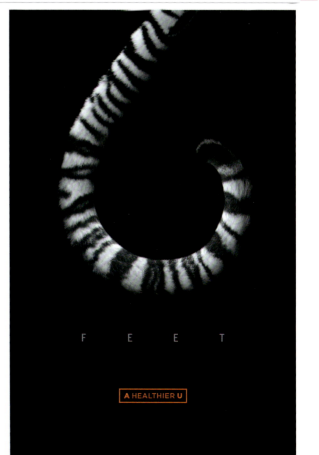

Title: **Auburn Spirit Poster Series** | Client: **Auburn University**
Design Firm: **Tatum Design**

TAKASHI AKIYAMA

Title: Tama Art University Doctoral Program Graduation Exhibition 2020
Client: Tama Art University | **Design Firm:** Takashi Akiyama Studio

KIYOUNG AN, HANA IKUNAMI

Title: KINDAI Graphis Art Course: SDGs | **Client:** Self-initiated
Design Firm: KINDAI University, Graphic Art course

KEN-TSAI LEE

Title: Promo. Posters of Design Dept. of The Nat'l. Taiwan Univ. of Science &
Tech. **Client:** Self-initiated | **Design Firms:** ken-tsai lee design lab, Taiwan TECH

RANDY CLARK

Title: X | **Client:** Wenzhou Kean University
Design Firm: Randy Clark

TRAVIS TATUM 🇺🇸

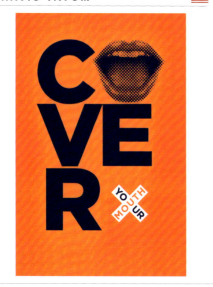

Title: Auburn Creative COVID-19 Poster Series
Client: Auburn University
Design Firm: Tatum Design

KIYOUNG AN ●

Title: SDGs Design Project in KINDAI University
Client: Self-initiated | **Design Firm:** KINDAI
University, Graphic Art course

JOSH EGE 🇺🇸

Title: Forged by Craft | **Client:** Dallas Society
of Visual Communications Foundation
Design Firm: Josh Ege

TRAVIS TATUM 🇺🇸

Title: Auburn Hand Sanitizer Series
Client: Auburn Univ. | **Design Firm:** Tatum Design

TOYOTSUGU ITOH ●

Title: GO! DOHO | **Client:** Doho University
Design Firm: Toyotsugu Itoh Design Office

ROBIN MCLOUGHLIN 🇺🇸

Title: Jessup 2021 | **Client:** ILSA
Design Firm: White & Case LLP

TAKASHI AKIYAMA ●

Title: Earthquake Japan 2019 | **Client:** The
Earthquake Poster Project, Tama Art University
Design Firm: Takashi Akiyama Studio

SARAH EDMANDS MARTIN 🇺🇸

Title: IUN School of the Arts | **Client:** Indiana
University Northwest School of the Arts
Design Firm: Sarah Edmands Martin Designs

VIKTOR KOEN 🇺🇸

Title: SVA Summer Illustration Residency
Client: School of Visual Arts
Design Firm: Attic Child Press

JAMIE STARK 🇺🇸

Title: Parasite Poster | Client: Intended as a licensed product
Design Firm: Stark Designs, LLC

ARSONAL 🇺🇸

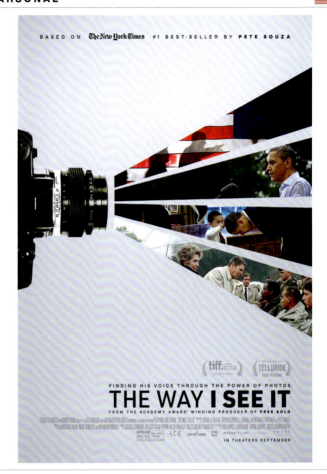

Title: The Way I See It | Client: Focus Features
Design Firm: ARSONAL

ARSONAL 🇺🇸

Title: The Way I See It | Client: Focus Features
Design Firm: ARSONAL

DAVID O'HANLON 🇺🇸

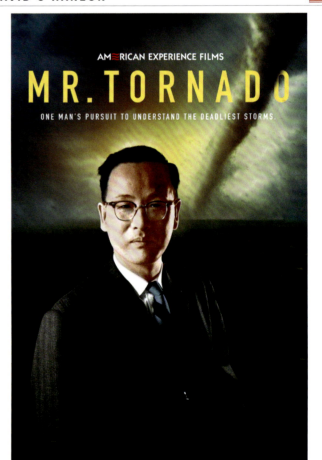

Title: Mr. Tornado | Client: Chika Offurum, American Experience Films
Design Firm: SJI Associates

ARSONAL 🇺🇸

Title: The Challenge: Double Agents S36 | **Client:** MTV
Design Firm: ARSONAL

ARSONAL 🇺🇸

Title: How To With John Wilson | **Client:** HBO
Design Firm: ARSONAL

ISMAEL MEDINA 🇪🇸

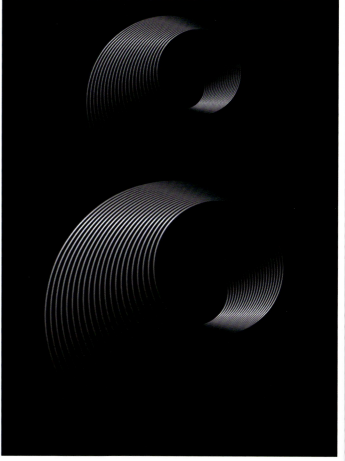

Title: 8 | **Client:** 8th Gear | **Design Firm:** Virgen extra

YUSUKE OHTA, ICHIRO YATSUI

Title: RON RON MARRON QUEEN | Client: TBS RADIO/TWINKLE Corporation Inc. | Design Firm: Beacon Communications k.k. (Leo Burnett Tokyo)

SCOTT LASEROW

Title: Heartbeat | Client: Biophilia Posters
Design Firm: Scott Laserow Posters

MARLENA BUCZEK SMITH

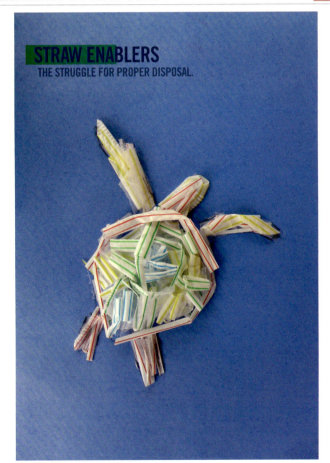

Title: Straw Enablers | Client: Self-initiated
Design Firm: Marlena Buczek Smith

MYKOLA KOVALENKO

Title: Biophilia | Client: Biophilia Poster
Design Firm: Mykola Kovalenko Studio

BRAD TZOU

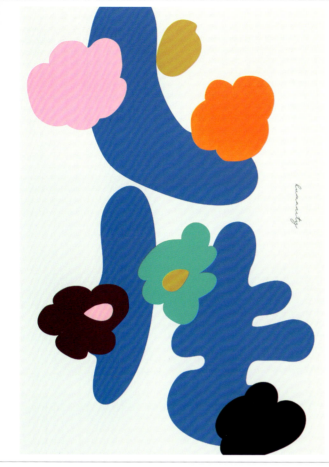

Title: Humanity | Client: Biophilia Poster Competition
Design Firm: Human Paradise Studio

RIKKE HANSEN, ARAM HUERTA

Title: Biophilia Connected with Nature | Client: Biophilia Poster Competition | Design Firms: Rikke Hansen/Aram Huerta

YIJIE ZHANG

DON'T FLUSH OUR PLANET'S
MOST VALUABLE RESOURCE.

Title: Stop Running Out of Water
Client: Self-initiated | Design Firm: Yijie Zhang

PEKKA LOIRI

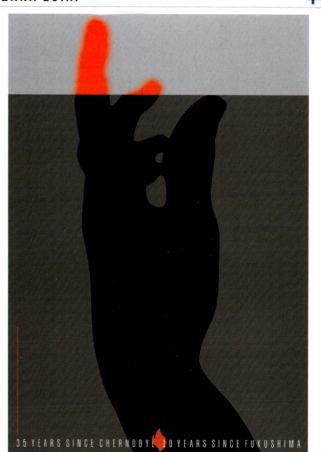

35 YEARS SINCE CHERNOBYL / 10 YEARS SINCE FUKUSHIMA

Title: 35 Years Since Chernobyl / 10 Years Since Fukushima
Client: The 4th Block / Ukraine | Design Firm: Studio Pekka Loiri

TOYOTSUGU ITOH

Title: FALLING | **Client:** Chubu Creators Club
Design Firm: Toyotsugu Itoh Design Office

HIROYUKI MATSUISHI

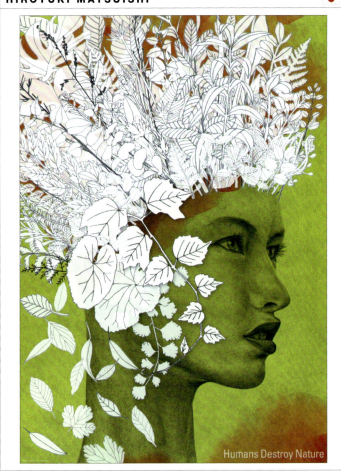

Title: Humans Destroy Nature | **Client:** Self-initiated
Design Firm: Hiroyuki Matsuishi Design Office

SEBASTIAN ARAVENA

Title: Naturehood | **Client:** SocioCultural Awareness
Design Firm: Sebastian Aravena

KATHY DELANEY, SCOTT CARLTON

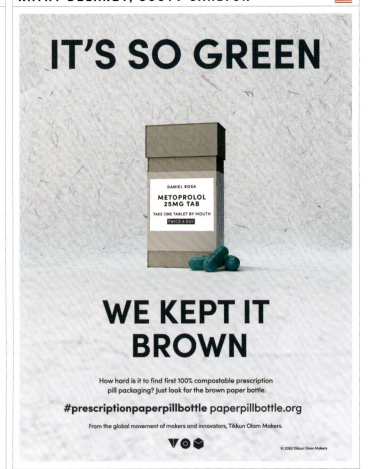

Title: The Prescription Paper Pill Bottle | **Client:** Tikkun Olam Makers-
TOM | **Design Firm:** Saatchi & Saatchi Wellness

KEITH KITZ

Title: I Know You, You Know Me | Client: Biophilia Poster Competition
Design Firm: Keith Kitz Design

DOUGLAS MAY

Title: Fandango Motorcycle | Client: Texas Fandango, Inc.
Design Firm: May & Co.

KHUSHBOO UDAY NAYAK

Title: Indic Callifest Event Poster- Calligraphy | Client: Self-initiated
Design Firm: Savannah College of Art and Design

BYOUNG IL SUN

Title: Marcus | Client: Art & Science, Poland
Design Firm: Namseoul University

RIKKE HANSEN

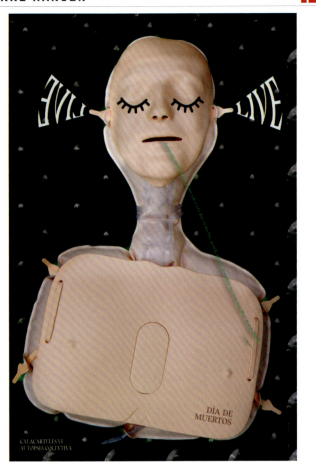

Title: Day of the Dead – Día de Muertos | Client: Autopsia Colectiva CALACARTELES VI | Design Firm: Rikke Hansen

TOYOTSUGU ITOH

Title: 7 GRAPHIC DESIGNERS IN NAGOYA 2020 | Client: Nagoya City Cultural Promotion Agency | Design Firm: Toyotsugu Itoh Design Office

CHAOQUN WANG

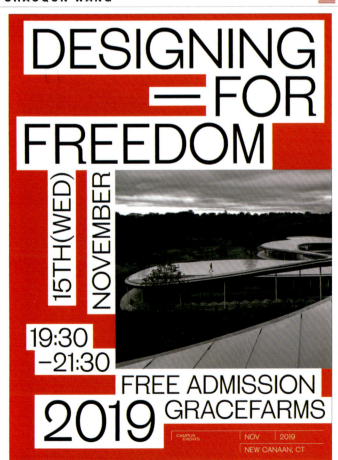

Title: Designing for Freedom | Client: Grace Farm Design Firm: School of Visual Arts

MICHAEL PANTUSO

Title: 100 BEES SHOW | Client: Acquisitions of Fine Art Design Firm: Michael Pantuso Design

ANA ALVES DA SILVA

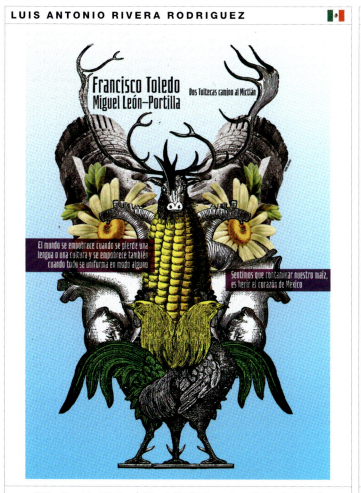

Title: Bombarda 2020 | Client: Ágora - Cultura e Desporto do Porto/CMP
Design Firm: anacmyk

PEP CARRIÓ

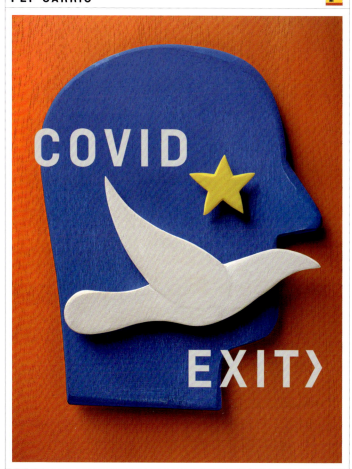

Title: Covid Exit | Client: Foro de Empresas por Madrid/Ayuntamiento de Madrid/DIMAD | Design Firm: Estudio Pep Carrió

LUIS ANTONIO RIVERA RODRIGUEZ

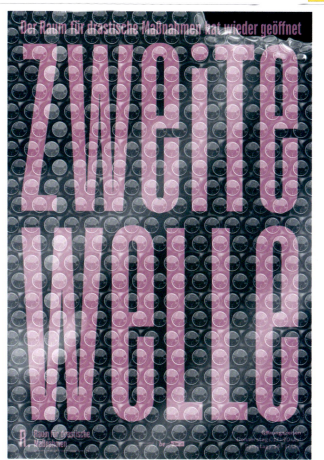

Title: Road to Mictlan | Client: Red Interuniversitaria de Cartel
Design Firm: monokromatic

SVEN LINDHORST-EMME

Title: Zweite Welle (Second Wave) | Client: R. Raum für Drastische Maßnahmen | Design Firm: studio lindhorst-emme

TABER CALDERON

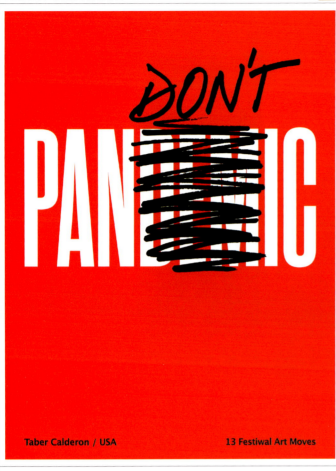

Title: Don't Panic | **Client:** Art Moves Festival, Torun, Poland
Design Firm: Taber Calderon Graphic Design

JORGE ARAÚJO

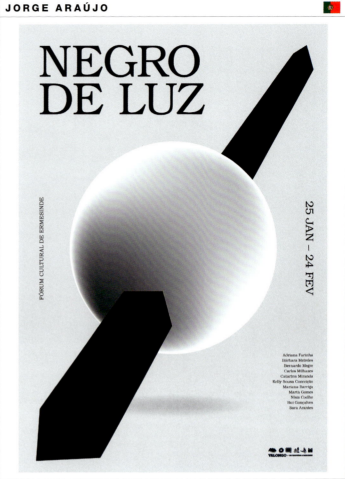

Title: Negro de Luz | **Client:** Fórum Cultural de Ermesinde
Design Firm: 1/4 studio

CHIKAKO OGUMA

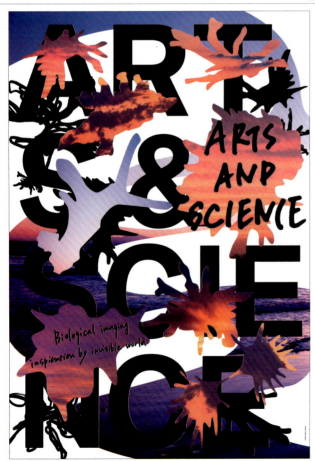

Title: ARTS & SCIENCE | **Client:** ARTS & SCIENCE
Design Firm: Chikako Oguma Design

TABER CALDERON

Title: Burning Croc | **Client:** Calanca Biennale 2021
Design Firm: Taber Calderon Graphic Design

STEPHEN GUENTHER

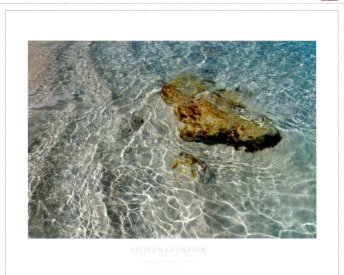

**Title: Show Poster | Client: Self-initiated
Design Firm: Foto + Film**

DAVID H. GWALTNEY

**Title: Mystical Creatures/Close Encounter of Moorish Idols
Client: Self-initiated | Design Firm: dGwaltneyArt**

TAKAHIRO ETO ●

**Title: Para-GRAPH | Client: Tokyo Polytechnic
University | Design Firm: STUDY LLC.**

EDUARDO DAVIT

**Title: Veintisiete Punto Cinco
Client: Self-initiated | Design Firm: Eduardo Davit**

TSUYOSHI OMORI ●

**Title: OBJECT LESSON | Client: Mika Yamakoshi
Design Firm: TRIPLET DESIGN INC.**

PATRYCJA LONGAWA

**Title: In a Literary Style | Client: University of
Rzeszow | Design Firm: Patrycja Longawa**

BÜLENT ERKMEN

**Title: Borders/Trash it! | Client: AGI Congress,
Paris, France | Design Firm: BEK Design**

SASCHA FRONCZEK

**Title: Wände | Walls | Client: Stiftung Kunstmuseum
Stuttgart gGmbH | Design Firm: studio +fronczek**

PATRYCJA LONGAWA

Title: **In Podkarpackie Region** | Client: **Pastula Gallery of Contemporary Art** | Design Firm: **Patrycja Longawa**

JINSOO JEON

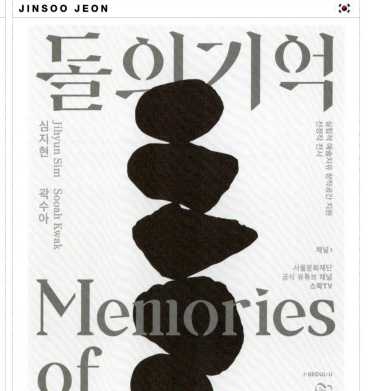

Title: **Memories of the Stone** | Client: **Seoul Foundation for Arts and Culture** | Design Firm: **BRAND DIRECTORS**

EVELYNE KRALL

Title: **Europa Wonderland** | Client: **Asociația Culturală Contrasens** Design Firm: **Evelyne Krall**

OLGA SEVERINA

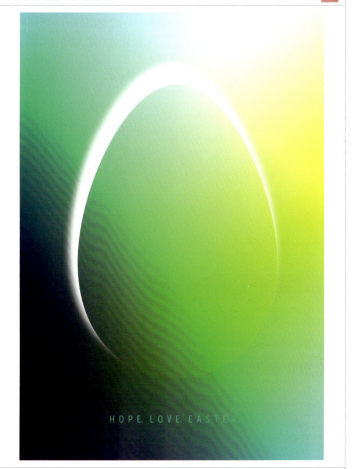

Title: **Hope. Love. Easter 2020** | Client: **Self-initiated** Design Firm: **PosterTerritory**

ATSUSHI ISHIGURO

DRIVE

Title: BLACK and BLOCK | **Client:** PEOPLE AND THOUGHT
Design Firm: OUWN

DAVID BIELOH

HOPE

Title: A Glimmer of Hope | **Client:** Emirates International Poster Festival
Design Firm: David Bieloh Design

JINU HONG

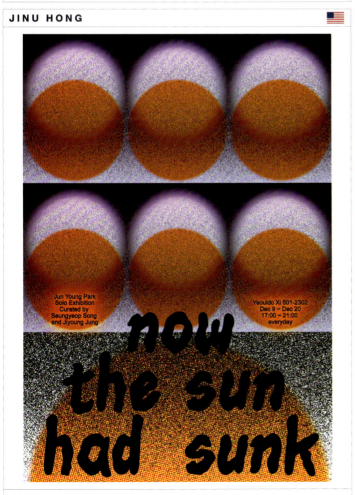

Title: Now the Sun Had Sunk | **Client:** Xi Gallery
Design Firm: Jinu Hong

BÜLENT ERKMEN

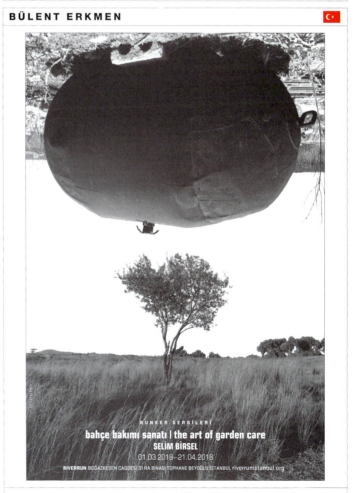

Title: The Art of Garden Care | **Client:** Norgunk Publications
Design Firm: BEK Design

YUSUKE OHTA, ICHIRO YATSUI

Title: Yatsui Festival | **Client:** SHIBUYA TELEVISION | **Design Firm:** Beacon Communications k.k. (Leo Burnett Tokyo)

JOHN BUTLER, KELLY BERNARD

Title: Mill Valley Film Festival Poster | **Client:** Mill Valley Film Festival | **Design Firm:** BSSP

ANDRÉ BARNETT 🇺🇸

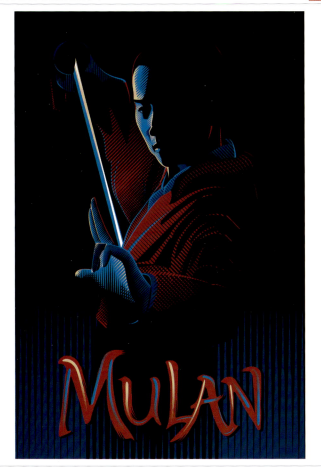

Title: Mulan | **Client:** Self-initiated
Design Firm: Only Child Art

THE REFINERY 🇺🇸

Title: Amulet Campaign | **Client:** Magnolia Pictures
Design Firm: The Refinery

LEROY & ROSE 🇺🇸

Title: Tenet | **Client:** Warner Bros.
Design Firm: Leroy & Rose

HUI PAN, DAWANG SUN 🇺🇸

Title: Beijing Film Festival 2020 | **Client:** Beijing Film Festival
Design Firm: T9 Brand

LEROY & ROSE

Title: **Trolls World Tour** | Client: **Universal**
Design Firm: **Leroy & Rose**

EDUARD CEHOVIN

Title: **Fellini 100** | Client: **Project Fellini 100**
Design Firm: **Centre for Design Research**

HYUNJEONG YI

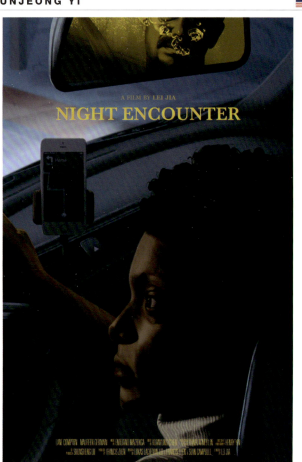

Title: **Night Encounter** | Client: **Lei Jia**
Design Firm: **Hyunjeong Yi**

CRISTIAN 'KIT' PAUL, ADRIAN STANCULET

Title: **Pant Hoot** | Clients: **Richard Reens, Barbara and Lewis Hollweg**
Design Firm: **Brandient**

LEROY & ROSE 🇺🇸

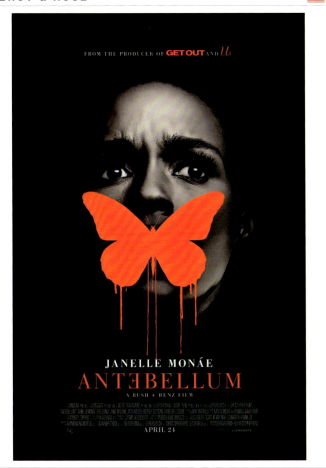

Title: **Antebellum** | Client: **Lionsgate**
Design Firm: **Leroy & Rose**

MEGHAN ZAVITZ 🇺🇸

Title: **Lilo & Stitch Movie Poster Re-Design** | Client: **Self-initiated**
Design Firm: **Meghan Zavitz**

VIVEK MATHUR, JAMES VERDESOTO 🇺🇸

Title: **El Angel** | Client: **K&S Films** | Design Firm: **Indika**

VIVEK MATHUR, JAMES VERDESOTO 🇺🇸

Title: **The Mauritanian** | Client: **Keri Moore** | Design Firm: **Indika**

LEROY & ROSE

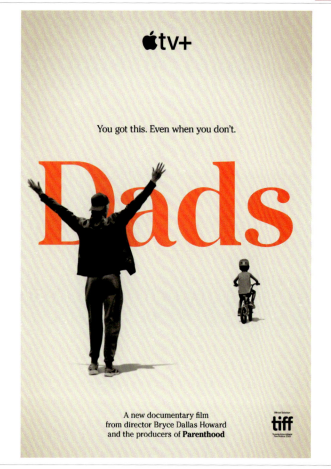

Title: Dads | Client: Apple
Design Firm: Leroy & Rose

BRAD D. NORR

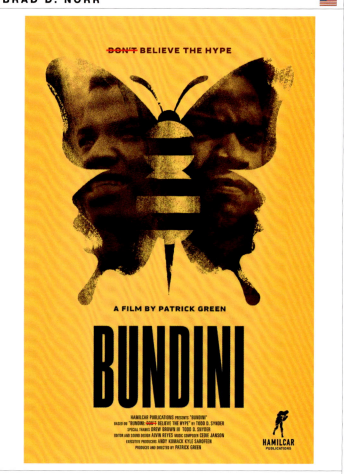

Title: "Bundini" Poster | Client: Hamilcar Publications
Design Firm: Brad Norr Design

ANDRÉ BARNETT

Title: Suicide Squad - Harley Quinn | Client: Self-initiated
Design Firm: Only Child Art

DAVID O'HANLON

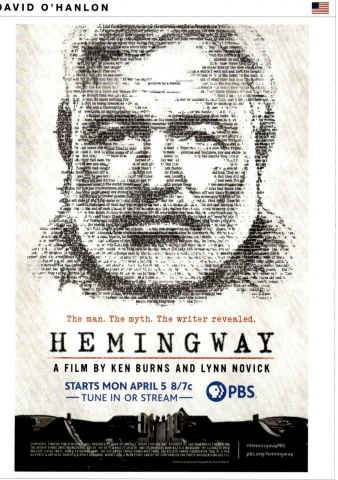

Title: HEMINGWAY: A film by Ken Burns and Lynn Novick
Clients: Claire Quin, John Ruppenthal, PBS | Design Firm: SJI Associates

TED WRIGHT

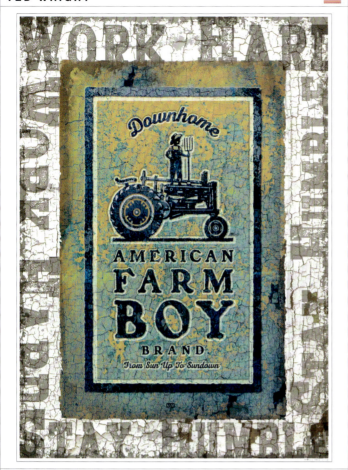

Title: American Farm Boy - Work Hard - Stay Humble | **Client:** Cracker Barrel Old Country Store | **Design Firm:** Ted Wright Illustration & Design

MICHAEL DAIMINGER

Title: Ferri Gelato | **Client:** Genc Belegu
Design Firm: Michael Daiminger Design

TOM VENTRESS

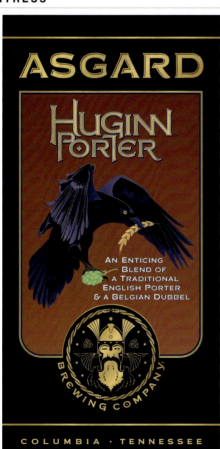

Title: Huginn Porter Poster | **Client:** Asgard Brewing Company
Design Firm: Ventress Design Works

NICOLE ELSENBACH

Title: 23rd Düsseldorf International Endoscopy Symposium
Client: COCS GmbH | **Design Firm:** Elsenbach Design

TE-SIAN SHIH

Title: Loving Message Poster for People Who Suffered or Affected by COVID-19. | **Client:** Self-initiated | **Design Firm:** Te Sian Lera Shih's Design Studio

NED DREW, BRENDA MCMANUS

Title: Stay Safe Letterpress Poster Series | **Client:** Pace University | **Design Firm:** BRED

PEKKA LOIRI

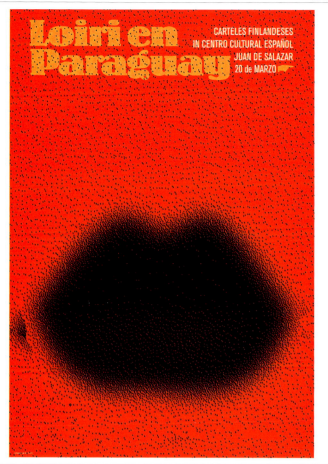

Title: **Loiri en Paraguay** | Client: **Centro Cultural Espanol**
Design Firm: **Studio Pekka Loiri**

CHONG VENG (EDDIE) CHEANG

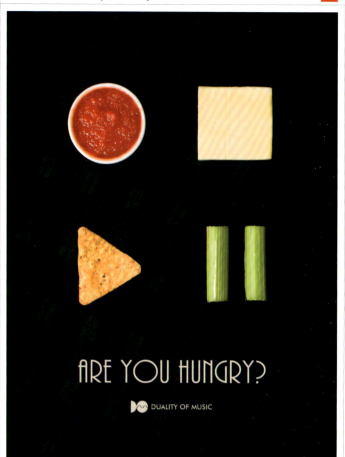

Title: **Are You Hungry?** | Client: **Duality of Music**
Design Firm: **WREC Multimedia Production**

FONS HICKMANN

Title: **Jazz am Mittwoch** | Client: **Neubad**
Design Firm: **Fons Hickmann m23**

YOSSI LEMEL

Title: **Haifa Museum of Art 70th Anniversary**
Client: **Haifa Museum of Art** | Design Firm: **Yossi Lemel**

DOUGLAS MAY 🇺🇸

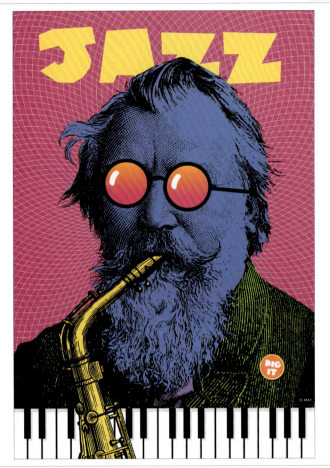

Title: Jazz | **Client:** Jazz in Ruins, Gliwice
Design Firm: May & Co.

NAOYUKI FUKUMOTO 🔴

Title: Ein Namenloses Konzert (Concert Without a Name)
Client: Tomizawa Music School | **Design Firm:** Imageon Co., LTD.

MARTIN FRENCH 🇺🇸

Title: Bird 100 | **Client:** Self-initiated
Design Firm: Martin French Studio

FINN NYGAARD 🇩🇰

Title: Tribute to Paul Motian, Jazzhus Montmartre
Client: Jazzhus Montmartre | **Design Firm:** Finn Nygaard

MIKE HUGHES 🇨🇦

Title: Mount Deed Poster | **Client:** Mount Deed (Band)
Design Firm: Mike Hughes Freelance Art Direction

HELENE HAVRO, JOHAN RESSLE 🇸🇪

Title: Floating Sounds | **Client:** Riche
Design Firm: Behind the Amusement Park

HELENE HAVRO, JOHAN RESSLE 🇸🇪

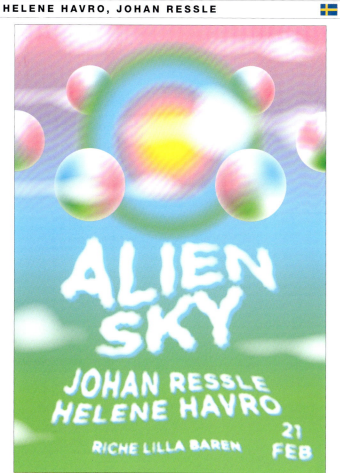

Title: Alien Sky | **Client:** Riche
Design Firm: Behind the Amusement Park

MARTIN FRENCH 🇺🇸

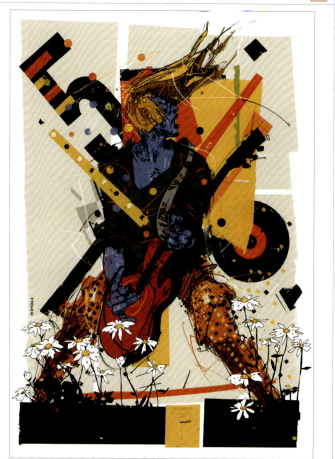

Title: Woodstock 50 | **Client:** The Bienal Internacional del Cartel
en México | **Design Firm:** Martin French Studio

MATTHIAS HOFMANN 🇨🇭

Title: Word of Moth | **Client:** Neustahl GmbH
Design Firm: Hofmann.to

SVEN LINDHORST-EMME 🇩🇪

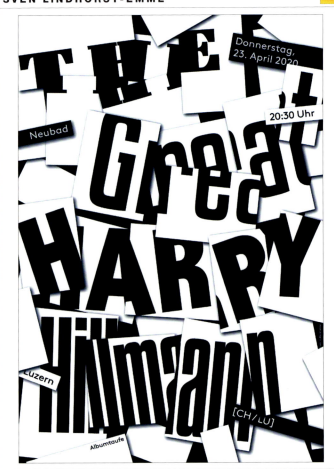

Title: The Great Harry Hillmann | **Client:** Neubad Lucerne
Design Firm: studio lindhorst-emme

MATTHIAS HOFMANN 🇨🇭

Title: LEKKER ZUKKER | **Client:** Neustahl GmbH
Design Firm: Hofmann.to

TED WRIGHT 🇺🇸

Title: Dwight Yoakam - Long Hard Road | **Client:** Warner Reprise Records
Design Firm: Ted Wright Illustration & Design

E. HALTINER, S. INGERHAM, R. WARCHOL, T. ZANNI

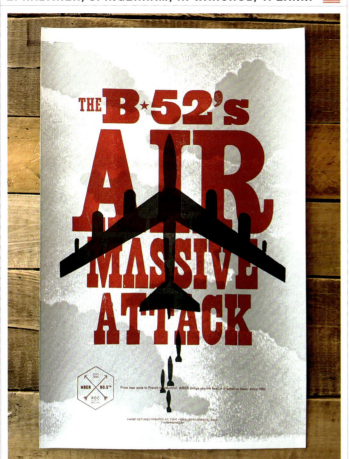

Title: 90.5fm WBER Poster Series | **Client:** 90.5
Design Firm: Brandtatorship

BOB DELEVANTE 🇺🇸

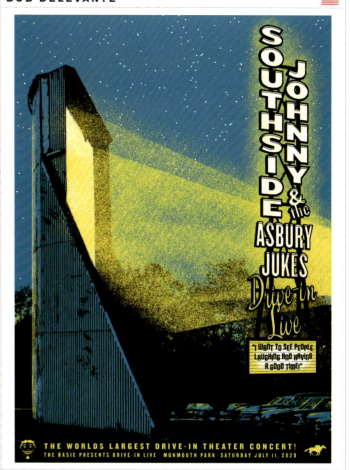

Title: Southside Johnny and the Asbury Jukes Drive-in Live
Client: Southside Johnny | **Design Firm:** Bob Delevante Studios

TIVADAR BOTE

Title: Carmen Metropolitan Opera Poster | **Client:** Self-initiated
Design Firm: Tivadar Bote Illustration

SIMON ELLIOTT

Title: The Valkyrie – ENO 2021 | **Client:** English National Opera
Design Firm: Rose

STEPHAN BUNDI

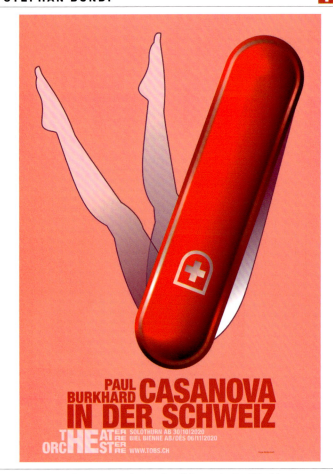

Title: "Casanova in Switzerland" Opera by Paul Burkhard.
Client: Theater Orchester Biel Solothurn | **Design Firm:** Atelier Bundi AG

HOWARD SCHATZ

Title: Anthology Poster | **Client:** Glitterati Publisher
Design Firm: Schatz/Ornstein Studio

XI HE

Title: Eyelash | **Client:** People
Design Firm: xihestudio

PEP CARRIÓ

Title: 2021 Barquito/Zapato | **Client:** Self-initiated
Design Firm: Estudio Pep Carrió

VIRGEN EXTRA 🇪🇸

Title: Rorschach | **Client:** Kitte
Design Firm: Virgen extra

DERWYN GOODALL 🇨🇦

Title: Holly Jolly | **Client:** Self-initiated
Design Firm: Goodall Integrated Design

BOB DENNARD, JAMES LACEY 🇺🇸

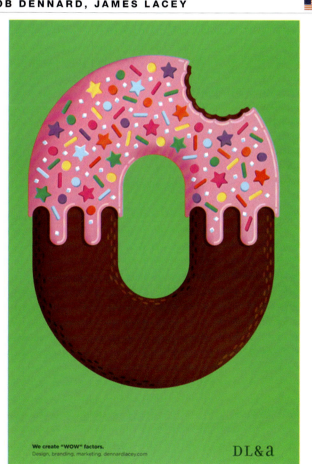

Title: We Create "Wow" Factors. (Donut) DL&A | **Client:** Self-initiated
Design Firm: Dennard Lacey & Associates

OLGA SEVERINA 🇺🇸

Title: DESIGN=HOPE | **Client:** KICD Conference
Design Firm: Olga Severina

SEUL CHOI

Title: New Year's Poster | Client: Torque.Co., Ltd.
Design Firm: che.s design institute

BOB DENNARD

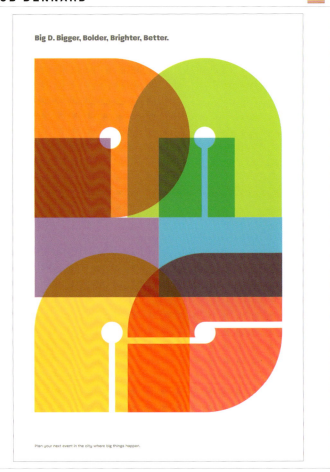

Title: Big D. Bigger, Bolder, Brighter, Better. | Client: Self-initiated
Design Firm: Dennard Lacey & Associates

DAVID BROWN

Title: Hats, Hooch, Horses, and Hope | Client: ALS Association
Wisconsin Chapter | Design Firm: Traction Factory

MARK SPOSATO

Title: Hey, It's Me | Client: Houndstooth Studios
Design Firm: Mark Sposato Graphic Design

ATSUSHI ISHIGURO ●

Title: Scramble Mother's Day | **Client:** SHIBUYA SCRAMBLE SQUARE | **Design Firm:** OUWN

DERWYN GOODALL 🇨🇦

Title: 202? | **Client:** Self-initiated
Design Firm: Goodall Integrated Design

JOHN SPOSATO 🇺🇸

Title: Winter 2019 | **Client:** Self-initiated
Design Firm: John Sposato Design & Illustration

JOHN SPOSATO 🇺🇸

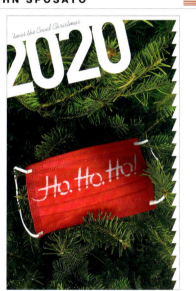

Title: Covid Christmas 2020 | **Client:** Self-initiated
Design Firm: John Sposato Design & Illustration

KEITH KITZ 🇺🇸

Title: Planning Optimism | **Client:** 4th Shenzhen Int. Poster Fest. | **Design Firm:** Keith Kitz Design

N. CAMPBELL, T. MCCANDLISS 🇺🇸

Title: Grace | **Client:** Self-initiated
Design Firm: McCandliss and Campbell

RAFAEL FERNANDES 🇧🇷

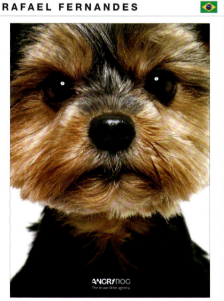

Title: The Brave Little Agency
Client: Self-initiated | **Design Firm:** Angry Dog

MICHAEL SCHWAB 🇺🇸

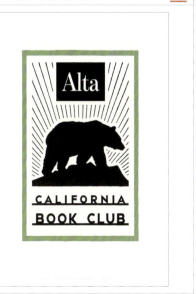

Title: ALTA Book Club | **Client:** ALTA Journal
Design Firm: Michael Schwab Studio

JOHN SPOSATO 🇺🇸

Title: Summer 2020 | **Client:** Self-initiated
Design Firm: John Sposato Design & Illustration

SHANGNING WANG

Title: Self-Portrait | **Client:** Self-initiated | **Design Firm:** Shangning Wang Graphic Design

CLARK MOST

Title: Unsalted — Lake Michigan | **Client:** Clark Most Photography
Design Firm: Design Direction, LLC

SHUICHI NOGAMI

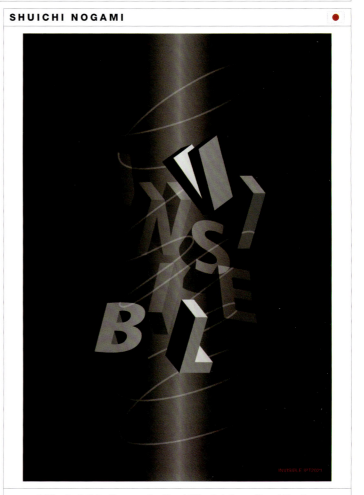

Title: Invisible Communication | **Client:** International Poster
Triennial in Toyama | **Design Firm:** Nogami Design Office

CRAIG FRAZIER

Title: Wear One | **Client:** Self-initiated
Design Firm: Craig Frazier Studio

SHUICHI NOGAMI

Title: Invisible Navigator | **Client:** International Poster Triennial
in Toyama | **Design Firm:** Nogami Design Office

VERONICA VAUGHAN

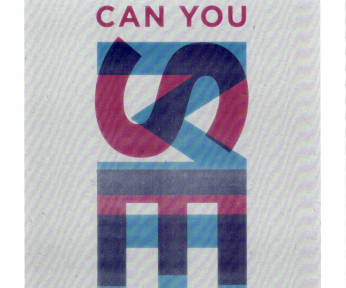

Title: Can You See Me | **Client:** Self-initiated | **Design Firm:** Vaughan Creative

LYNDA DECKER

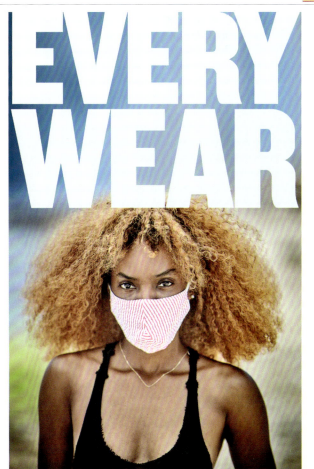

Title: Everywear | **Client:** Public Service Ad | **Design Firm:** Decker Design

DERWYN GOODALL

Title: BE | Client: Self-initiated
Design Firm: Goodall Integrated Design

JAN ŠABACH 🇺🇸

Title: VOTUE | Client: AIGA Get Out the Vote Campaign
Design Firm: Code Switch

DERWYN GOODALL 🇨🇦

Title: Love ICU | Client: Self-initiated
Design Firm: Goodall Integrated Design

EDUARDO AIRES

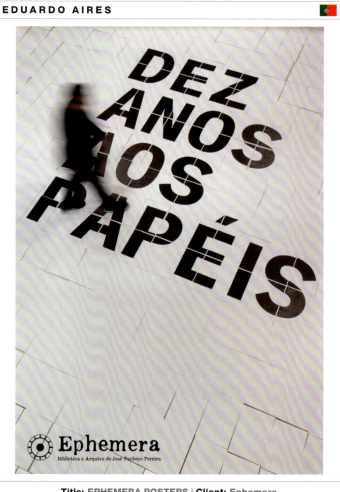

Title: EPHEMERA POSTERS | Client: Ephemera
Design Firm: Studio Eduardo Aires, S.A

ROB JACKSON

When we give to nature, we give to our community.

Title: Blandford Highlands Posters | **Client:** Blandford Nature Center
Design Firm: Extra Credit Projects

KATHY DELANEY

BE HEARD
DEAF 911
deafyn.org

The emergency app that gives deaf people a voice.

Title: Be Heard: Deaf 911 | **Client:** St. Ann's for the Deaf
Design Firm: Saatchi & Saatchi Wellness

VAVA BUITENKANT

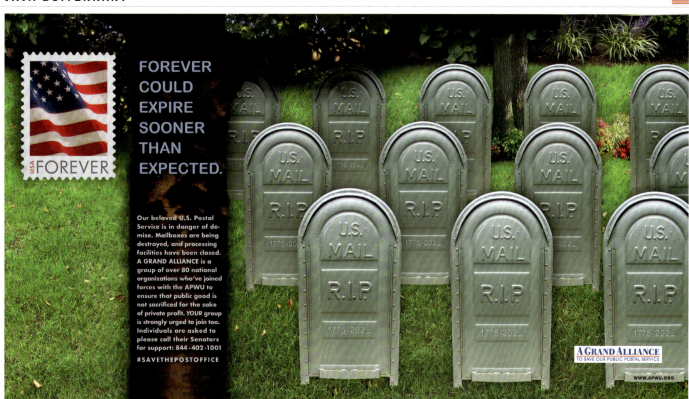

FOREVER
COULD
EXPIRE
SOONER
THAN
EXPECTED.

Our beloved U.S. Postal Service is in danger of demise. Mailboxes are being destroyed, and processing facilities have been closed. A GRAND ALLIANCE is a group of over 80 national organizations who've joined forces with the APWU to ensure that public good is not sacrificed for the sake of private profit. *YOUR* group is strongly urged to join too. Individuals are asked to please call their Senators for support: 844-402-1001

#SAVETHEPOSTOFFICE

A GRAND ALLIANCE
TO SAVE OUR PUBLIC POSTAL SERVICE

WWW.APWU.ORG

Title: USPS Graveyard | **Client:** American Postal Workers Union | **Design Firm:** Buitenkant Advertising & Design

DERWYN GOODALL 🇨🇦

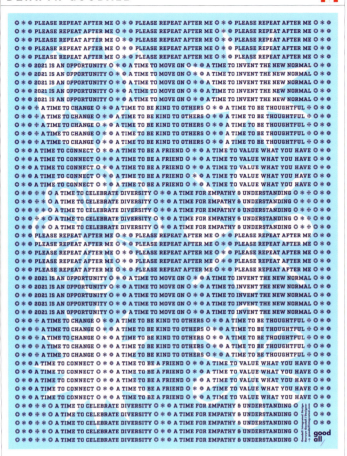

Title: Repeat After Me | **Client:** Self-initiated
Design Firm: Goodall Integrated Design

SHA FENG 🇨🇳

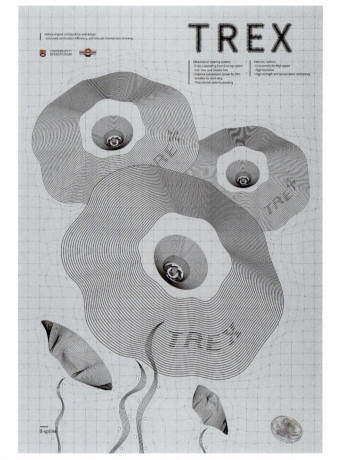

Title: Trex | **Client:** University of Birmingham
Design Firm: SoFeng Design

PATRYCJA LONGAWA 🇵🇱

Title: Alphabet Second-hand Bookshop
Client: Alphabet Second-hand Bookshop | **Design Firm:** Patrycja Longawa

YURKO GUTSULYAK 🇨🇦

Title: King Zero | **Client:** Telegraf.Design
Design Firm: Gutsulyak.Studio

NATHAN HOTTEN, DAMIAN WHEELER

Title: 1 Denison | **Client:** Winten Property Group | **Design Firm:** Hoyne

PAVEL PISKLAKOV

Title: Ways To Heaven | **Client:** Golden Bee Global Biennale of Graphic Design | **Design Firm:** Pavel Pisklakov

MARLENA BUCZEK SMITH

Title: Fragile Handle with Care | **Client:** MOASD Association of Designers
Design Firm: Marlena Buczek Smith

HOON-DONG CHUNG

Title: T for Tolerance | **Client:** Tolerance Poster Show
Design Firm: Dankook University

TABER CALDERON

Title: PAX | **Client:** Self-initiated
Design Firm: Taber Calderon Graphic Design

MARLENA BUCZEK SMITH

Title: Empathy | **Client:** Self-initiated
Design Firm: Marlena Buczek Smith

DERWYN GOODALL

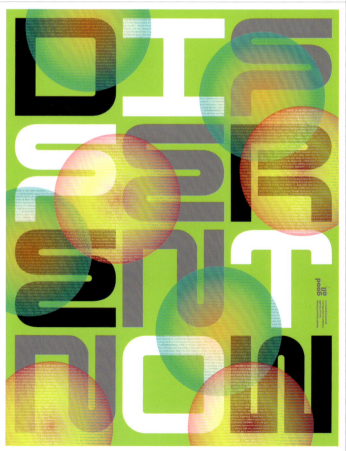

Title: Different Now | **Client:** Self-initiated
Design Firm: Goodall Integrated Design

JILLIAN COOREY 🇺🇸

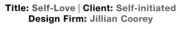

Title: Self-Love | **Client:** Self-initiated
Design Firm: Jillian Coorey

PAVEL PISKLAKOV 🇷🇺

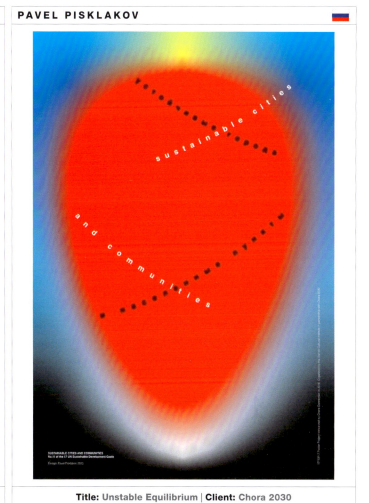

Title: Unstable Equilibrium | **Client:** Chora 2030
Design Firm: Pavel Pisklakov

RENE V. STEINER 🇨🇦

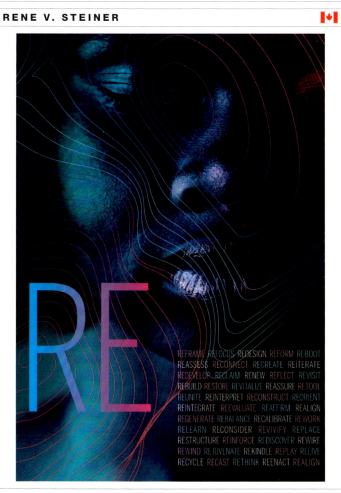

Title: Re: | **Client:** Self-initiated
Design Firm: Steiner Graphics

XOSE TEIGA 🇵🇹

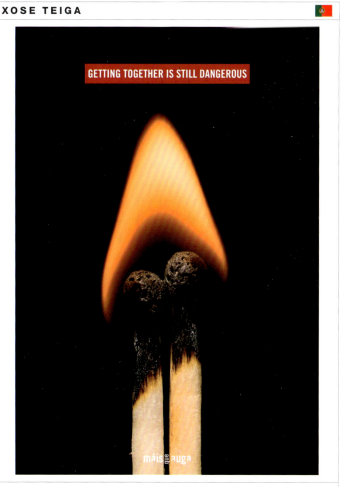

Title: Getting Together is Still Dangerous | **Client:** Mais que Auga
Design Firm: teiga, studio.

RIKKE HANSEN

Title: Zero Corruption – Misuse of Entrusted Power is Everywhere.
Client: 4th Block | Design Firm: Rikke Hansen

CARMIT MAKLER HALLER

Title: What Unites Us | Client: What Unites Us 2 Exhibition
Design Firm: Carmit Design Studio

LISA WINSTANLEY

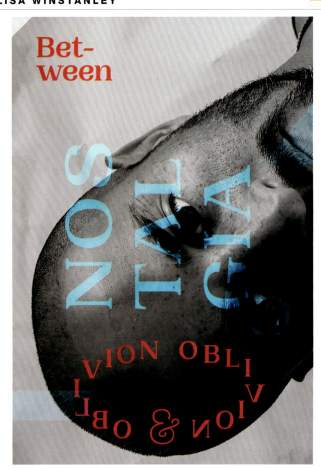

Title: Between Nostalgia & Oblivion | Client: Self-initiated
Design Firm: Lisa Winstanley Design

CHUN-TA CHU

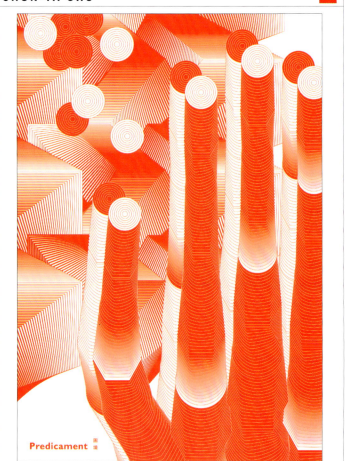

Title: Predicament & Adversity | Client: Self-initiated
Design Firm: Chun-Ta Chu

JAREK BUJNY

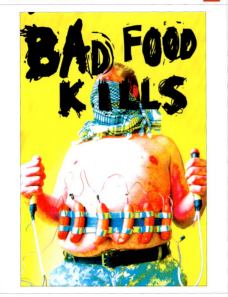

Title: BAD FOOD KILLS | **Client:** Posterheroes 4
Design Firm: VIS-ART

FONS HICKMANN

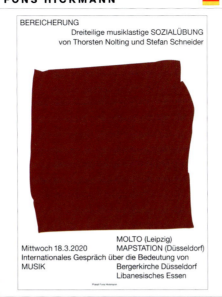

Title: Enrichment | **Clients:** Thorsten Nolting, Stefan
Schneider | **Design Firm:** Fons Hickmann m23

YOHEI TAKAHASHI

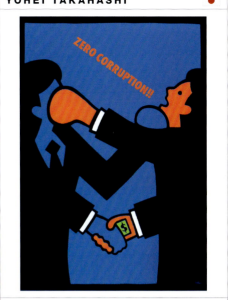

Title: ZERO CORRUPTION | **Client:** 4th Block
Design Firm: Yohei Takahashi

JOREL DRAY

Title: Buy Stamps. Save the USPS.
Client: Self-initiated | **Design Firm:** Jorel Dray

PEKKA LOIRI

Title: Vulture and a Dove | **Client:** German Montalvo,
City of Puebla | **Design Firm:** Studio Pekka Loiri

YOSSI LEMEL

Title: The Vaccine (Iwo Jima)
Client: Self-initiated | **Design Firm:** Yossi Lemel

VICKI MELONEY

Title: Danger | **Client:** 6 Hearts 1 Love
Design Firm: Latrice Graphic Design

JUN BUM SHIN

Title: To Vote is To Hope | **Client:** EIPF
Design Firm: Jun Bum Shin

JUN BUM SHIN

Title: Overcoming | **Client:** KDCA
Design Firm: Jun Bum Shin

SASHA VIDAKOVIC 🇬🇧

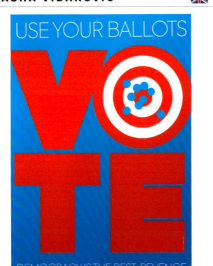

Title: Vote
Client: Self-initiated
Design Firm: SVIDesign

CARMIT MAKLER HALLER 🇺🇸

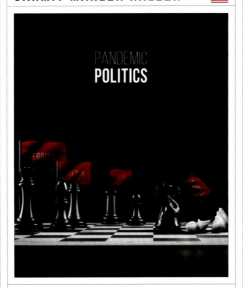

Title: Pandemic Politics
Client: 27th Int. Warsaw Poster Biennale
Design Firm: Carmit Design Studio

ANNE GIANGIULIO 🇺🇸

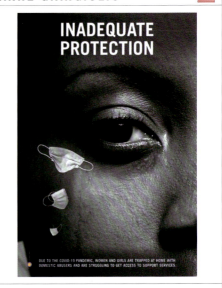

Title: Battleground; Invasive Procedure;
Inadequate Protection | Client: Self-initiated
Design Firm: Anne M. Giangiulio Design

CARMIT MAKLER HALLER 🇺🇸

Title: Stop Human Trafficking | Client: The Int.
Reggae Poster Contest/Human Trafficking
Design Firm: Carmit Design Studio

HOON-DONG CHUNG 🇰🇷

Title: NoNoNo
Client: Self-initiated
Design Firm: Dankook University

KELLY SALCHOW MACARTHUR 🇺🇸

Title: HOPE
Client: EIPF
Design Firm: elevate design

STEVEN JOSEPH 🇦🇺

Title: GetFact
Client: Praxis Communications
Design Firm: Spatchurstudio

IVAN KASHLAKOV 🇧🇬

Title: Social Sharks
Client: Self-initiated
Design Firm: Ivan Kashlakov

RES EICHENBERGER 🇨🇭

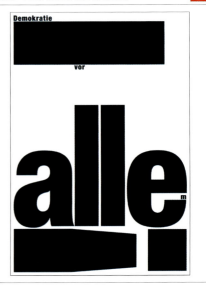

Title: Demokratie – vor Allem!
Client: Plakat-sozial e.V., Leipzig
Design Firm: Res Eichenberger Design

ANNE M. GIANGIULIO 🇺🇸

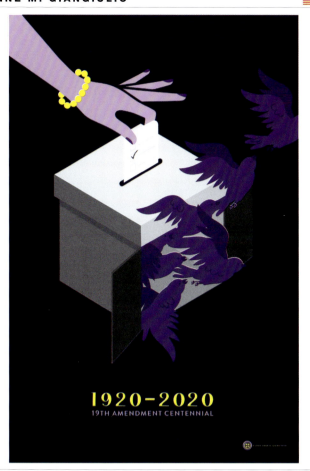

Title: Women's Suffrage Centennial 1920–2020 | **Client:** Self-initiated
Design Firm: Anne M. Giangiulio Design

DANIEL G. RODRIGUEZ 🇺🇸

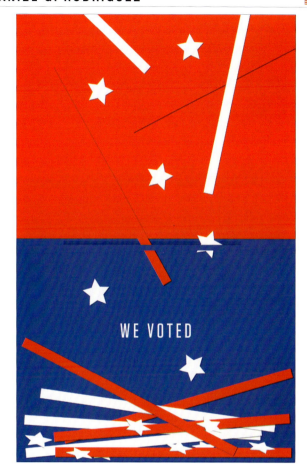

Title: We Voted (By Mail) | **Client:** Self-initiated
Design Firm: danielguillermo.com

MEAGHAN A. DEE 🇺🇸

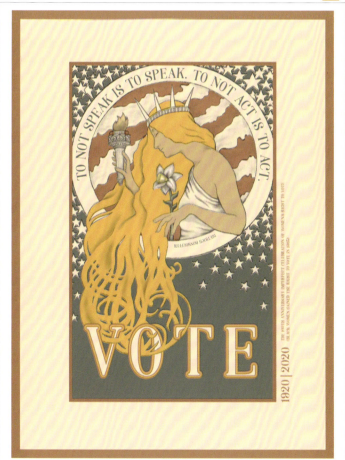

Title: To not speak is to speak. To not act is to act. | **Client:** AIGA Get Out
the Vote: Empowering the Women's Vote | **Design Firm:** Virginia Tech

MICHAEL BRALEY 🇺🇸

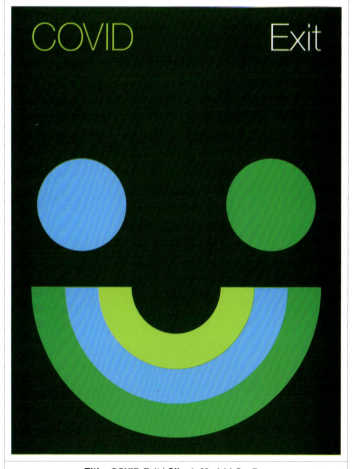

Title: COVID Exit | **Client:** Madrid Grafica
Design Firm: Braley Design

RENE V. STEINER

Title: Live is a Four Letter Word | **Client:** Self-initiated
Design Firm: Steiner Graphics

CAROL PALMER BOHAN

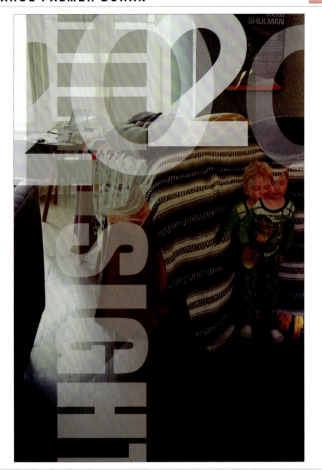

Title: 2020HIndSiGhT | **Client:** Self-initiated
Design Firm: Palmer+Bohan Design

ANDREW YANEZ

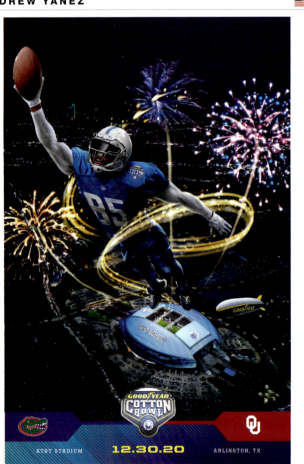

Title: Goodyear Cotton Bowl | **Client:** Cotton Bowl Athletic Association
Design Firm: PytchBlack

LEROY & ROSE

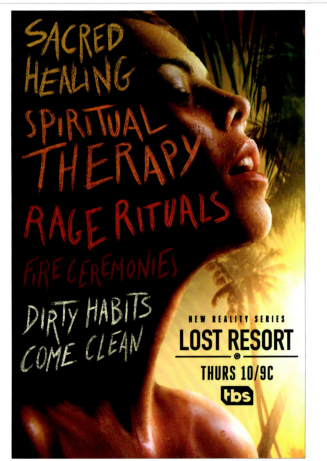

Title: Lost Resort | **Client:** TBS
Design Firm: Leroy & Rose

FX NETWORKS/THE REFINERY

Title: **Mrs. America** | Client: **FX Networks**
Design Firm: **The Refinery**

FX NETWORKS/LEROY & ROSE

Title: **What We Do in the Shadows Season 2 - Key Art 1**
Client: **FX Networks** | Design Firm: **Leroy & Rose**

DEJAN SIJUK

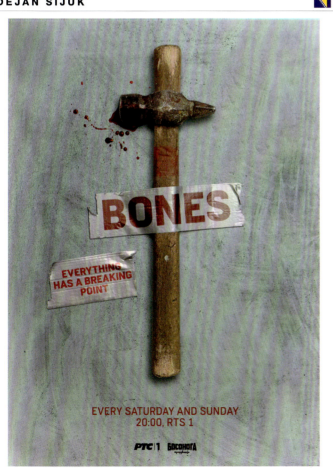

Title: **BONES (KOSTI) - TV Series** | Client: **Bosonoga Production**
Design Firm: **Aquarius**

THE REFINERY

Title: **Vida, Season 3, Key Art** | Client: **STARZ**
Design Firm: **The Refinery**

ANDRÉ BARNETT 🇺🇸

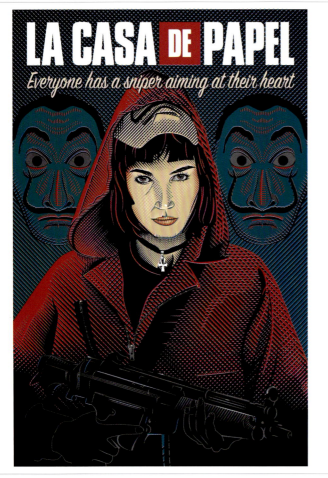

Title: Money Heist | Client: Self-initiated | Design Firm: Only Child Art

FX NETWORKS/ICON ARTS CREATIVE 🇺🇸

Title: Devs | Client: FX Networks | Design Firm: Icon Arts Creative

THE REFINERY 🇺🇸

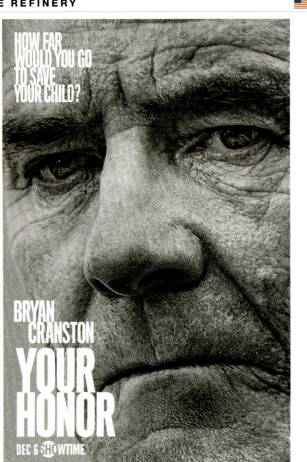

Title: Your Honor | Client: Showtime
Design Firm: The Refinery

MIRKO ILIC 🇺🇸

Title: The 20th Anniversary of the Ulysses Theatre
Client: The Ulysses Theater, Croatia | Design Firm: Mirko Ilic Corp.

MIRKO ILIC 🇺🇸

Title: **Screw the One Who Started It** | Client: **Yugoslav Drama Theater, Serbia** | Design Firm: **Mirko Ilic Corp.**

CARLO FIORE 🇮🇹

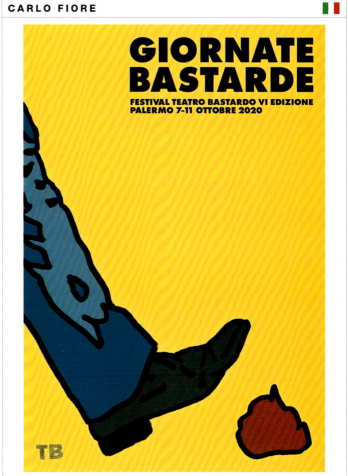

Title: **Giornate Bastarde (Bastard Days)** | Client: **Festival Teatro Bastardo**
Design Firm: **Venti caratteruzzi**

MIRKO ILIC 🇺🇸

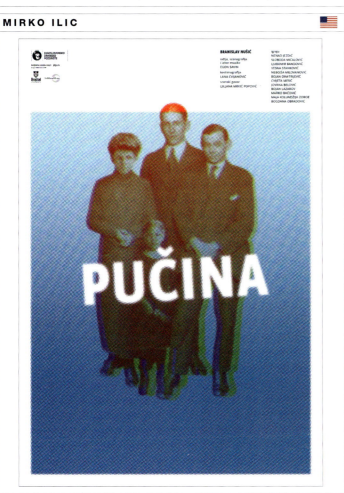

Title: **Offing** | Client: **Yugoslav Drama Theater, Serbia**
Design Firm: **Mirko Ilic Corp.**

JON LAWRENCE RIVERA 🇺🇸

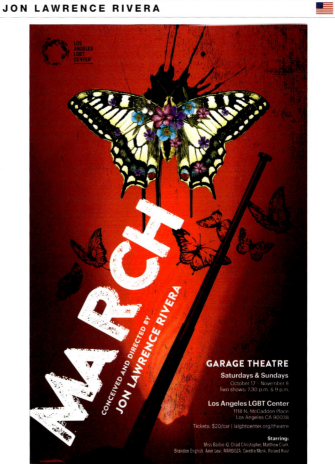

Title: **MARCH** | Client: **Self-initiated**
Design Firm: **Los Angeles LGBT Center**

STEPHAN BUNDI

Title: Romeo und Julia (Romeo and Juliet)
Client: Theater Orchester Biel Solothurn | Design Firm: Atelier Bundi AG

JULIANE PETRI

Title: Sagunt a Escena XXXVII ed. 2020
Client: Institut Valencià de Cultura | Design Firm: Juliane Petri

MIRKO ILIC

Title: Kaspar | Client: Yugoslav Drama Theater, Serbia
Design Firm: Mirko Ilic Corp.

MIRKO ILIC

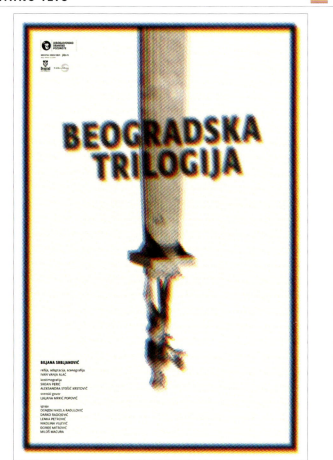

Title: Belgrade Trilogy | Client: Yugoslav Drama Theater, Serbia
Design Firm: Mirko Ilic Corp.

EDUARDO AIRES

**Title: Porto Municipal Theatre - Rivoli | Client: Porto Municipal Theatre
Design Firms: Studio Eduardo Aires, S.A; Oupas Design (Foco Familia)**

THOMAS KÜHNEN, MERLE TEBBE

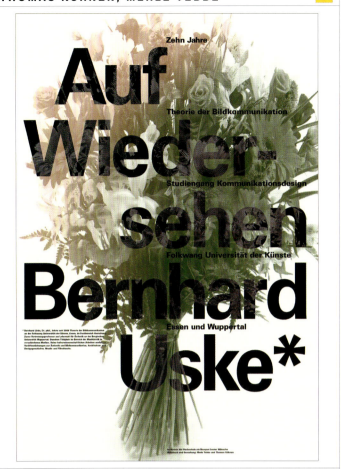

**Title: Goodbye Bernhard Uske | Client: Folkwang UdK
Design Firm: Thomas Kühnen**

SASCHA LÖTSCHER

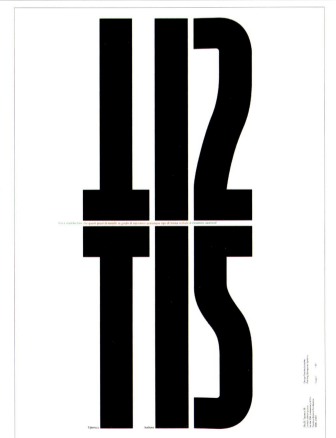

**Title: A Birthday Poster for Tipoteca | Client: Tipoteca Italiana
Design Firm: Gottschalk+Ash Int'l AG**

RIKKE HANSEN

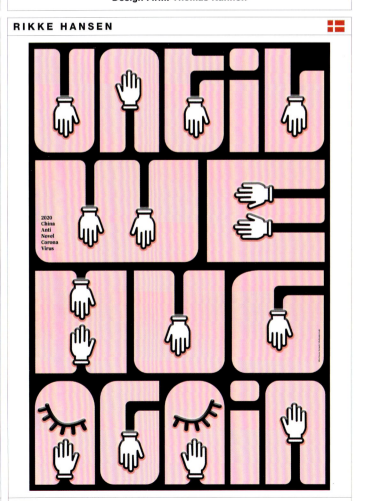

**Title: Until We Hug Again | Client: 2020 China Anti-Novel
Coronavirus Exhibition | Design Firm: Rikke Hansen**

SOYEON KWON

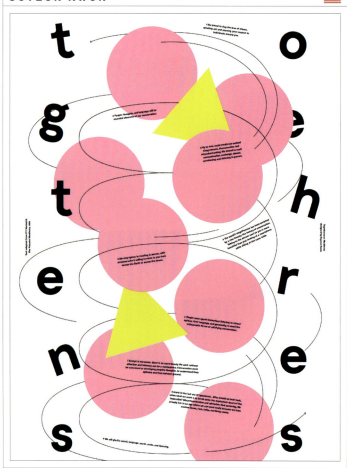

Title: **Togetherness Manifesto** | Client: **Self-initiated**
Design Firm: **Maryland Institute College of Art**

FA-HSIANG HU

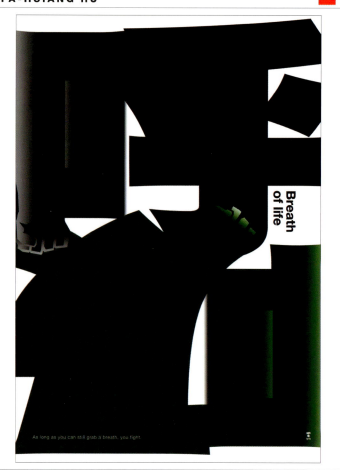

Title: **Breath of Life** | Client: **Taiwan Poster Design Association**
Design Firms: **hufax arts/FJCU**

BO YUN HWANG

Title: **The Wire** | Client: **Jason Heuer**
Design Firm: **School of Visual Arts**

KOBI FRANCO

Title: **Molecular Typography Laboratory** | Client: **Self-initiated**
Design Firm: **Kobi Franco Design**

LEO LIN

Title: Jan 100 | **Client:** Brno Biennale Association
Design Firm: Leo Lin Design

HENRIK KUBEL, SCOTT WILLIAMS

A modern geometric sans available in 10 styles. Carefully crafted with an international pedigree.

www.a2-type.co.uk/reg-modn

A B C D E F G H I J K L M N
O P Q R S T U V W X Y Z
1 2 3 4 5 6 7 8 9 0
abcdefghijklmn
opqrstuvwxyz
({[&!--

Reg.Modn

Title: Reg.Modn | **Client:** Self-initiated
Design Firm: A2/SW/HK + A2-TYPE

IVAN KASHLAKOV

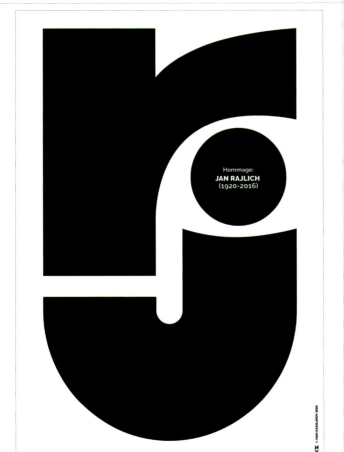

Hommage:
JAN RAJLICH
(1920-2016)

Title: Hommage: JAN RAJLICH (1920 -2016)
Client: Brno Biennale Association | Design Firm: Ivan Kashlakov

ATSUSHI ISHIGURO

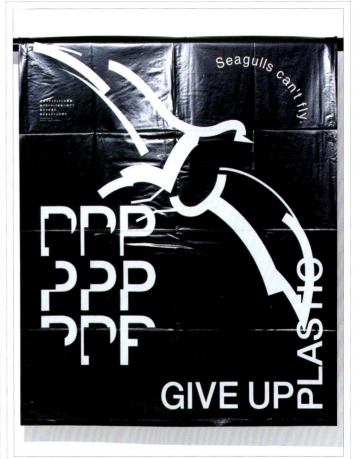

Title: GIVE UP PLASTIC | Client: PEOPLE AND THOUGHT
Design Firm: OUWN

Haejin Kang 🇺🇸

Angry Dog 🇧🇷

Concrete 🇨🇦

Studio AND 🇺🇸

203 Infographic Lab 🇰🇷

Gelia 🇺🇸

Gonca Koyuncu Art Studio 🇹🇷

Virgen extra 🇪🇸

Christine Puchner Graphik-Design 🇦🇹

Daisuke Kashiwa 🇯🇵

L3&D Studio 🇺🇸

Seeying Eye Design 🇨🇦

Josh Ege 🇺🇸

Komprehensive Design 🇺🇸

David Wolske 🇺🇸

Kaylen Couch 🇺🇸

Joshua Lowe

Tatum Design

A2/SW/HK

ARSONAL

Leroy & Rose

Joshua Lowe

Leroy & Rose

ARSONAL

SJI Associates

Eleven19

TSDdesign.inc

Jie-Fei design

Childers Design

Michael Schwab Studio

PosterTerritory

teiga, studio.

Cassie Hester

Elsenbach Design

Jennifer Sterling Design

Choong Ho Lee

nmillercreative

Dongsik Hong

SVIDesign

Anna Leithauser

Art Collart Office

hyungjookimdesignlab

David Bieloh Design

BRAND DIRECTORS

BEK Design

T9 Brand

Choong Ho Lee

studio lindhorst-emme

David Torrents 🇪🇸

BEK Design 🇹🇷

Keith Kitz Design 🇺🇸

Taber Calderon Graphic Design 🇺🇸

diotop 🇯🇵

Uhlein Design 🇺🇸

Spela Draslar s.p. 🇸🇮

studio +fronczek 🇩🇪

DOG & PONY 🇺🇸

BEK Design 🇹🇷

Renée Windman 🇺🇸

BEK Design 🇹🇷

Ariane Spanier Design 🇩🇪

Ceb Design 🇨🇦

Ted Wright Illustration & Design 🇺🇸

Rhea Vergis 🇺🇸

Caillet-Bois Ad&design 🇺🇸

Amanda Lenig Design 🇺🇸

legis design 🇺🇸

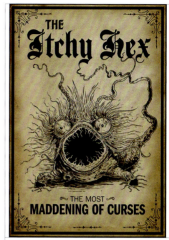

Neon, An FCB Health Network Co. 🇺🇸

Studio Lonne Wennekendonk 🇳🇱

Brian Danaher 🇺🇸

DeviDevi Inc. 🇺🇸

Te Sian Lera Shih's Design Studio 🇺🇸

1/4 studio 🇵🇹

SVIDesign 🇬🇧

Bob Delevante Studios 🇺🇸

Purdue University 🇺🇸

Gelia 🇺🇸

Studio Usher 🇺🇸

OSTRO DESIGN 🇺🇸

TSDdesign.inc 🇺🇸

xihestudio

Lisa Winstanley Design

Caillet-Bois Ad&design

Upperquad

McCandliss and Campbell

TIFFANY JOY PRATER

Braley Design

creativEGG Design

Studio Eduardo Aires, S.A

Dongsik Hong

BY-ENJOY DESIGN

Martin French Studio

Sean Nagao

Anna Sorokina Art

Yinsen

Mi Jung Lee

CREATIAS ESTUDIO

Ibán Ramón Design Studio

Rhea Vergis

Aufuldish & Warinner

Sarah Tan

Randy Clark

Jennifer Sterling Design

Nick Mendoza

Hossein Abdi

Christopher Scott

Hsiao-Wen Hu

Martin French Studio

Chun-Ta Chu

Symbiotic Solutions

Blaž Rojs

Daisuke Kashiwa

khopdesign, LLC 🇺🇸

Taste Inc. 🔴

BRED 🇺🇸

T9 Brand 🇺🇸

Aesthetic Apparatus 🇺🇸

Dunn&Co. 🇺🇸

Leroy & Rose 🇺🇸

The Refinery 🇺🇸

Only Child Art 🇺🇸

Jennifer Sterling Design 🇺🇸

Mirko Ilic Corp. 🇺🇸

Ron Taft Design 🇺🇸

Studio Lonne Wennekendonk 🇳🇱

Kaveh Haerian 🇺🇸

Sergio Olivotti 🇮🇹

Lombardo 🇺🇸

Cassie Hester 🇺🇸

BRAND DIRECTORS 🇰🇷

Dalian RYCX Advertising Co., Ltd. 🇨🇳

OUWN inc. 🇯🇵

Tatum Design 🇺🇸

Tatum Design 🇺🇸

J David Deal Graphic Design 🇺🇸

Houda Bakkali 🇪🇸

Jun Lin 🇺🇸

&Barr 🇺🇸

&Barr 🇺🇸

Fallano Faulkner & Associates 🇺🇸

Symbiotic Solutions 🇺🇸

Dunn&Co. 🇺🇸

VIS-ART 🇵🇱

Traction Factory 🇺🇸

2012 PLATINUM WINNERS:

9 MATTHEW CARTER H POSTER | Design Firm: Visual Dialogue | Designer: Fritz Klaetke
Client: AIGA Boston | Photographer: Kent Dayton
Production Coordinators: Jill Giles, Susan Battista | Digital Artist: Fritz Klaetke

Assignment: In conjunction with the AIGA Boston Fellow Award event honoring legendary type designer Matthew Carter, we were one of 13 local designers asked to graphically interpret a letter in Matthew's name that would be printed as poster to be auctioned off at the event.

Approach: The "H" letterform is made up of tools of the trade, which have become obsolete in our computer-centric world — a world that Matthew transformed his work to seamlessly. The three-dimensional object was not only visually intriguing but also provided an opportunity to do some housekeeping in the studio by "repurposing" old art supplies that hadn't been used in years.

10 X EXHIBITION A | Design Firm: SenseTeam | Designers: Hei Yiyang, Wang Xiaomeng, Zhao Meng, Liu Zhao, Huang Muqiu | Client: SGDA | Project Manager: Zhong Qiu
Creative Director: Hei Yiyang | Photographer: Zhang Qing

Assignment: A Chinese company named SenseTeam has designed an interesting exhibition, featuring design elements through the typeface, exhibition space, posters and other applications.

Approach: SenseTeam is devoted to integrated design. A kind of material is used as a new communication medium, breaking the traditional exhibition mode. This medium goes through space of the exhibition — from external space of the exhibition hall to the signage system inside the exhibition to the exhibition promotion. This kind of design is like virus, filling people's sense and consciousness. "X Exhibition" is a process. In "X Exhibition," SenseTeam employed light to break the dark matter of design. Light takes the place of graphic images. Graphic images take the place of lighting. Light takes the place of language. Language takes the place of the signage system of the exhibition. Light can express what is "X." Light is idea and inspiration. It stresses the role of every designer of the exhibition and maximizes their genius and creation. The process of designers' looking for creativity is that of looking for brightness. We really hope that all participants can gain endless thoughts, surprise and creative power from this exhibition. Background: "X Exhibition" is one of the exhibitions of Graphic Design in China. Its international juries are from GDC. They are Michael Rock from the United States, David Ellis from the United Kingdom, Norito Shinmura from Japan, Tommy Li from Hong Kong and Chen Shaohua from China. The juries recommend 11 young designers from home and abroad to join the exhibition. The committee pays attention to not only juries but also designers they recommend. Various communications bring diverse thoughts to the public. Eleven designers represent the advanced development trend and direction. The works cover environment, multimedia, device, video, experimental music, product, posters, book design and animated drawing. All the 11 exhibitors are from five countries and regions, recommended by GDC international judges: • Michael Rock (US) recommended young designers Linked by Air (Tamara Maletic + Dan Michaelson) & Eric Adolfsen • David Ellis (UK) recommended young designers David Pearson & Simon Keep • Norito Shinmura (Japan) recommended young designers Tadahiro Gunji, Tomoaki Furuya Yosuke & Kobayashi • Tommy Li (Hong Kong) recommended young designers Javin Mo & Hung Lam • Chen Shaohua (China) recommended young designers Xiaomage+Chengzi (Ma Huimin+Guo Chengcheng) & Chen Brother (Chen Longque+Chen Dunhuang) We chose modulating tube with emanative light to be luminous body. 30cm, 60cm and 90cm are the three main fixed mode of modulating tube. They become the basic size of presenting graphic images, spelling the exhibition theme and all the names of designers. "Characters of Light", the unique typeface system is created, going through the whole exhibition. The lightening exhibition name and theme are on the surface of the exhibition hall. When it is going dark, the light is around the architecture. It means that the energy and power of design go through everywhere of the city. We use the same method inside the exhibition, making a signage system to divide areas for different works. Without too much decoration, the essential power of design has been emphasized. Participants have more freedom and space to have imagination. Meanwhile, the signage of "Characters of Light" solves the lighting problem. Luminous bodies exist everywhere of the "X Exhibition". For the exhibition posters, we take photos of city space superposition. Putting designers' names made by modulating tubes at markets, villages, bridges, underground passages, car parking and old roof and so on. People pass the quiet luminous bodies, connecting the exhibition theme and the city. These series of images is a kind of language, expressing the power of the creative group in the city.

Results: "X" stands for the unknown world, cultural communication, extended and endless possibility and unstable answer. In the same space, we present 11 eastern and western young designers' works. We hope that this presentation can bring unknown feedback and reaction as "X."

11 BIRTH & DEATH | Design Firm: Kasai Noriyuki | Designer: Kasai Noriyuki
Client: Visual Information Design Association of Korea | Typographer: Kasai Noriyuki
Creative Director: Kasai Noriyuki | Copywriter: Kasai Noriyuki | Art Director: Kasai Noriyuki

Assignment: Produce the poster taken up with the social trouble as the theme for "Message to the World, 2010 International Poster Exhibition".

Approach: "Ethnic Conflicts" was taken up in theme. Ethnic conflicts always happen in the Middle East. Life and the death happen naturally. This poster can see the death and the life by arousing what's likely to die out. It was expressed with visual impact.

Results: The exhibition was held in each country of Asia. It became a chance that we thought about one "Ethnic Conflicts".

12 ANAM 2010 SEASON | Design Firm: Mike Barker Design
Designer: Mike Barker | Client: Australian National Academy of Music

Assignment: The Australian National Academy of Music is Australia's elite training center for young classical musicians. It occupies a unique niche on the Australian classical music landscape by offering a performance-based training program that fosters inventiveness, imagination and courage in developing the country's future musical leaders. The Academy required a striking image to become a marketing beacon for the 2010 performance season and to symbolize its risk-taking personality.

Approach: The solution demanded a simplistic yet powerful iconography. From the outset, the intent was to avoid cliché classical music stimuli and focus instead on the potent and unusual while being respectful of the art form. The image was specifically created to speak with an unexpected and abstract tone. Digital manipulation of expressive human limbs and violinist's bow meshes with bold typography to define a dynamic presence. It seeks to come across as a fresh twist on a traditionally conservative genre, representing the intertwining of music with the soul and embodying the uniqueness and aspiration of youth. A stark, monochromatic color scheme was utilized in order to lend sophistication and command attention within a highly saturated color environment.

Results: The client and its industry associates deemed the resulting season image successful in reflecting the leading-edge character of the academy. Sparking interest at various points of contact for the organization's existing subscriber base and general public alike, it played a role in increased ticket sales and enticing world class artists to mentor and perform with its students

13 DON'T DISCRIMINATE (HIV) | Design Firm: Andrea Castelletti
Designer: Andrea Castelletti | Client: LILA - Italian League for the fight against AIDS
Photographer: Matteo Engolli | Copywriter: Andrea Castelletti | Art Director: Andrea Castelletti

Assignment: The client asked us to design a poster to communicate that being HIV positive is not a criminal offence. In fact, AIDS sufferers are legally and socially discriminate against every day.

Approach: After reading the brief, I decided to represent using typography how the HIV virus could be a problem of every of us. I focused on representing the human being in his simplicity while trying to not be obscene.

Results: The poster was selected as one of the best of Good 50x70 contest. It was exhibited at LaTriennale Design Museum (Milan, Italy), Bozeman, Montana State University (USA), Luleå-Norrbottens Museum (Sweden); Beit Meirov Art Center (Holon, Israel) and in other cities all over the world. Moreover, it was published in magazines and books in Italy, Netherlands, India, France and it was use as case of studies in more than 10 blogs of medicine, marketing and graphic design.

14, 15 PLACES | Design Firm: Zubi Advertising | Client: Ford Dealer/ Gus Machado
VP Creative Director: Andres Ordoñez | Creative Director: Ivan Calle
Art Director: Francisco Losada | Copywriter: Jonathan Jauregui
Photographer: Mauricio Candela | Production Company: The Blur Office

16 LYCEUM FELLOWSHIP 2011 | Design Firm: Skolos-Wedell
Designers: Nancy Skolos, Thomas Wedell | Client: Lyceum Fellowship Committee
Photographer: Thomas Wedell | Typographer: Nancy Skolos

Assignment: The poster was a CFE for the annual Lyceum Fellowship Student Architecture Competition. The 2011 program title was "Earth Curvature: A Local/Global Rest Area" and it called for a structure that would engage a proposed land art installation in the Great Salt Lake Desert.

Approach: As always, our approach with the poster was to capture the spirit of the program without suggesting a specific design approach to the project so that the poster can create an atmosphere and generate curiosity among the student entrants.

Results: The clients on the fellowship board are all architects and have been very responsive to our experimental approach. Over the years, we have developed a series of posters that push the two-dimensional picture plane of the poster into an architectural space.

17 VENTI CARATTERUZZI - TEATRO MASSIMO 2010 | Design Firm: Venti caratteruzzi
Designer: Carlo Fiore | Client: Fondazione Teatro Massimo

Description: Teatro Massimo in Palermo, the third largest opera house in Europe, began its activities in 1897 with regular seasons of operas, ballets and concerts. In 2006, Venti caratteruzzi (an editing and graphic design studio with rare high degree skills in musicology) was commissioned to design all theatre printing materials related to musical seasons

in order to produce a different series each year of coordinate posters, program note covers and large billboards to be displayed side by side close to the building's main entrance.

Approach: Together with this assignment, Venti caratteruzzi started an ongoing research project devoted to the first ever history of visual identity of opera theatre, which is now in progress. The previous works done for Massimo were designed, among others, by some relevant artists, such as Milton Glaser, Marco Lodola, Tullio Pericoli and Emilio Tadini. Accordingly, Venti caratteruzzi have undertaken a process of studying the evident as well as the hidden musical and textual relationships of each opera, trying to summarize each one in a single highly representative image by taking inspiration from the greatest examples of modern design in the field (from Josef Müller-Brockmann Jan Lenica to Pierre Mendell). The synthesis process, started in 2006, reached in 2010 a series of poster/covers using a signage-like layout set in Futura typeface (easily readable in the A5 format of the program notes as well as in the biggest billboard) with a square photo that unequivocally refers to the central issue of each opera. The story of Aida has been summarized by an Egyptian statue that matches erotic attraction and tragic fate; the love story of La bohème shows a couple of humble young people suddenly portrayed after an idyll; the subject of Don Quixote is readable in nothing else than the armor emptied of any "human" contents; the metaphor of the objectified woman in Coppélia has been paired with the well known 20th century icon of Maria from Fritz Lang's Metropolis; the historical context of Nabucco and his account of ancient Jewish people, has been summarized with a rabbi listening an old radio.

Results: With this project — which produces about a hundred of items per year and reaches the highest level of consistency between music and visual —the overall image of the opera theatre started to change from an old-fashioned to a more modern one that stresses actual opera houses demanding to became not a "old folk's home" but the meeting place for everyone. Thanks to this visual campaign, the Teatro Massimo undertook a large array of initiatives for students and children that from 2006 to 2010 increased the overall "under 40" audience by over 200%.

18 HAMLET | Design Firm: Palio | Client: Saratoga Shakespeare Company
Photographer: Eric Sahrmann (Alter Images) | Associate Creative Director: Bob Rath
Chief Global Creative Officer: Guy Mastrion | Senior Art Director: Tom Rothermel
Senior Production: Manager: Marcia Lyon | Account Supervisor: Ellen Nowakowski
Associate Director: Nora Kiernan | Art Buyer: Kim Werther

Assignment: Saratoga Shakespeare Company is a local not-for-profit theater company committed to bringing professional performances of Shakespeare's work to the Capital Region. As a player in the busy cultural scene of Saratoga Springs, the Company needed a distinctive, compelling campaign for its 10th anniversary season. The producers put together a show that satisfied Shakespeare enthusiasts while giving newcomers to his work, especially families, a fun, exciting introduction.

Approach: Palio developed imagery to reflect the company's production of Hamlet. The Company transformed Congress Park into Shakespeare's Denmark, where ghosts and graveyards, grief and melancholy and murder and revenge rule the court. Hamlet is a play about madness, revenge, and mortality. Yet people everywhere identify with Hamlet, a man who summons everything that makes us human in order to make sense of a world gone wrong. The great mystery of Hamlet lies in his trying to figure out where true morality lies. Is he mad? Should he revenge his father's death? Should he kill himself? Is murder ever legitimate — even when the ghost of your father commands you to commit it? Hamlet's struggle to retain his sanity and integrity in a confused, morally corrupt world speaks to us today. It is one of the reasons the play has endured through the centuries.

Results: Over 4,500 people of all ages attended the performances over 10 nights. The Company also received generous financial support by local businesses and foundations.

19 SLICK | Design Firm: Naughtyfish | Designer: Paul Garbett
Client: Australian National Poster Annual 2010 | Creative Director: Paul Garbett

Assignment: This poster was created for the 2010 Australian Poster Annual. Designers were invited to challenge the notion that design is only about beautiful things and it is in this value that design can affect real change.

Approach: Visual communication (including branding) is a powerful tool. In the right hands and with the right strategy, it can inform, challenge, guide, inspire, reinvent and even shift perceptions.

PLATINUM WINNERS:
38 I KNOW BECAUSE I READ | Design Firm: Katarzyna Zapart
Designer: Katarzyna Zapart | Client: Fundacja Nowe Teraz

Assignment: "I know because I read" is a project promoting reading among students, troubled youth and convicts. It is a series of meetings with Paweł Cwynar - ex gangster who had successfully started a new life as a writer. The aim of the meetings is to encourage reading and writing, to show the advantages of it.

Reading reduces stress, stimulates the brain, helps to develop artistic sensitivity and enhances empathy. It is a perfect tool for rehabilitation and personal development.

Approach: As the target group is pretty wide, I have decided to illustrate the fact that books stimulate the brain. I used paper as a tool of choice - a very bookish material. I cut colorful papers into shapes and i made photos. Then I photographed books and combined images in Photoshop.
Results: The client was very happy with the outcome.

39 KINDAI GRAPHIC ART COURSE | Design Firm: KINDAI university, Graphic Art course
Designers: Kiyoung An, Mei Kitamura | Client: Self-initiated

40 THE MONKEY KING | Design Firm: Dalian RYCX Advertising Co., Ltd.
Designer: Yin Zhongjun | Client: Heiwa Court | Creative Director: Yin Zhongjun

Assignment: The Monkey King is a world-famous mythical figure in the famous Chinese literary book Journey to the West.
Approach: The experimental deconstruction of Peking Opera elements and modern art inspires more possibilities.
Results: The poster awakened the author's childhood memories and received good reviews.

41 BIODIVERSITY | Design Firm: João Machado Design
Designer: João Machado | Client: Bienal Internacional del Cartel en México

42 PROCESS | Design Firm: Sanja Planinic
Designer: Sanja Planinic | Client: PDP Conference

Assignment: Poster created for the ALLSTARS exhibition organized by PDP Conference in Novi Sad, Serbia. Seventy designers, illustrators and other visual artists presented their work on the theme of Process.

43 LA STRADA | Design Firm: Pirtle Design
Designer: Woody Pirtle | Client: Fellini Project

Assignment: Project was designed to celebrate Fellini's 100th birthday.
Approach: The creative process for my poster was to focus on Fellini's film, La Strada (The Road).
I chose the most significant graphic elements from the film to symbolize the content. The tire, representing the road, the lips and red nose (significant elements of the makeup of the key female actress). La Strada ("The Road") is an Italian drama directed by Fellini in 1954. It's one of my favorite Fellini films and Bob Dylan credits La Strada as being the primary influence for his
song 'Mr Tambourine Man'. The story is a journey filled with an ongoing emotional exchange between the two lead characters, Zampano (Anthony Quinn) a brutal strongman and Gelsomina (Giulietta Masina) a young woman exhibiting questionable intelligence. The film won an Academy Award for Best Foreign Language Film in 1957.
Results: Project was well received.

44, 45 ACADEMY CONCERTS SEASON 2021/22 | Design Firm: Ariane Spanier Design
Designer: Ariane Spanier | Client: Orchestra of the National Theatre Mannheim

Assignment: Campaign posters for the concert season 2021 / 22 of "Academy concerts" of the Orchestra of the National Theatre Mannheim.
Approach: The new season design of the 2020/21 season is characterized by collage-like visual compositions that continue the idea of visualization to classical music. While color, shape and movement played a major role in the design in the previous season, the focus is now on a variety of structures, cutouts and arrangements of different colored elements. Although abstract in appearance, the textures in the forms create and support associations with movement and sound. There is an impression of coming together or drifting apart, just like the musicians, the instruments and tones in the orchestra in ever new constellations and intensities create the experience of classical music.
Results: The client was very pleased with the design. However due to the pandemic, most of the concerts had been cancelled since the beginning of the season and the posters were not placed in public space. Some of the designs found their way to smaller announcements in print or online, on cd or dvd recording covers, as the orchestra did their best to work around the obstacles of this tough time for classical music performers.

46 RIAS CHAMBER CHOR | Design Firm: Fons Hickmann M23
Designers: Fons Hickmann, Raúl Kokott, Paul Theisen | Client: Rias Kammerchor Berlin

Assignment: Based on the corporate design that M23 developed for RIAS Kammerchor, the digital and analog media are redesigned each season. This year's season is characterized by colorful, fluid movements. In digital applications, the visualizations come to life: Three-dimensional animations dance to the classical music of RIAS Chamber chor.

47 HOPE | Design Firm: Rikke Hansen
Designer: Rikke Hansen | Client: EIPF

Assignment: Poster for 2nd Emirates International Poster Festival (EIPF). Emirates International Poster Festival (EIPF) is the first-of-its-kind creative platform in the MENA region developed to showcase and celebrate contemporary poster design from around the world.

Approach: Hope is part of our daily practice. We constantly hoping for something, often at both, individual or collective level. In times of pandemic, fake news, elections, environmental crisis, wars, we have different approaches to hope. Our mindset even determines whether the needle bursts the balloons or not. Our mindset can take us both ways.

Results: Exhibited at Emirates International Poster Festival during Design Week Dubai 2020.

48 LIGHT & SHADOW | Design Firm: Tsushima Design
Designer: Hajime Tsushima | Client: Japan Graphic Designers Association Hiroshima
Creative Director: Yukiko Tsushima

Assignment: It is a peace poster for the Peace Poster Exhibition to be held annually in Hiroshima.

Approach: This poster expresses various lights and shadows. There are many stars in the large universe spreading in the night sky. The source of energy that makes a star shine is a fusion reaction occurring in the center of the star. When the star runs out of this fuel, the star can no longer continue to shine and will "die".In short, light means the birth and death of life. And where there is light there is a shadow. ■ I expressed the light and shadow in black and white.

Results: This poster has conveyed a message of peace to many people.

49 TWIT | Design Firm: Coco Cerrella
Designer: Coco Cerrella | Client: Self-initiated

Assignment: This poster attempts to represent with a critical look, the construction of lies and hate through social networks.

Results: This poster was distinguished by Iberoamerican Design Biennial, Latinamerican Design Awards and the prestigious Poster Bolivian Bienniale (BICeBé).

50, 51 FARGO SEASON 4 - KEY ART | Design Firms: FX Networks/Arsonal /Icon Arts Creative/Eclipse Advertising/LA | Designers: FX Networks/Arsonal/Icon Arts Creative/Eclipse Advertising/LA | Client: FX Networks | Project Manager: Laura Handy, Senior Project Manager, Print Design | Production Manager: Lisa Lejeune, Senior Production Manager, Print Design Photographer: Matthias Clamer | Creative Directors: Todd Heughens, SVP, Print Design, Stephanie Gibbons, President, Strategy, Creative, and Digital Multiplatform Marketing Art Director: Rob Wilson, VP, Print Design

Assignment: Fargo, when homespun meets dangerously in over your head – the series travels from the snowy north to a violent 1950 Kansas City, Missouri and pits rival gangs in search of their slice of the American Dream against each other.

Approach: To communicate the folksy façade, time period, Midwest and the violence we chose ordinary canned food labeling to key viewers in on the narrative – Italian Americans versus Black Americans, period-accurate typography, Midwest locale and immigration – with a single bullet hole dripping red tomato sauce as the exclamation point. We photographed stacked canned goods, put a hole through one and used a mix of tomato products to get the perfect drip down the side.

Results: These finishes were featured in our outdoor and online campaigns and were well received by the industry.

GOLD WINNERS:
54 GREAT ARCHITECTS | Design Firm: Marcos Minini Design
Designer: Marcos Minini | Client: MON

Assignment: A series of posters honoring great 20th century architects

Approach: Through the use of photos and graphic elements I show on the posters the main works of each of the three architects

55 YOUR DECISION COUNTS | Design Firm: Hanson Dodge
Designer: Damian Strigens | Client: Roush CleanTech | Producer: Michael Joyce
Executive Creative Director: Chris Buhrman | Digital Artist: Hac Job
Creative Director: Joe Ciccarelli | Copywriter: Katherine Schmidt
Account Management: Chris Becker

Assignment: ROUSH CleanTech designs, engineers, manufactures and installs clean technology fuel systems, including propane autogas and electric propulsion technology for medium-duty Ford commercial vehicles and school buses. This campaign was developed to drive awareness and sales for a new 7.3L clean-energy engine for school buses.

Approach: School transportation directors succeed when they can save their district money. This campaign focused on how the new 7.3L engine can save money over time and how those incremental savings can be used for other critical needs, like supplies for teachers and students.

Results: The messaging of the campaign, which focused on the emotional connection with school transportation directors, was one of the first creative-led initiatives for ROUSH CleanTech and garnered positive engagement with internal stakeholders. However, due to the Covid-19 pandemic, the production timeline for the new engine was pushed to Q1 2021.

56 BELOVED | Design Firm: Taber Calderon Graphic Design
Designer: Taber Calderon | Client: Negra40

Assignment: Celebrate Beethoven's 250 anniversary

Approach: Play on words with colorful electric feel illustration

Results: Accepted to exhibition platform

57 YEAR OF THE OX | Design Firm: Gravdahl Design
Designer: John Gravdahl | Client: Self-initiated

Assignment: Greetings for the New Lunar New Year

Approach: 2021 is the year of the Ox. I use a picturesque typographic illustration to suggest the strength and determination of the Ox. We have much work to do in 2021.

58 MILTON GLASER TRIBUTE | Design Firm: Harris Design Inc.
Designer: Jack Harris | Client: Self-initiated

Assignment: Losing Milton Glaser is an enormous loss to both the design profession and the many people whose lives he touched professionally and personally. The Milton Glaser commemorative poster is a dramatic teaching aid, a reminder and a celebration of an artist and a man whose legacy will forever be an inspiration to aspiring and accomplished designers.

Approach: Inspired by Glaser's varied career and constant exploration of the visual vocabulary of previous eras of both fine and commercial art, the design of this poster uses one of Glaser's most recognizable fonts in a typographic waterfall that implies a sense of evolution, growth and motion. The poster celebrates Glaser's life in a colorful and dramatic statement that represents the joy of the artist's life and work.

Results: The poster has been well-received by academic peers, students and in social media and effectively encourages an academic discussion of Milton Glaser's life and work in all aspects of design.

59 HOMAGE MILTON GLASER | Design Firm: Gravdahl Design
Designer: John Gravdahl | Client: BICéBe Bolivia

Assignment: Tribute to the 91 years of the life and times of Milton Glaser.

Approach: Typographic honors to the influence of this master on his creative professional descendants.

60 FROM HIROSHIMA TO THE WORLD | Design Firm: Storm Graphics
Designer: Shinji Arashigawa | Client: Mitsubishi Corporation

Assignment: This is the poster of the Mitsubishi Corporation Hiroshima branch It is a design of a communication space to unite the feelings of the Mitsubishi Corporation and group companies. It is expressed using the Japanese carp that is the identity of Hiroshima.

Approach: The reason why it uses the carp shape is that Hiroshima has long been called the city of water and that it was also called "the city of carp" because carp lived there. Therefore, we have tried overlapping it with the image of Nishikigoi (a brocade carp) wearing the Mitsubishi colors "red, black, and white" to express both Hiroshima and Mitsubishi. The ripples of water represent the expansion from Hiroshima to the world.

Results: These posters are displayed at the entrance and in the communication space, making the space more colorful. It also allows us to work in unison as the same colleagues within the group companies.

61 READ MORE | Design Firm: Underline Studio | Designer: Fidel Peña
Client: Self-initiated | Creative Directors: Claire Dawson, Fidel Peña

Assignment: A self-initiated poster to promote reading amongst designers. A project that we started in 2018 and we hope to continue for a few years.

Approach: Top Ten Books Read in 2019 illustrated in a poster format.

Results: High interest in the topic, covered by several design blogs and publications sparking a conversation about literature and graphic design.

62 11. MESSAGE ILLUSTRATION POSTER IN NAGAOKA
Design Firm: Takashi Akiyama Studio | Designer: Takashi Akiyama
Client: Tama Art University Illustration Studies

63 SVA/MFA ILLUSTRATION EXHIBITION | Design Firm: Attic Child Press
Designer: Viktor Koen | Client: School of Visual Arts

Assignment: Poster for an exhibition of School of Visual Arts MFA Illustration department, based on the short story titled Chuck's Bucket, by award winning author Chris Offutt.

Approach: Ink dripping when an old typewriter is turned upside down isn't pragmatic. But makes for a great image to encapsulate this bizarre story – a severe case of writer's block leading to extreme scientific methods of overcoming it by disregarding boundaries of any kind.

64 HALLOWEEN SNACKMIX | Design Firm: Randy Clark
Designer: Randy Clark | Client: Wenzhou Kean University

Assignment: Poster created for our annual Halloween Snackmix where students and faculty jointly celebrate this event.

Approach: This is a fun poster to design where (mostly) anything goes.

Results: We had a huge turnout. Chinese students tend to really get into cosplay, which fits right into Halloween.

65 DUNE POSTER | Design Firm: Stark Designs, LLC
Designer: Jamie Stark | Client: Intended as a licensed product

Assignment: Created as a self-directed project for the upcoming Dune film with the intent to license and distribute through a gallery.

Approach: I wanted to create a different approach to the idea of the traditional movie poster. Letterpress and foil stamping are not techniques you see in entertainment marketing often so I was trying to get outside the box of traditional poster design.

Results: The project got noticed by people associated with the film and the production company with positive results.

66 PRODIGAL SON S2 | Design Firm: ARSONAL | Designer: ARSONAL
Client: FOX ENTERTAINMENT | Photographer: Mark Seliger
Creative Director: ARSONAL | Art Director: ARSONAL

Assignment: Prodigal Son tells the story of a father/son relationship where the father is a notorious serial killer, and the son is a criminal psychologist who uses his knowledge of how killers think to help law enforcement solve crimes and stop killers.

We were tasked with developing a high concept and unexpected piece that would convey the themes of internal struggle, layered relationships and the push and pull of good vs. evil. Unlike season one, the season two art needed to showcase the talent to capitalize on the equity season one had built in its characters.

Approach: While season one utilized a more literal approach of father and son being inside each other's heads, this season we utilized a reflection as a visual representation of their interconnectedness. Situating the son in a stark white environment (representing the purity of the son's intentions and actions), and the father in blood (referencing the father as a killer), symbolized the central show dynamic of them sharing similar qualities, but using them to opposite ends.

Results: The client was happy with the final piece and its ability to showcase the complex father/son dynamic in a compelling, clean, graphic way.

67 CHAOS WALKING | Design Firm: Leroy & Rose
Designer: Leroy & Rose | Client: Lionsgate

Assignment: We were tasked with making the film feel big and mysterious – it's the next big YA dystopian hit, after all.

Approach: In the movie "the noise" refers to women's abilities to read men's minds (a major plot point to the mystery). We needed a way to portray this without making it look trite and comedic.

Results: When the client responding well to our gold palette, we took it a step further and used fire as the sci-fi element that allowed Viola (Daisy Ridley) to read Todd's (Tom Holland) mind.

68 PERRY MASON | Design Firm: ARSONAL | Designer: ARSONAL
Clients: HBO; Zach Enterlin, EVP, Program Marketing & Creative Services (HBO), Steven Cardwell, VP Program Marketing (HBO), Alex Diamond, Director Program Marketing (HBO), Zach Krame, Manager Program Marketing (HBO), Keanine Griggs, Coordinator Program Marketing (HBO), Danny Marks, Coordinator Program Marketing (HBO)
Art Director: ARSONAL | Photographer: Gavin Bond | Creative Director: ARSONAL

Assignment: The goal was to convey the grit and underbelly of the 1930's Los Angeles setting while remaining beautiful, eye-catching and visually arresting. Instead of focusing on the context of the story, our primary focus was to establish a tone that well reflected the show and helped introduce audiences to a new iteration of an older property.

Approach: It was important to avoid common tropes and clichés associated with the noir crime genre, so this particular set-up helped establish a time and place in a natural and believable way. Lighting and treatment played an integral part in elevating the piece to a place of beauty while maintaining the gritty realism of the tone helping it to stay grounded.

Results: Audiences responded very well to the key art and, as a direct result, HBO experienced one of the highest viewership for a premiering series in nearly two years. This made our client extremely happy with the result of the key art and the subsequent viewership it resulted in.

69 THE CODEBREAKER | Design Firm: SJI Associates | Designer: Christian Luis
Client: Chika Offurum, American Experience Films | Art Director: David O'Hanlon

Assignment: Create interest in the fascinating, virtually unknown story of Elizebeth Smith Friedman, the groundbreaking cryptanalyst whose decoding work for the U.S. government sent infamous gangsters to prison in the 1930s and brought down a massive Nazi spy ring in WWII.

Approach: A colorized historical image of Friedman looking like an ordinary woman heading to work was juxtaposed with closeups of intriguing cyphers and codes that she used in her trailblazing work.

Results: The key art drove interest and awareness for the film and its unsung hero, driving tune-in and streaming views.

70 X | Design Firm: Marlena Buczek Smith
Designer: Marlena Buczek Smith | Client: Self-initiated

Assignment: Chernobyl and Fukushima 35-10 year anniversary.

Results: To strive and to achieve a non nuclear world.

71 BIODIVERSITY | Design Firm: João Machado Design
Designer: João Machado | Client: Bienal Internacional del Cartel en México

72 BIOPHILIA | Design Firm: João Machado Design
Designer: João Machado | Client: 4th Block

73 LIVING SPACE | Design Firm: Wuhan Yanzhanglian Design Consultant
Designer: Zhanglian Yan | Client: Qian Yifeng Gallery

Assignment: Environmental pollution, ecological imbalance

Approach: It is expressed through masks, contaminated garbage, and small spaces where animals are squeezed.

Environmental pollution caused by humans makes the living space of animals living on the earth smaller and smaller, and the harsh ecological environment will also cause humans to be punished.

Results: Great visual tension, shocking performance!

74 DIALOGUE WITH NATURE | Design Firm: Mykola Kovalenko Studio
Designer: Mykola Kovalenko | Client: Self-initiated

75 HOPE OF EARTH | Design Firm: Tsushima Design | Designer: Hajime Tsushima
Client: Emirates International Poster Festival | Copywriter: Yukiko Tsushima

Assignment: This poster is for Emirates International Poster Festival. ■ This exhibition will be held in Cyber Exhibition Hall at NADWA from November 9th to December 10th. ■ The theme of the poster is hope.

Approach: I made this poster with the theme of hope. ■ Countless lives and deaths have been repeated since the birth of the earth. ■ I learned the hearts of people who seek peace from the mistakes of the past due to war I hope our future is hopeful.

Results: I think this poster exhibition is being held. I hope this poster will make people who visit the exhibition feel something.

76 BIOPHILIA | Design Firm: João Machado Design
Designer: João Machado | Client: 4th Block

77 TRANSFORM YOURSELF/A CLASSROOM LIKE NO OTHER
Design Firm: Hanson Dodge | Designer: Damian Strigens
Client: Juneau Icefield Research Program | Executive Creative Director: Chris Buhrman
Copywriter: Mike Betette | Account Management: Chris Becker
Retoucher: Brad Rochford

Assignment: The Juneau Icefield Research Program (JIRP) is a program where college students become the environmental leaders of tomorrow. These posters were made to inspire students to learn more about the life-changing experience of JIRP.

Approach: Students endure a multi-week trek from Alaska into British Columbia conducting hands-on research, surviving the wilderness and mountaineering, team building and finding personal growth. The creative strategy was to communicate, "a classroom experience like no other," leveraging breathtaking photography from the glacial landscape.

Results: The JIRP team utilized the posters to recruit students for future programs via social media and in print across select campuses. JIRP garnered positive response and engagement with students who were compelled to reach out and learn more.

78 OUR LEGACY, THEIR FUTURE | Design Firm: 21xDesign
Designers: Patricia McElroy, Dermot Mac Cormack | Client: Self-initiated
Photographer: Patricia McElroy

Assignment: Our goal was to create a poster to raise awareness about climate change, its impact on our environment, and the legacy we may leave to our children if we do not take action.

Approach: During this Covid lockdown, while looking at the wildfires in California, we thought about how everything seemed like it was in turmoil at that time. So, when we came to designing this particular poster, we wanted to give the poster a sense of that turmoil, and the fragility of how we live in our environment. During Covid, we went for long walks, always taking photographs along the way. During one such hike, we came across a vast hill where a forest had recently been cleared away, leaving only tree stumps and debris along a steep hill. It was a powerful image and immediately we both knew that this devasted forest could be the foundation of this poster. We combined several images in Photoshop of aspects of this destruction, along with an archived image of a child, that Patricia had photographed many years ago. We went through many iterations of the images and the type but were not completely satisfied until we came up with the idea to slightly tilt the image, and the accompanying text to give the poster a sense of motion and tension while referring back to the ruined hill of the original photograph.

Results: The end result is a poster that focuses attention on the wildfires in California, and the ongoing issue of climate change, and its devastating impact on our land. Our hope is that this poster will continue to engage and move the dialogue forward for this important issue in our society.

79 BIO | Design Firm: João Machado Design
Designer: João Machado | Client: UnknowDesign

80 MIDSOMMARAFTON | Design Firm: Behind the Amusement Park
Designers: Johan Ressle, Helene Havro | Client: Riche

Assignment: Design and illustration for the midsummer celebration at Riche Lilla Baren in Stockholm. "Midsommarafton" is a swedish tradition where people dance around a midsummer pole decorated with flowers.

Approach: Design and illustration for the midsummer celebration at Riche Lilla Baren in Stockholm. "Midsommarafton" is a swedish tradition where people dance around a midsummer pole decorated with flowers.

Results: Design and illustration for the midsummer celebration at Riche Lilla Baren in Stockholm. "Midsommarafton" is a swedish tradition where people dance around a midsummer pole decorated with flowers.

81 HOMMAGE Á JAN RAJLICH | Design Firm: Studio Pekka Loiri
Designer: Pekka Loiri | Client: The Moravian Gallery in Brno
Assignment: Friends of Jan Rajlih, former students and the Biennial of Graphic Design Brno commissioned a poster from 100 international poster artists for the 100th anniversary of the birth of Jan Rajlich Sr., founder of the International Biennial of Graphic Design in Brno.
Approach: Sometime many years ago, in some seminar, I was sitting behind Jan Rajlih. Rajlich was bald on his head but on the sides his hair grew "wild" looking. A convincingly gentleman. I made a quick sketch of him in my sketchbook. For this poster I used my old sketch, I added poster like color surfaces to the picture and it had Jan Rajlich both physically but above all mentally.
Results: An exhibition poster, or rather a poster made for an exhibition, does not contain "functionality" or efficiency, its effectiveness can only be judged by its charm.

82 VEX | Design Firm: Ron Taft Design | Designer: Ron Taft
Client: VoxCupio | Artist: Bianca De Loreno
Assignment: Create a gallery event poster for an exhibition of photoworks by Bianca De Loreno, whose abstracted contours and hues of the female form reveal and illuminate the graceful, sublime splendor of the vagina.
Approach: A dominantly typographic solution was not in the cards for this particular exhibit. We wanted a "no apologies" approach and opted to allow the purity of an—at first—unrecognizable, alluring photographic image, to take center stage. We did, however, feel that a minimal use of typography would enhance the poster design so we came up with a simple title, VEX, that is an acronym for "The Vagina Exhibit". Additionally, because of the particular photo we used as key art, we decided on an oversized, tall, slender poster format that gave Bianca's delicate, albeit audacious imagery, generous negative space, rarely given an event poster. We felt that once the viewer realized the content of this important exhibition, they would make the effort to read the small, event information unobtrusively positioned on the poster.
Results: The VoxCupio Gallery of Photography is going to produce a special, signed, limited Giclée of the poster for the opening.

83 MIDNIGHT BIRD ISLAND | Design Firm: LUFTKATZE Design
Designer: Tamaki Hirakawa | Client: Jo Gallery
Assignment: This is the main visual for a nighttime exhibition on birds of the world. The concept was to travel around the island through birds that are rarely seen in Japan. The goal was to convey the image of the exhibit and create an impression that would catch the attention of visitors.
Approach: The fact that the exhibit is about birds and the use of tropical colors will The use of tropical colors will attract many people to the exhibition and encourage them to visit.
Results: The visuals were eye-catching and attracted many visitors. Sales of goods related to the visuals were also strong. The client was pleased with the success of this exhibition.

84 FELLINI EXHIBITION | Design Firm: Attic Child Press
Designer: Viktor Koen | Client: the Fellini project
Assignment: Poster for tribute poster exhibition commemorating a hundred years from film-making master Federico Fellini's birthday, 1920-2020.
Approach: Having the Fellini legend embedded to my DNA, tried to express monumentality while finding the appropriate F letterform to provide a solid base for the composition. Merging movie cameras into massive heads is no news, but here, the fusion epitomized our questioning if it's art that imitates life or life imitating Fellini's vision of the world around us.

85 INDUSTRIEPLAKATE | Design Firm: Melchior Imboden
Designer: Melchior Imboden | Client: Format F4
Assignment: Creating a poster for a series of exhibitions showing industry posters from the last 100 years in Switzerland.
Approach: Swiss posters and graphic works for industry, commerce, tourism and large international companies are well-known at home and abroad and are admired for their formal discipline. They are elements of visual communication. Posters combine economic and social history in an intense and illustrative form. They act as a mirror of time, bring social aspects to the point, and often say more than extensive treatises.
Results: I decided not to show any exhibits on the poster but create a certain atmosphere by combining typography with industrial elements.

86 BAUHAUS 100 | Design Firm: Namseoul University
Designer: Byoung il Sun | Client: Golden Bee14, Moscow
Assignment: In this poster design, I expressed the spirit of the Bauhaus, which has greatly influenced the world and became a star in design history with the keywords of abstract, geometry, shape, simplification, and modern. In addition, as it aims for structural design and expressionist change, the identity of Bauhaus conformed to the change of design research over time was expressed in three dimensions.
Approach: Bauhaus mind. Structural design. It is a poster design that advocates expressionism and combines it with harmony.

Results: The 100th anniversary of Bauhaus is a design spirit that everyone should remember even if it turns 1000 in the future.

87 BAUHAUS ON A VISIT - EXHIBITION | Main Contributor: Eduard Cehovin
Client: MGLC - International Centre of Graphic Arts, Ljubljana, Slovenia
Assignment: The project of Tanja Devetak and Eduard Čehovin, BAUHAUS ON A VISIT, is inspired and ties in with the 100th anniversary of the world-famous Bauhaus school (originally Staatliches Bauhaus), which opened its doors in April 1919 in Weimar, Germany.
Approach: The BAUHAUS ON A VISIT project lasted for nine months, from 24 April 2019 to 20 December 2019. Nine (9) installations were produced, created using the same size frames measuring 80 x 100 x 4 cm and featuring a variety of design solutions inside/around/outside that looked into the subject at hand. Nine different quotes from the Bauhaus authors and educators were used: Anni Albers, Josef Albers, Gunta Stölzl, Herbert Bayer, Otti Berger, Walter Gropius, Marianne Brandt and Johannes Itten. The compositions of the newly created design works reinterpret the quotes using a variety of techniques, materials and mediums. The latter have been chosen according to the contemporary nature of the term and the referential consistency of the subject that follows through in the BAUHAUS ON A VISIT project (weaving, screen printing, mobile installation, embroidery, wood, textiles, paper, metal ...). The investigative and educational approach to pictorial articulation provides an insight into the meaning and structure of an important phenomenon in the field of design and architecture – the Bauhaus. The exhibition projects are based on the statement of Walter Gropius: "Our guiding principle was that design is neither an intellectual nor a material affair, but simply an integral part of the stuff of life, necessary for everyone in a civilized society."
Results: And finally all nine installations for the first time were exhibited together in MGLC - International Center of Graphic Arts, Ljubljana, Slovenia on 13.8.2020.

88 THE LAST CHASSID OF RADOMSKO IN LA PAZ | Design Firm: Yossi Lemel
Designer: Yossi Lemel | Client: BiceBe, Bolivia Poster biennial
Assignment: A poster for a Solo traveling exhibition.
Approach: the exhibition describes the journey I made in the footsteps of my Grandfather that was an important religious Rabbi in the Chassidic court in the city Radomsko in Poland. all the 50,000 members of this court including my Grandfather were murderd during the Holocaust.
in the exhibition I dress up like an orthodox Rabbi and recreate the life of the Chassidic court and the Grand Rabbi that no longer exist. In the poster there is a self portrait of me as a Grand Rabbi from behind.
Results: An exhibition that was planned in the occasion of the Biennial in La Paz, Bolivia.

89 EMPEROR AND THE LIONFISH | Design Firm: dGwaltneyArt
Designer: David H. Gwaltney | Client: Self-initiated
Assignment: Create a strong visual on climate and environmental change to promote a series of signed limited edition prints of my digital art works at the Artists Gallery.
Approach: Illustrations were hand drawn on the Apple iPad Pro using the Procreate app.
Results: This promoted my digital art and sales and resulted in invitations to several to YouTube videos and shows

90 PANEJAMENTO | Design Firm: 1/4 studio
Designers: Ana Mota, Jorge Araújo | Client: Galeria Ocupa!
Assignment: The goal was to announce a sculpture exhibit that featured large concrete volumes that occupied the space in different ways, forcing the crowd to interact with the pieces in order to move through the space. This exhibit was also mutable; the artist changed the layout of the arranged volumes daily, in essence creating a new exhibit daily. By the end, the pieces would be cracked and broken, showing the structure of the concrete moulds. The imagery for the visual communication intended to reflect this process of production.
Approach: In order to turn the attention to the pieces, we opted to turn the type itself into volumes/moulds. It was important that the type/mould would simultaneously have the characteristics of the mould but also of the wire structure that lives inside the concrete pieces. To create this, we commissioned a local FabLab to print the title of the exhibit in 3D, with the model we sent them. After that, it was a matter of arranging the letters in a composition and taking some photos of the result, as if the type were the sculptures themselves.
Results: The client was thrilled with the result and actually commissioned a small publication, relating to the exhibit, as a result.

91 HOPE IN PEOPLE | Design Firm: Ivette Valenzuela Design | Designer: Ivette Valenzuela
Client: Emirates International Poster Festival (EIPF) Dubai Design Week
Assignment: Hope in people that live and let live.
Approach: Technique: Alcohol ink on paper / Digital

92 WOMEN TEXAS FILM FESTIVAL 2020 | Design Firm: Peterson Ray & Company
Designer: Scott Ray | Client: Women Texas Film Festival

Assignment: Assignment was to design a poster to be displayed at the participating movie theaters weeks before and during the festival. The festival client wanted a captivating image to grab the attention of the movie goer and inform of the upcoming festival/dates.

Approach: Our approach was to design a simple and powerful image that conveyed the festival name visually and to credibly portray them as the one and only "State of Texas" women's film festival. The festival had gained popularity after the first two years, but it wasn't visually promoted professionally, so we wanted to give them an image that instantly contrasted to the busy/messy posters they had in the past in order to give the message that they have become a growing professional festival.

Results: The results were much higher attendance levels and the comments - "wow, you guys have really come a long way, we love the new look" by numerous attendees and our festival clients were very pleased with how we branded their 3rd annual festival.

93 FRAMES OF MIND | Design Firm: Judd Brand Media
Designer: Patti Judd | Client: Coronado Island Film Festival
Creative Director: Patti Judd | Copywriter: Merridee Book

Assignment: Our campaign for 2020 captured and blended a little bit of Hollywood bravado by adding glitz to the coastal vibe, sea, and sand. The concept for Judd Brand Media's identity for the Coronado Film Festival is inspired both by its incredible location and a desire to present the Festival in a fresh light.

Approach: Inspired by the iconic location, our golden mermaid (or film muse) emerges from the shoreline with the retro film reel becoming the focal point. Frames of Mind represents each filmmaker's minds eye that goes into every scene, every frame, every second that goes into creating a film. The reel serves as a window to reveal the wonders of how film takes you on a journey of heart and mind to different places and moments. The background evolved the sandy beach into tiny bright orbs & spotlights complemented by rich aqua waves as sky taking their brand color palette beyond literal expressions. The individual holding the reel represents for the filmgoer the hand selection of each film by the festival, and for the filmmaker, the coveted "gold" reel — a metaphor for their accomplishment, no small feat! Layered circles of light dance playfully around the reel, portraying the magic and spirit of imagination innate to the independent film experience.

94 FOUR SEASONS FESTIVAL | Design Firm: Maryland Institute College of Art
Designer: Soyeon Kwon | Client: Self-initiated | Instructor: Kiel Mutschelknaus

Assignment: Four Seasons Festival is an imaginary botanical festival held throughout the year. The theme of the festival changes according to the blooming time of each flower.

Approach: Rather than simply showing a flower photo, I intended to create a 3D character for each blooming season to create a different visual from the existing flower festivals.

Results: The 3D characters can be used in different channels: social media posts, videos, and a website. After the end of the Four Seasons Festival, the characters can create different storytelling content during non-seasonal periods.

95 ARTISAN GUITAR SHOW POSTERS | Design Firm: Fallano Faulkner & Associates
Designer: Frank Fallano | Clients: Artisan Guitar Show, John Detrick
Photographer: Frank Fallano | Illustrator: Frank Fallano

Assignment: Create a poster that can be used to promote as well as commemorate the event. The Artisan Guitar Show is an internationally-recognized event showcasing the work of some of the finest guitar makers in the world. The handcrafted, often one-of-a-kind work of more than 30 preeminent luthiers is exhibited. Also featured are master classes in performance and instrument construction by world-class experts. A concert series rounds out the event with performances by internationally acclaimed performing artists.

Approach: Since the craft of guitar making was the heart of the event, we decided to pay homage to John D'Angelico (1905-1964), one of the most celebrated American luthiers. As a master in the field, D'Angelico is a name familiar to all who would attend the event. The poster imagines the renowned instrument maker's bench and reminds us of the traditional techniques fundamental to the modern luthier's craft. The poster would also serve to commemorate the event, with a signed limited edition sold at the show.

Results: Initial reactions to the concept and the design were extremely positive. We had developed a few approaches and quickly settled on 2 designs to present to the client. The client liked them so much that we followed through on producing both. Additional variations allowed for body copy, inclusive of event listings, schedules, and descriptions as needed. Unfortunately the show was cancelled for 2020 due to the public health situation, but plans for the 2021 show are pending.

96 LA DOLCE VITA | Design Firm: Katarzyna Zapart
Designer: Katarzyna Zapart | Client: Fellini Project by Cedomir Kostovic

Assignment: Fellini Project by Cedomir Kostovic is an invitational poster exhibition. I had complete freedom to pick any of Fellini's film or he himself as a topic to this creative challenge.

Approach: La Dolce Vita is a bitter - sweet film about looking for happiness in hedonism. Marcello, the main character is living a crazy life, full of parties and sexual adventures. However, his life doesn't seem happy. The poster shows a dessert (made of white chocolate) in a shape of feminine breast - but it's as empty as Marcello's life.

Results: The client was happy with the result of my work.

97 FELLINI 1920/2020 | Design Firm: Atelier Bundi AG
Designer: Stephan Bundi | Client: Fellini Project by Cedomir Kostovic

Assignment: Posters for Fellini project by Cedomir Kostovic & Iwona Rypesc-Kostovic.

Approach: Fellini was a talented journalist and caricaturist at a young age. A special feature of the Fellini films are the remarkable personalities with their character heads. He continues the tradition of expressive masks, the Commedia dell'Arte, with filmic means.

Results: The posters tribute to Federico Fellini was exhibited and presented on social media.

98 MERCADOS MUNICIPAIS DE MATOSINHOS | Design Firm: Vestígio Design
Designer: Emanuel Barbosa | Client: Câmara Municipal de Matosinhos

Assignment: Built between 1936 and 1946, Matosinhos Market was projected by ARS-Arquitectos. A Portuguese modernist architecture icon, characterized by its white strong light and the seaside lifestyle. A building of public interest, Matosinhos Municipal Market maintains its original function, and has been open since the first half of the 20th century. Famous for the fresh fish, it succeeds in allying the tradition of ancient markets – where visitors are confronted with a cornucopia of different delicacies and multicolored stalls – with the architectural beauty of the surrounding space. Vestígio designed the graphic identity of the market.

Approach: Inspired by the building's modernist shapes, modularity, tiles and color, the communication system of the Matosinhos Market is a modular system, developed to become the base for type compositions, patterns and illustrations - a reflex of the new users of this market. The poster was designed by using only this very limited modular system.

Results: A colorful poster for promotion of the Market. The COVID-19 pandemic created an urge to attract clients to the market in order to help the local sellers.

99 203_FOOD&DRINK_SERIES | Design Firm: 203 Infographic Lab
Designer: 203 | Client: Street H

Assignment: It is to convey a variety of informative information about food and beverage to people with easy-to-understand and attractive graphics.

Approach: Although 203 is a graphic studio that mainly focuses on client jobs, it is difficult for us to publish infographic poster monthly without autonomy, ideas and executive power. In the process of understanding information and organizing it, all designers could grow as a data analyst. Above all, it is fun to meet new readers and consumers who see, communicate and enjoy our posters.

Results: We make and sell twelve excellent infographic posters annually. As of 2018, 77 different types of infographic posters were completed.

100 48TH ISTANBUL MUSIC FESTIVAL | Design Firm: Studio Geray Gencer
Designer: Geray Gencer | Client: İKSV Istanbul Foundation for Culture and Arts
Illustrator: Müjde Polatkan

Assignment: 'The Enlightened World of Beethoven', the festival opens a window unto the composer's world, which is based upon the novel and libertarian ideals of the Enlightenment, as well as his love for nature and humanity that underlies his visionary music language. In addition to the theme Festival will be organized in spring so the positive mood of the spring time should be considered as well.

Approach: Flowers are combined with the different forms of musical symbols in accordance with the concept.

Results: Beethoven, his music, love for nature and the enlightenment mood of the spring meet in Istanbul.

101 B-250 LET THERE BE ROCK | Design Firm: Antonio Castro Design
Designer: Antonio Castro H. | Client: Negra40

Assignment: Negra40 is a small community of independent artists in Mar de Plata, Argentina that invited designers from all over the world to design a poster commemorating the 250 years anniversary of the birth of Ludwig Van Beethoven.

Approach: Beethoven's music has transcended time, cultures, and disciplines. His music has achieved a global reach that affects not only musicians of all ages but artists in general. Personally, depending on what Beethoven's piece I am listening to, it makes me feel joy, excitement, melancholy, etc. But if asked to describe Beethoven's music, I would

say that it is thunderous. With that in mind, and in trying to compare a contemporary genre of music with that of Beethoven, I thought of how rock and roll has also transcended time and cultures, and one of the bands that I believe has achieved that, is the Australian Rock band AC/DC. It is amazing how my 12 year old son sings and rocks to Back in Black, Thunderstruck, and other AC/DC songs that I also used to love when I was his age. The poster was inspired on AC/DC's Let There be Rock album cover released in 1977, and the icon/logo design by Gerard Huerta.
Results: The Negra40 online exhibition gathered more than 80 posters from international designers (http://www.negra40.com/proyecto/b250-beethoven-250-anos/). This exhibition will be exhibited at MAR / Museo de Arte Contemporáneo in Mar de Plata, Argentina in 2022.

102 FESTIVAL ARCHIPEL | Design Firm: WePlayDesign
Designers: Cedric Rossel, Sophie Rubin | Client: Festival Archipel
Assignment: Archipel is an annual music festival featuring contemporary music, performances and sound installations, exploring the creation of music in all forms. The festival has been renamed Archip-elles for its 2019 edition. The 2019 programme is 100% feminine, featuring composers from all generations, origins and showcasing a wide variety of music.
Approach: The 2019 visual identity of the Archipel Festival explores the imagery and codes of femininity. It deconstructs stereotypes through the creation of a visual language advocating an uninhibited affirmation of femininity referring to the consciously stylized and self-referential expressions of femininity. Borrowing from both the codes of feminism and femininity, the visual identity proposes an iconography that is sometimes humorous, cynical and irreverent.
Results: Posters in public space as advertising material.

103 BEETHOVEN 250 | Design Firm: Ivette Valenzuela Design
Designer: Ivette Valenzuela | Client: Negra40
Approach: The ear as a particular element of the great composer Beethoven, fused with the key of music Fa. Tessitura full of color.

104, 105 "EVEN THE DARKEST NIGHT WILL END AND THE SUN WILL RISE" FROM CHAMBER MUSIC PLAYERS OF TOKYO | Design Firm: AYA KAWABATA DESIGN
Designer: Aya Kawabata | Client: CHAMBER MUSIC PLAYERS OF TOKYO
Assignment: The main visual of inspiration is the music that shines in the dark. ■ A year of anxiety all over the world on 2020, I made images of the dawn from midnight with the meaning that "the darkest night is over and the sun rises". May music illuminate the world at any time. ■ Entire image title is "Even the darkest night will end and the sun will rise " ■ Each image explains Midnight, Middle of the night, and the Break of dawn.
Approach: creative process: Talk about the ideas and concepts with client: Chamber Music Players of Tokyo. After choosing the ideas sketches, I made the design.
Results: Project success.

106 SYNCOPATION | Design Firm: Centre for Design Research
Designer: Eduard Cehovin | Client: 16. JAZZ IN THE RUINS 2020, Gliwice, Poland
Assignment: My assignment was to make a jazz poster without any of the visual musical symbols of jazz.
Approach: That's why I chose the word SYNCOPATION as an approach to the project (a musical term that means different rhythms that we play together to make some musical part, with a part or even a melody or a musical part standing out).
Results: The result was a poster with different visual samples and rhythms that I put together to make some impression of urban jazz.

107 TRIBUTE TO JOE LOVANO JAZZHUS MONTMATRE | Design Firm: Finn Nygaard
Designer: Finn Nygaard | Client: Jazzhus Montmatre

108 TRIBUTE TO STEVE GADD JAZZHUS MONTMARTRE | Design Firm: Finn Nygaard
Designer: Finn Nygaard | Client: Jazzhus Montmartre

109 TEATRO REAL. TEMPORADA DE ÓPERA 2020/21
Design Firm: Estudio Pep Carrió | Designer: Pep Carrió
Client: Bacab / Teatro Real | Photographer: Antonio Fernández
Assignment: This project, made in collaboration with the communication agency Bacab, includes the creation of images for the visual identity of the 2020/2021 opera season of Teatro Real (Madrid). The goal was to create unforgettable images that would establish a recognizable code for the opera season.
Approach: Each poster is a little diorama, a scenario, in which an iconic element of the play is photographed. The set between this element, the floor and the background create a metaphorical image of the play.
Results: The project has a lot of visibility in the city and in the media. The result was very appreciated by the public and, since we also developed the posters for the previous season, is a recognizable visual identity of the Teatro Real.

110 HERZOG BLAUBARTS BURG (BLUEBEARD'S CASTLE)
Design Firm: Atelier Bundi AG | Designer: Stephan Bundi
Client: Theater Orchester Biel Solothurn

Assignment: "Bluebeard's Castle" Opera by Béla Bartók
The seven doors in Bluebeard's Castle are gradually unlocked.
Approach: The key part used to open the bolt is called the "key-beard".
Results: The visual was used for advertisements and program brochures.

111 OPERA | Design Firm: NOCIONES UNIDAS
Designer: BOKE BAZÁN | Client: LES ARTS · GENERALITAT VALENCIANA
Illustrators: JUAN MIGUEL AGUILERA & BOKE BAZÁN
Assignment: Les Arts is the opera of Valencia. The opera season has a program of eight plays. The objective was to create an identity poster campaign different from what had always been done. The opera in Valencia had communicated with photography until then. The change with a new image coincides with a new direction.
Approach: Operas and 'zarzuelas' (spanish opera) are timeless and universal stories. On them we work the symbols to connect with the most cultured public when it comes to attracting them to interpret such well-known works. And to give that differential value, we worked with illustration in a space of maximum simplicity on white backgrounds, which also allowed us greater visibility on urban advertising media, also connecting with the white color of the singular and monumental building by the architect Santiago Calatrava. The typographic unit -Gilroy, designed by Radomir Tinkov- guaranteed the unity of the campaign with the red of the showiness and passion that opera means.
Results: The communication campaign with this collection of posters represented a break that the client and the public appreciated with the request for posters to frame in their homes.

112 EMPTY CHAIR | Design Firm: T9 Brand
Designers: Hui Pan, Dawang Sun | Client: NCPA
Assignment: This is a poster designed for the drama "Empty Chair".
Approach: A star pierced a chair, reflecting the theme of the drama.
Results: The conflicting posters played a very good role in promoting the drama and attracted more audiences to watch the drama in the theater.

113 LA SERVA PADRONA / STABAT MATER | Design Firm: Gunter Rambow
Designer: Gunter Rambow | Client: Oper Frankfurt
Assignment: Poster for two operas in one evening.
Approach: The cross hinders the love of the characters in both operas.
Results: Shown on poster pillars in Frankfurt.

114 SPACE FOR 5G | Design Firm: SoFeng Design
Designer: Sha Feng | Client: Toyama Prefectural Museum of Art and Design
Assignment: In my opinion, 5G space is a parallel space filled with circles of various sizes, which are connected to each other to form a new parallel space, transmitting various messages.

115 BASKET CASE | Design Firm: Keith Kitz Design
Designer: Keith Kitz | Client: Self-initiated
Assignment: Self-promotion
Approach: Mixed media digital print
Results: Accepted to multiple exhibitions.

116 THE KITE FACTORY VALUES POSTER SERIES | Design Firm: CURIOUS
Designer: CURIOUS | Client: The Kite Factory
Assignment: We previously worked with The Kite Factory, formerly known as MC&C, to develop their new position and brand identity showing the ambitious company they had become; an agency where brilliant, insightful people let their imaginations fly. We were delighted to work with them again to produce a series of posters visualising their new company values.
Approach: Our original work was based on the insight that ideas lie at the heart of The Kite Factory. And not just any ideas, the sort that deliver measurable, tangible results. Ideas grounded in rigour and data-driven insights that are tightly connected to the real world. The charming twist in the design was that the kite itself was never seen. Instead, the string that tethers the kite to the ground was the main feature. It was and is the perfect reflection of the brand purpose: ideas that take flight but are deeply grounded in insight. We used this thinking to inspire our new project.
Results: In the poster series the kite string is the focus, but this idea is taken further. As the kite string extends from the logo it twists into shapes that visually represent The Kite Factory's values; 'Aim higher, Think freely, 'Win together, 'Get involved, and 'Stay smart'. The posters are displayed throughout the Kite Factory office to encourage their employees to aspire to these values as they work.

117 FINE ART SCHATZ! | Design Firm: Schatz/Ornstein Studio
Designers: H. Kim, Bjarne Pedersen | Client: Lawrence Fine Art
Photographer: Howard Schatz | Creative Director: Bjarne Pedersen
Assignment: Posters to highlight photography exhibition by Howard Schatz

118 BIBLIOTECA PALERMO LIBRO/ESCALERA | Design Firm: Estudio Pep Carrió
Designer: Pep Carrió | Client: Artes Gráficas Palermo | Photographer: Antonio Fernández
Assignment: Biblioteca Palermo is a proposal by Estudio Pep Carrió for Artes Gráficas Palermo, which is specialized in art books printing. Since

2014, we've been creating images in which books and poetry go hand by hand, creating a unique collection.

Approach: The image shows a book with a hole in the middle, through which a ladder rise. This makes mention of COVID-19. The ladder as hope, the book an element that's accompanied us in these difficult times.

Results: Clients and collaboratiors expect this project every year, becoming a large collection of visual metaphors around the book.

119 LOVE | Design Firm: McCandliss and Campbell
Designers: Nancy Campbell, Trevett McCandliss | Client: Self-initiated

Assignment: This is a promotional poster for McCandliss and Campbell, a design team.

Approach: We created the type design from found objects, natural elements and pastels.

Results: Everyone loved it.

120 WE CREATE "WOW" FACTORS. (MOUTH) DL&A
Design Firm: Dennard, Lacey & Associates | Designer: James Lacey | Client: Self-initiated
Illustrator: James Lacey

Assignment: Our studio created a series of self-promotional pieces titled We create "wow" factors. This poster was printed at a large size of 24" x 36" and direct mailed to prospective clients.

Approach: Great graphic design can indeed elicit a "wow" from the viewer - whether a casual viewer, someone you'd like to work with - or a client. We thought it would be fun to illustrate what it might look like if we could see the word itself as it's being spoken in all of its glory.

Results: Created as a 'foot in the door', our success rate in hearing back from prospective clients was high. We've heard a few "wows" in response.

121 TRUCKEE SPRINGS POSTER/BANNER | Design Firm: Michael Schwab Studio
Designer: Michael Schwab | Client: Truckee Donner Land Trust
Production: Carolyn Gibbs | Illustrator: Michael Schwab

Assignment: We were commissioned to create a poster/banner to commemorate Truckee Springs, a newly acquired - now public - property along the river in the town of Truckee, California.

Approach: Our goal was to graphically portray and celebrate this unique property as not only outdoorsy and healthy, but a place with hiking/biking trails that are still somewhat untamed and actually, wild.

Results: The design works well as mailers, cards, ads and banners - as well as limited edition prints for generous donors. The image has an allure to all and inspires philanthropy.

122 CLASSICS MADE MODERN | Design Firm: FCB Chicago
Designer: Kevin Grady | Client: Chicago Public Library

Assignment: With all the new devices available to our younger audience, the Chicago Public Library system was trying to figure a way to get young readers to return to the libraries and revisit the old classic books.

Approach: Our goal was to lure young readers in by making these classics, super hip fresh and attractive to our young readers. A new fashion was created for each of our classic books characters. Through a major poster campaign and advertising campaign we created these beautiful visuals of a modern-day Frankenstein, Jungle Boy, The Scarlet letter etc.

Results: The project was a huge success with the Client being overwhelmed by the responses received from new attendees of the local Chicago library branches. The posters brought new energy to the classics baby boomers grew up with. The campaign went on to win many awards.

123 SUMMER | Design Firm: Goodall Integrated Design
Designer: Derwyn Goodall | Client: Self-initiated

Assignment: My intention was to create a poster that reminded people to do their part in keeping Covid under control.

Approach: To communicate a somber, yet positive feeling through expressive typography, an abstract image and a bright colour palette.

Results: Clients, colleagues, and peers were pleased by this poster.

124 TAKE CARE | Design Firm: Craig Frazier Studio
Designer: Craig Frazier | Client: Self-initiated

Assignment: On Earth Day, April 22, the pandemic was just beginning to surge and the global impact was apparent. Our health care workers were united around the world trying to save lives. This was a downloadable poster for display by hospitals and individuals.

Approach: Keep it simple

125 TOLERANCE | Design Firm: STUDIO INTERNATIONAL
Designer: Boris Ljubičić | Client: Self-initiated

Assignment: Tolerance is a naturally motivated motive for human life. The question is how tolerance as a problem in many countries of the world is universally represented by design solution.

Approach: Chess pieces are always in only two contrasting colors because they must be clearly distinguished in order for the game to be possible. In the chess game of white and black pieces, one piece wins ("eats") the other colors. However, when chess pieces are painted in several colors, this game, like a small war, is no longer possible.

Results: The poster was especially noticed at the "Tolerance" poster exhibitions organized by designer and activist Mirko Ilić on the global stage.

126 LIFE POSTER | Design Firm: Osborne Ross Design
Designers: Deborah Osborne, Andrew Ross | Client: Housebound Project

Assignment: Poster for Housebound Project, an initiative to inspire creatives during the time of quarantine. All proceeds were donated to the charity Mind, helping those who struggle with mental health.

Approach: Osborne Ross symbolised the stresses and strains of the Covid pandemic using a found graphic: the iconic masthead of LIFE magazine, ragged and torn but taped back together and still in once piece.

127 THREE ROOMS TWO HALLS | Design Firm: Shanghai Daqu Art Design Co., Ltd
Designer: Bangqian Zheng | Client: Zhejiang Literature & Art Publishing House
Writer: Bo Han | Photographer: Fei Wei | Illustrator: Hui Zhang
Director of Photography: Xuezhou Zhang | Artist: Bing An

Assignment: Three rooms and two halls is a new book by poet Han Bo, published by Zhejiang literature and Art Publishing House. "Three rooms and two halls" is not only the survival ideal of many contemporaries, but also the boundary for them to look at the world. They are firmly limited in the three rooms and two halls. Ordinary people have many imaginations about the future, but in the end, they are all immersed in daily trivialities, while the people and souls in the novel are confined to three rooms and two halls. The body is curled up, just like their soul, unable to stretch freely. Just like, to put a person into a poster is to convey the book's emotions and emotions to the readers through the intuitive poster, so as to facilitate the readers to enter the door of reading and enter the author's spiritual world.

Approach: According to the real size of a person, a transparent glass box is made according to the length width ratio of the poster, and the body surface of the performing artist is covered with white. This kind of skin texture is not real, but it expresses a kind of "typicality", as if he has become a basic module of "social man", just like a Lego building block of Chinese society. After people are stuffed into the "poster", the whole space is filled. Use realistic photography to infect the depressed atmosphere to the audience. The title of the poster is tattooed on the face, just like the marks on the face of ancient prisoners, which can never be removed, painful and profound. Through this group of posters, the cover of the design book is developed to form an overall visual system.

Results: This book provides an independent intellectual perspective to explore the great social changes in China since the 1990s. After the publication of "three rooms and two halls" book, it has won a lot of affirmation from readers and critics, and also achieved double harvest of word-of-mouth and sales. Who says that serious books can't have a market? Serious books are small circles? The awakening of the masses needs guidance and cultivation. A healthy society should not have only one voice. Let's pay attention to ourselves, to the society, to the influence of the times, to our living space, and to our smallness.

128 IRENE SOLÀ | Design Firm: Anagraphic
Designer: Anna Farkas | Client: Magvető

Assignment: The "Canto yo y la montaña baila" starting with the death of a farmer caused by lightning.

Approach: Stories about mythical beings like water women, about war, about the survival of humans and wild animals, about fanaticism... but also about beauty and goodness.

Results: Irene Solà (1990) is a Catalan writer. In 2020 she won the European Union Prize for Literature.

129 RICHMOND ROSE | Design Firm: Hoyne | Designer: Glenn Kynnersley
Client: Positive Investment Enterprise | Production Manager: Richard Hollins
Group Account Director: Vivien Mears | Creative Director: Glenn Kynnersley
Copywriters: Kathryn O'Hara, Rachel Walton | Account Director: Emma Wilson

130 PARKLINE PLACE | Design Firm: Hoyne | Designers: Nathan Hotten, Walter Ochoa
Clients: Investa Property Group, Oxford Properties Group | Production Manager: Leigh Butler
Creative Directors: Andrew Hoyne, Cam Dunnet | Copywriter: Kathryn O'Hara
Account Director: Harriet Unwin

131 COMPASS FALL 2019 RETREAT | Design Firm: Compass Florida Designers
Designers: Kevin Clancy, Carlos Salazar, Hannah Tsvayberg | Client: Compass

Assignment: The Annual Fall REtreat was a three-day event held in Miami for real estate agents of Compass. Over 1,700 nationwide agents travelled to participate in a variety of programs with the goal of networking, learning ways to improve their business and grow their referral network. The event branding for this project included a series of directional signage and posters. All of which were inspired by Miami. We are lucky to live amongst many preserved Art Deco buildings, some still painted in colors commonly used in the 20s. Pink and teal are common colors here – think flamingos, palm trees, the Miami Dolphins, even Super Bowl LIV. We chose these elements because they're easy to distinguish for wayfinding purposes and they encapsulate a timeless sentiment of our bright region.

Approach: The first actionable thing we did was walk through the spaces where the events were taking place. Doing so helped us to envision the scale of the pieces we were going to work on, how agents would navigate through the environment, and solutions for wayfinding signage. We then created a branding system and guidelines to ensure an efficient process from the beginning. This system included pattern, color implementation, supplementary design elements, and typography treatment.
Results: In retrospect, we turned out 120 outputs in less than two months—welcoming over 1,700 real estate agents nationwide. The project was an overall success for the company as it was the largest retreat to date and received positive feedback from agents and senior leadership.

132 PEACE BE WITH YOU! | Design Firm: Gunter Rambow
Designer: Gunter Rambow | Client: Golden Bee, Moscow
Assignment: To find an image for "Peace be with you"
Approach: Peace is a force that can penetrate anything.
Results: Shown in the Golden Bee exhibition.

133 TOLERANCE | Design Firm: Leo Lin Design
Designer: Leo Lin | Client: Mirko Ilic Corp.

134 TOLERANCE | Design Firm: Underline Studio
Designer: Fidel Peña | Client: Mirko Ilić | Creative Directors: Claire Dawson, Fidel Peña
Assignment: We were invited by Mirko Ilić to participate in The Tolerance Project, a travelling poster exhibition which has brought a message of social acceptance to 27 countries.
Approach: Our poster aims to give a clear and direct message about inclusion and tolerance.
Results: The Tolerance Project, a poster exhibition took place in 27 countries.

135 TOLERANCE | Design Firm: João Machado Design
Designer: João Machado | Client: The Tolerance Travelling Poster Show

136 STAY HOME, STAY SAFE | Design Firm: Woosuk University
Designer: Mi-Jung Lee | Client: Ministry of Health and Welfare
Assignment: In these days, living in the pandemic era, which is a global pandemic, staying at home is a design concept that guarantees optimal safety.
Approach: By arranging familiar objects between ducks and eggs, the prevention of Corona 19 emphasized that living at home is the best.
Results: This poster is scheduled to be displayed for campaigns in Korea in March 2021.

137 REALITY AND MENTAL HEALTH | Design Firm: João Machado Design
Designer: João Machado | Client: 4th Block

138 DEATH AND DENIAL | Design Firm: Franziska Stetter
Designer: Franziska Stetter | Client: Self-initiated
Assignment: The denial of reality during the pandemic led to suffering and death, which are shown as cause and consequence of the same equation as a graph. This project shows the world-wide cumulative covid cases from January 2020 to January 2021 using related news headlines.
Approach: The objective was to represent the contrast between the denial and misinformation and it's real world impact. The result is an infographic, a collage, of hundreds of headlines related to Covid misinformation and denial around the world. The lighter colored headlines in the background are arranged by date showing that the articles increased drastically from October to January. The exponential curve, visualized by darker colored headlines for contrast, shows the gruesome toll of the disease, month by month and a more rapid increase the closer it gets to January 2021.
Results: "Death and Denial" illustrates the fascinating absurdity of denying the existence of a major self-evident crisis, though a cacophony of lies, deception and rage.

139 THE CELL | Design Firm: Yossi Lemel | Designer: Yossi Lemel | Client: Self-initiated

140 FIERCE GRACE POSTER SERIES | Design Firm: CURIOUS
Designer: CURIOUS | Client: Fierce Grace
Assignment: There are many types of yoga systems from Ashtanga to Lyengar to Bikram, but not many have a strong market presence as a 'brand'. Fierce Grace is a new powerful system led by a respected yoga teacher with four great studios in London. They believe that yoga is not just for the fit and young but to make every age young and fit. We needed to help them develop a strong brand identity that challenged yoga's Zen etheric perception and embraced the brutal, ugly, sweaty, funny, glorious, and messy reality of practising yoga. Just like Fierce Grace, it needed to be unpretentious, real and welcoming to everyone.
Approach: To create a brand that felt different from other yoga companies, we stayed away from the spiritual, bowing, meditation and chanting, and focused on the ideas behind the creation of Fierce Grace. Founder Michele Pernetta believes that yoga balances strength, which is the masculine element (Fierce) with flexibility, the feminine element (Grace). This belief informed our approach to the design and allowed us to create a brand that truly reflected what Fierce Grace was about.

Results: We used bold, contemporary photography and delicate typography to portray the balance between strength and flexibility that lies at the heart of Fierce Grace. The posters feature at all four Fierce Grace locations across London and since creating, we have received positive feedback from the Fierce Grace team and their customers.

141 BLACK NARCISSUS - KEY ART 2 | Design Firm: Icon Arts Creative
Designers: FX Networks/Icon Arts Creative | Client: FX Networks
Creative Directors: Stephanie Gibbons, President, Strategy, Creative, and Digital Multiplatform
Art Director: Todd Russell, Director, Print Design | Photographer: Pari Dukovic
Project Coordinator: Sarit Snyder, Project Coordinator, Print Design
Production Manager: Lisa Lejeune, Senior Production Manager, Print Design
Marketing: Todd Heughens, SVP, Print Design
Assignment: We developed key art for Black Narcissus, a 3-part miniseries that was a re-interpretation of the 1947 film of the same name. We aimed to avoid duplicating imagery directly from the original film, but instead we channeled the same themes through a modern lens.
Approach: While the Bell Tower art is more inspired by the setting of the film directly, this poster evokes the psychological themes in its graphic
Approach: The encroaching blacks mirror the internal struggle of Sister Ruth throughout the course of the series. Sister Ruth, as she's photographed here, is captured at the moment she leaves the notion of her previous life of chastity and obedience and crosses over, giving in to her temptations.
Results: Complemented by the Primary finish, our Black Narcissus Poster created a dynamic outdoor and online campaign that was well-received by the industry.

142 BLACK NARCISSUS - KEY ART 1 | Design Firm: Icon Arts Creative
Designers: FX Networks/Icon Arts Creative | Client: FX Networks
Art Director: Todd Russell, Director, Print Design | Creative Directors: Todd Heughens, SVP, Print Design; Stephanie Gibbons, President, Strategy, Creative, and Digital Multiplatform Marketing
Project Coordinator: Sarit Snyder, Project Coordinator, Print Design
Production Manager: Lisa Lejeune, Senior Production Manager
Photographer: Pari Dukovic | Agency: PixclArk, Finishing Agency
Assignment: We developed key art for Black Narcissus, a 3-part miniseries that was a re-interpretation of the 1947 film of the same name. We aimed to avoid duplicating imagery directly from the original film, but instead we channeled the same themes through a modern lens.
Approach: In line with the award-winning cinematography and art direction from the original film, we wanted to capture that same essence of creating a true "in-camera moment" as close as possible. The intense, forced-perspective highlights the setting of the extreme height of the Monastery nestled deep in the Himalayas.
Results: Complemented by the secondary finish, our Black Narcissus Poster created a dynamic outdoor and online campaign that was well-received by the industry. It also garnered some top Key Art accolades at the end of 2020.

143 DIE PANNE | Design Firm: Atelier Bundi AG
Designer: Stephan Bundi | Client: Theater Orchester Biel Solothurn
Assignment: "The breakdown". Play by Friedrich Dürrenmatt A car breakdown and the subsequent process.
Approach: Car breakdown and death by hanging, two events merged.
Results: The visual was also used for advertisements and the program brochure. Swiss Poster Award Culture Gold.

144 THE VISITOR | Design Firm: Ron Taft Design
Designer: Ron Taft | Client: Robert Allan Ackerman | Photo Illustrator: Ron Taft
Assignment: Design a poster for an upcoming play. When a celebrated playwright has written a new play, theatre groups often announce the upcoming production to build anticipation, even before a director has been attached.
Approach: This play is a dark, provocative, twisted tale about a woman who is visited by a masked robber who turns out to be her estranged son. He was abducted for child sex trafficking when he was 8 and was never heard from again. The golden airplane comes from a bedtime story his mother told him when he was very little about a beautiful golden plane taking him to far-away magical places. The golden plane inside the skicap mask made for a compelling, haunting image as a base for the play's title.
Results: Robert Ackerman, the playwright, was thrilled.

145 MANDATE | Design Firm: Stavitsky Design
Designer: Vitaly Stavitsky | Client: State Drama Theatre "Na Liteinom"
Assignment: poster for the play "Mandate"
Approach: The combination of images of Lenin, Marx and Tsar Nicholas II creates the image of a new man of the era
Results: The project is successful and has attracted a lot of public attention

146 THE SPIRIT OF LANGUAGE | Design Firm: Noriyuki Kasai
Designer: Noriyuki Kasai | Client: Asia Network Beyond Design
Assignment: These posters were exhibited in the Asia Network Beyond Design (ANBD) Exhibition, which was held in 2008 and countless of artworks have been in Tokyo, Whnzhou, Yunlin and Seoul since then. From 2017, ANBD started to extend its network to other cities and countries. A specific Theme is designated each year, and the theme for 2020 is "Sound of Asia".
Approach: Through this exhibition, I intended to introduce the sound

of Japanese which is my native language. Japanese taiko drum is well-known around the world, and many Japanese learners are amazed by the various onomatopoeia in Japanese expressions.

Results: Non-Japanese speakers might not understand the meaning of the Japanese language, but through this exhibition, they could have a good imagination when they see my designs and hear the sound of Japanese.

147 KOTODAMA | Design Firm: Noriyuki Kasai
Designer: Noriyuki Kasai | Client: The Earth is Friend Office

Assignment: This project was a poster for a charity exhibition whose theme is social issue, environment and natural disasters.

Approach: I took this opportunity to utilize the font I made, and I chose the first Hiragana character "a". It's easy to comment or criticize someone by words, but the impact might be much "kotodama" which is literally "spirit of word". I came up with the phrase people. To accentuate the spirit of the word, I added face to the character.

Results: I hope people could think more carefully before they comment on anything. Those who comment might explain that they have freedom of speech, but those who are harmed by their abrupt comments might suffer the rest or their lives. Through the poster, I hope to think about it.

SILVER WINNERS:

149 INTERDISCIPLINARY STUDIO | Design Firm: Atelier Ceren Caliskan
Designer: Ceren Caliskan | Client: Istanbul Arel University

149 BAND AID | Design Firm: Eduardo Davit
Designer: Eduardo Davit | Client: Mankind's Fragile Heritage

149 FRANKIMPACT | Design Firm: Traction Factory
Designer: Kristina Karlen | Client: Snap-on Tools | Project Coordinator: Danny Yadgir
Production Artist: Jenni Klafka-Wierzba | Print Producer: Krista Dercola
Photographer: Jimmy McDonald | Main Contributor: Kristina Karlen
Digital Artist: Jimmy McDonald | Creative Director: Steve Drifka
Copywriter: Tom Dixon | Account Director: Shannon Egan

149 FIRST STEP ON THE MOON / 50 YEARS | Design Firm: Studio AND
Designers: Jean-Benoit Levy, Martin Venezky | Client: Self-initiated
Printer: Serigraphie Uldry | Photographer: Martin Venezky

150 SILK RIVERS | Design Firm: Scott Laserow Posters
Designer: Scott Laserow | Client: International Charity Poster Design Invitational Exhibition

150 1986 CHERNOBYL + FUKUSHIMA 2011 | Design Firm: Kari Piippo
Designer: Kari Piippo | Client: 4th Block Biennale

150 CAMPANILE DI FELLINI | Design Firm: Gravdahl Design
Designer: John Gravdahl | Client: The Fellini Project | Photographer: John Gravdahl

150 MILTON GLASER 1929-2020 | Design Firm: T9 Brand
Designers: Hui Pan, Dawang Sun | Client: Self-initiated

151 TRIBUTE TO MILTON GLASER | Design Firm: teiga, studio.
Designer: Xose Teiga | Client: Self-initiated

151 MAX FRISCH AND FRIEDRICH DÜRRENMATH | Design Firm: Krammer Atelier
Designer: Jean-Paul Krammer | Client: Self-initiated

151 BEETHOVEN 250 | Design Firm: Gravdahl Design
Designer: John Gravdahl | Client: Negra40

151 ZYTE POSTER SERIES | Design Firm: CURIOUS
Designer: CURIOUS | Client: Zyte

152 DANCE STUDY 1436 | Design Firm: Schatz/Ornstein Studio
Designer: Howard Schatz | Client: Self-initiated

152 MOMIX DANCE COMPANY | Design Firm: Schatz/Ornstein Studio
Designer: Howard Schatz | Client: Momix

152 EARTHQUAKE JAPAN 2019 | Design Firm: Takashi Akiyama Studio
Designer: Takashi Akiyama | Client: The Earthquake Poster Project at Tama Art University

152 ART+DESIGN PURDUE | Design Firm: hyungjookimdesignlab
Designer: Hyungjoo A. Kim | Client: Dept. of Art and Design | Photographer: Eli Craven

153 TAMA ART UNIVERSITY DOCTORAL PROGRAM GRADUATION EXHIBITION 2020
Design Firm: Takashi Akiyama Studio | Designer: Takashi Akiyama | Client: Tama Art University

153 ASU DESIGN SCHOOL LECTURE SERIES | Design Firm: Danielle Foushée
Designer: Danielle Foushée | Client: ASU Design School

153 AART'S IMAGINE | Design Firm: hufax arts
Designer: Fa-Hsiang Hu | Client: FU-JEN Catholic University

153 AUBURN SPIRIT POSTER SERIES | Design Firm: Tatum Design
Designers: Anna Bowen, Joey Nees, Marion Powers | Client: Auburn University
Design Director: Travis Tatum | Copywriters: Catherine Ross, Wendy Tatum

154 TAMA ART UNIVERSITY DOCTORAL PROGRAM GRADUATION EXHIBITION 2020
Design Firm: Takashi Akiyama Studio | Designer: Takashi Akiyama
Client: Tama Art University

154 KINDAI GRAPHIC ART COURSE : SDGS
Design Firm: KINDAI university, Graphic Art course | Designers: Kiyoung An, Hana Ikunami
Client: Self-initiated

154 PROMOTION POSTERS OF DESIGN DEPARTMENT OF THE NATIONAL TAIWAN UNIVERSITY OF SCIENCE AND TECHNOLOGY | Design Firms: ken-tsai lee design lab,

Taiwan TECH | Designer: ken-tsai lee | Client: Self-initiated

154 X | Design Firm: Randy Clark
Designer: Randy Clark | Client: Wenzhou Kean University

155 AUBURN CREATIVE COVID-19 POSTER SERIES | Design Firm: Tatum Design
Designers: Anna Bowen, Joey Nees, Marion Powers | Client: Auburn University
Design Director: Travis Tatum | Copywriters: Catherine Ross, Wendy Tatum

155 SDGS DESIGN PROJECT IN KINDAI UNIVERSITY
Design Firm: KINDAI university, Graphic Art course | Designer: Kiyoung An
Client: Self-initiated

155 FORGED BY CRAFT | Design Firm: Josh Ege | Designer: Josh Ege
Client: Dallas Society of Visual Communications Foundation | Writer: Wayne Geyer

155 AUBURN HAND SANITIZER SERIES | Design Firm: Tatum Design
Designers: Anna Bowen, Joey Nees, Marion Powers | Client: Auburn University
Design Director: Travis Tatum | Copywriters: Rich Paschall, Catherine Ross, Wendy Tatum

155 GO! DOHO | Design Firm: Toyotsugu Itoh Design Office
Designer: Toyotsugu Itoh | Client: Doho University

155 JESSUP 2021 | Design Firm: White & Case LLP
Designers: Jaime Foll, Donna Manahan | Client: ILSA | Project Manager: Saeyoung Kim
Production Manager: Lillian Martinez | Creative Director: Kim Robak
Chief Creative Director: Robin McLoughlin | Art Director: Erin Mutlu

155 EARTHQUAKE JAPAN 2019 | Design Firm: Takashi Akiyama Studio
Designer: Takashi Akiyama | Client: The Earthquake Poster Project Tama Art University

155 IUN SCHOOL OF THE ARTS | Design Firm: Sarah Edmands Martin Designs
Designer: Sarah Edmands Martin | Client: Indiana University Northwest School of the Arts
Junior Designer: Julia Fegelman | Art Director: Sarah Edmands Martin

155 SVA SUMMER ILLUSTRATION RESIDENCY | Design Firm: Attic Child Press
Designer: Viktor Koen | Client: School of Visual Arts

156 PARASITE POSTER | Design Firm: Stark Designs, LLC
Designer: Jamie Stark | Client: Intended as a licensed product

156 THE WAY I SEE IT | Design Firm: ARSONAL
Designer: ARSONAL | Client: Focus Features | Art Director: ARSONAL
Creative Directors: ARSONAL, Blair Green (Focus Features) | Copywriter: ARSONAL
Photographer: Pete Souza

156 THE WAY I SEE IT | Design Firm: ARSONAL
Designer: ARSONAL | Client: Focus Features | Art Director: ARSONAL
Creative Directors: ARSONAL, Blair Green (Focus Features) | Copywriter: ARSONAL
Photographer: Pete Souza

156 MR. TORNADO | Design Firm: SJI Associates
Designer: David O'Hanlon | Client: Chika Offurum, American Experience Films

157 THE CHALLENGE: DOUBLE AGENTS S36 | Design Firm: ARSONAL
Designer: ARSONAL | Client: MTV | Art Director: ARSONAL
Senior Vice President: Thomas Berger, SVP Brand Design (MTV Entertainment Group)
Senior Producer: Vivian Castelo (MTV Entertainment Group)
Creative Directors: ARSONAL, Casiel Kaplan (MTV Entertainment Group)

157 HOW TO WITH JOHN WILSON | Design Firm: ARSONAL
Designer: ARSONAL | Clients: HBO; Zach Enterlin, EVP, Marketing; Jim Marsh, SVP, Program Marketing; Dana Flax, VP, Program Marketing; John Allman, Senior Manager, Program Marketing; Zach Krame, Manager, Program Marketing; Francesca Schirripa, Coordinator, Program Marketing | Illustrator: John Wilson (title treatment) | Creative Director: ARSONAL
Art Director: ARSONAL | Copywriter: John Wilson

157 8 | Design Firm: Virgen extra | Designer: Virgen extra | Client: 8th Gear
Graphic Designers: Davide Barriva, Antonio Lajara | Creative Director: Ismael Medina
Brand Strategy: Sebastian Cangiano | Account Director: Benjamin Hillman

158 RON RON MARRON QUEEN | Design Firm: Beacon Communications k.k. (Leo Burnett Tokyo) | Designer: Yusuke Ohta | Clients: TBS RADIO/TWINKLE CORPORATION INC.
Illustrator: Ardneks Paraiso Graphica | Creative Directors: Yusuke Ohta, Ichiro Yatsui
Art Director: Yusuke Ohta

158 HEARTBEAT | Design Firm: Scott Laserow Posters
Designer: Scott Laserow | Client: Biophilia Posters

158 STRAW ENABLERS | Design Firm: Marlena Buczek Smith
Designer: Marlena Buczek Smith | Client: Self-initiated

158 BIOPHILIA | Design Firm: Mykola Kovalenko Studio
Designer: Mykola Kovalenko | Client: Biophilia Poster

159 HUMANITY | Design Firm: Human Paradise Studio
Designer: Brad Tzou | Client: Biophilia Poster Competition

159 BIOPHILIA CONNECTED WITH NATURE | Design Firms: Rikke Hansen/Aram Huerta
Designers: Rikke Hansen, Denmark / Aram Huerta, Mexico
Client: Biophilia Poster Competition

159 STOP RUNNING OUT OF WATER | Design Firm: Yijie Zhang
Designer: Yijie Zhang | Client: Self-initiated

159 35 YEARS SINCE CHERNOBYL / 10 YEARS SINCE FUKUSHIMA
Design Firm: Studio Pekka Loiri | Designer: Pekka Loiri | Client: The 4th Block / Ukraine

160 FALLING | Design Firm: Toyotsugu Itoh Design Office
Designer: Toyotsugu Itoh | Client: Chubu Creators Club

160 HUMANS DESTROY NATURE | Design Firm: Hiroyuki Matsuishi Design Office
Designer: Hiroyuki Matsuishi | Client: Self-initiated

CLIENTS

EXECUTIVE CREATIVE DIRECTORS/CREATIVE DIRECTORS/ASSOCIATE CREATIVE DIRECTORS...ETC

EXECUTIVE ART DIRECTORS/SENIOR ART DIRECTORS/ART DIRECTORS/DESIGN DIRECTORS

COPYWRITERS/WRITERS

PHOTOGRAPHERS/DIRECTORS OF PHOTOGRAPHY/ ILLUSTRATORS/PHOTO ILLUSTRATORS/RETOUCHERS

PLATINUM

Ariane Spanier Design
www.arianespanier.com
Oranienstraße 22
10999 Berlin
Germany
Tel +49 304 403 3923
mail@arianespanier.com

ARSONAL
www.arsonal.com
3524 Hayden Ave.
Culver City, CA 90232
United States
Tel +1 310 815 8824
cynthia@arsonal.com

Coco Cerrella
www.coco.com.ar
Gascón 1245
1181 Buenos Aires
Argentina
Tel +54 9 11 6569 6337
info@coco.com.ar

**Dalian RYCX
Advertising Co., Ltd.**
www.rycxcn.com
A6-12 No. 419 Minzheng St.
Shahekou District
Dalian, Liaoning 116021
China
Tel +86 (0411) 8451 9866
rycxcn@163.com

Eclipse Advertising
www.eclipsead.com
1329 Scott Road
Burbank, CA 91504
United States
Tel +1 818 238 9388
info@eclipsead.com

Fons Hickmann m23
www.m23.de
Mariannenplatz 23 Gartenhaus
10997 Berlin
Germany
Tel +49 306 951 8501
fons@m23.de

FX Networks
www.fxnetworks.com
10201 W. Pico Blvd.
Bldg. 103, Rm. 3549
Los Angeles, CA 90064
United States
Tel +1 310 369 5983
sarit.synder@fxnetworks.com

Icon Arts Creative
www.iconartsla.com
10390 Santa Monica Blvd.,
Suite 310
Los Angeles, CA 90025
United States
Tel +1 424 444 4200
contact@iconartsla.com

João Machado Design
www.joaomachado.com
Rua Padre Xavier Coutinho,
125
Porto 4150-751
Portugal
Tel +351 22 610 3772
geral@joaomachado.com

Katarzyna Zapart
www.behance.net/kazapart
ul. Szpitalna 5a/26
Krasnik 23-210
Poland
Tel +48 694 370 899
zapart1988@gmail.com

**KINDAI University,
Graphic Art course**
www.facebook.com/ANkiy
oung
Sinkamikosaka 228-3,
Higashi-osaka
Osaka 577-0813
Japan
Tel +81 90 9319 9396
aky6815@hotmail.com

LA
www.lassociates.com
6721 Romaine St.
Los Angeles, CA 90038
United States
Tel +1 323 952 2700

Pirtle Design
www.pirtledesign.com
506 Union St.
Hudson, NY 12534
United States
Tel +1 845 417 4611
woody@pirtledesign.com

Rikke Hansen
www.wheelsandwaves.dk
Klovtoftvej 32, Jels
6630 Roedding
Denmark
Tel +45 23 31 35 60
rh@wheelsandwaves.dk

Sanja Planinic
www.sanjaplaninic.com
New York, NY
United States
studio@sanjaplaninic.com

Tsushima Design
www.tsushima-design.com
1-17 Matsukawa-cho,
Minami-ku
Hiroshima 204 Matsukawa
Heights 204
Japan
Tel +81 08 2567 5586
info@tsushima-design.com

GOLD

1/4 studio
Estrada da Circunvalação
12119
Cave Porto 4250-155
Portugal
Tel +351 91 465 6769
jorge.araujo.91@hotmail.com

203 Infographic Lab
www.203x.co.kr
92-3 3rd Floor, Dongmak-ro,
Mapo-gu
Seoul 04075
South Korea
Tel +82 010 4211 7715
pigcky@gmail.com

21xdesign
www.21xdesign.com
2713 S. Kent Road
Broomall, PA 19008
United States
Tel +1 610 325 5422
info@21xdesign.com

Anagraphic
www.anagraphic.hu
Attila út 105
Budapest 1012
Hungary
Tel +36 12 020 555
anagraphic@anagraphic.hu

Antonio Castro Design
www.acastrodesign.net
6148 Loma de Cristo Dr.
El Paso Texas 79912
United States
Tel +1 915 356 0775
antcastro@utep.edu

ARSONAL
www.arsonal.com
3524 Hayden Ave.
Culver City, CA 90232
United States
Tel +1 310 815 8824
cynthia@arsonal.com

Atelier Bundi AG
www.atelierbundi.ch
Schlossstrasse 78
Boll Berne CH-3067
Switzerland
Tel +41 79 479 36 94
bundi@atelierbundi.ch

Attic Child Press
www.viktorkoen.com
310 E. 23rd St., #11J
New York, NY 10010
United States
Tel +1 212 254 3159
viktor@viktorkoen.com

AYA KAWABATA DESIGN
www.ayakawabata.com
Tokyo
Japan
ayakawabatadesign@gmail.
com

Behind the Amusement Park
www.behindtheamusement-
park.com
Långa Gatan 12
Stockholm 11521
Sweden
Tel +46 0 73 331 10 09
helene@b-t-a-p.com

Centre of Design Research
www.cehovin.com
Ulica Milana Majcna 35
Ljubljana SI-1000
Slovenia
Tel +386 40 458 657
eduard.cehovin@siol.net

Compass Florida Designers
www.compass.com
605 Lincoln Road, 7th Floor
Miami Beach, FL 33012
United States
Tel +1 305 409 3114
laura.morales@compass.com

Craig Frazier Studio
www.craigfrazier.com
19 Morning Sun Ave.
Mill Valley, CA 94941
United States
Tel +1 415 755 8127
craig@craigfrazier.com

CURIOUS
www.curiouslondon.com
41 Shelton St.
London, WC2H 9HG
United Kingdom
Tel +55 020 7240 6214
Maria@curiouslondon.com

Dennard Lacey & Associates
www.dennardlacey.com
4220 Proton Road, Suite 150
Dallas, TX 75244
United States
Tel +1 972 233 0430
james@dennardlacey.com

dGwaltneyArt
www.dgwaltneyart.com
5437 Branchwood Way
Virginia Beach, VA 23464
United States
Tel +1 757 581 1701
dgwaltneyart@gmail.com

Estudio Pep Carrió
www.pepcarrio.com
C/ Génova, 11, 7ºD
Madrid, 28004
Spain
Tel +34 913 080 668
info@pepcarrio.com

Fallano Faulkner & Associates
www.fallano.com
19 S. Stricker St.
Baltimore, MD 21223
United States
Tel +1 410 945 2092
ffallano@fallano.com

FCB Chicago
www. sandrofilm.com
2540 W. Huron St.
Chicago, IL 60612
United States
Tel +1 773 486 0300
sandro@sandrofilm.com

Finn Nygaard
www.FinnNygaard.com
Strandvænget 62
Mors 7900
Denmark
Tel +45 21 63 06 30
fn@finnnygaard.com

Franziska Stetter
www.franziskastetter.de
Bruchstrasse 20
Luzern 6003
Switzerland
Tel +14 01 433 86 59
hello@franziskastetter.de

Goodall Integrated Design
www.goodallintegrated.com
366 Adelaide St. W., Suite 207
Toronto, Ontario M5V 1R9
Canada
Tel +1 416 679 0711
derwyn@goodallintegrated.
com

Gravdahl Design
www.gravdahldesign.com
Dept. Art & Art History, Colo-
rado State Univ.
Fort Collins, CO 80523
United States
Tel +1 970 491 5482
john.gravdahl@colostate.edu

Gunter Rambow
www.gunter-rambow.com
Domplatz 16
18273 Guestrow
Germany
Tel +49 0 384 368 6503
GunterRambow@web.de

Hanson Dodge
www.hansondodge.com
220 E. Buffalo St.
Milwaukee, WI 53202
United States
Tel +1 414 347 1266
mjoyce@hansondodge.com

Harris Design Inc.
25 Frank Ave.
Farmingdale, NY 11735
United States
Tel +1 302 290 0225
jackharris@me.com

Hoyne
www.hoyne.com.au
Level 5 99 Elizabeth St.
Sydney, NSW 2000
Australia
Tel +0419290768
hello@hoyne.com.au

Icon Arts Creative
www.iconartsla.com
10390 Santa Monica Blvd.,
Suite 310
Los Angeles, CA 90025
United States
Tel +1 424 444 4200
contact@iconartsla.com

Ivette Valenzuela Design
www.ivettevalenzueladesign.
com
940 Edgecliff Dr.
Reno, NV 89523
United States
Tel +1 775 742 6498
ivettevv@gmail.com

João Machado Design
www.joaomachado.com
Rua Padre Xavier Coutinho,
125
Porto 4150-751
Portugal
Tel +351 22 610 3772
geral@joaomachado.com

Judd Brand Media
www.juddbrandmedia.com
249 S. Hwy 101 #322
Solana Beach, CA 92075
United States
Tel +1 858 880 7730
pjudd7@gmail.com

Katarzyna Zapart
www.behance.net/kazapart
ul. Szpitalna 5a/26
Krasnik 23-210
Poland
Tel +48 694 370 899
zapart1988@gmail.com

Keith Kitz Design
www.keithkitz.com
1945 Commonwealth Ave.,
Unit 2
Boston, MA 02135
United States
Tel +1 857 321 0957
keith.kitz@gmail.com

Leo Lin Design
11F, No. 64, 700th Lane
Chung-Cheng Road
Hsintien, Taipei 231
Taiwan
Tel +886 2 8218 1446
leoposter@yahoo.com.tw

Leroy & Rose
www.leroyandrose.com
1522 Cloverfield Blvd., Suite F
Santa Monica, CA 90404
United States
Tel +1 310 310 8679
michelle@leroyandrose.com

LUFTKATZE Design
www.tamakidesign.com
Imagawa 3-3-4-201
Suginamiku
Tokyo 1670035
Japan
Tel +81 35 938 3752
luftkatze@gmail.com

Marcos Minini Design
www.marcosminini.com
Dr. Manoel Pedro 227 Apt. 172
Curitiba PR 80035-030
Brazil
Tel +55 41 999 710 860
minini@marcosminini.com

Marlena Buczek Smith
www.marlenabuczek.com
United States
marlenabuczeksmith@gmail.
com

**Maryland Institute College
of Art**
www.kwonsoyeon.com
Soyeon Kwon
1300 W. Mt. Royal Ave.
Baltimore, MD 21217
United States
Tel +1 443 527 5810
skwon02@mica.edu

McCandliss and Campbell
www.mccandlissandcampbell.
com
433 N. Windsor Ave.
Brightwaters NY 11718
United States
Tel +1 631 252 3527
mcandcstudio@gmail.com

Melchior Imboden
www.melchiorimboden.ch
Eggertsbühl
CH-6374 Buochs
Switzerland
Tel +41 79 402 38 92
mail@melchiorimboden.ch

Michael Schwab Studio
www.michaelschwab.com
108 Tamalpa Ave.
San Anselmo, CA 94960
United States
Tel +1 415 257 5792
studio@michaelschwab.com

Mykola Kovalenko Studio
www.mykolakovalenko.eu
Cyprichova 2476/22
Bratislava 831 54
Slovakia
Tel +421 949 852 712
design@mykolakovalenko.eu

Namseoul University
www.sunbi.kr
Byoung il Sun, Department
of Visual Information Design
91 Daehak-ro,
Seonghwan-eup, Seobuk-gu
Cheonan-si,
Chungcheongnam-do
South Korea
Tel +82 105 276 5312
sunbi155@naver.com

NOCIONES UNIDAS
www.nocionesunidas.com
Plaza Federico García Lorca
6 Bajo El Puig
Valencia 46540
Spain
Tel +961 472 662
hola@nocionesunidas.com

Noriyuki Kasai
2-42-1 Asahigaoka Nerima-ku
Tokyo 176-8525
Japan
Tel +81 35 995 8691
kasai.noriyuki@nihon-u.ac.jp

Osborne Ross Design
www.osborneross.com
62A Linden Gardens
Chiswick, London W4 2EW
United Kingdom
Tel +44 020 8742 7227
andrew@osborneross.com

Peterson Ray & Company
www.peterson.com
2220 S. Harwood St. Unit #105
Dallas, TX 75215
United States
Tel +1 214 954 0522
scott@peterson.com

Randy Clark
www.randyclark.myportfolio.
com
88 Daxue Road, Ouhai District
Wenzhou, Zhejiang
China
Tel +86 5775 5870 000
randyclarkmfa@icloud.com

Ron Taft Design
www.rontaft.com
PMB 372
2934 Beverly Glen Circle
Los Angeles, CA 90077
United States
Tel +1 310 472 8093
ron@rontaft.com

Schatz/Ornstein Studio
www.howardschatz.com
31 W. 21st St.
New York, NY 10010 US
United States
Tel +1 212 334 6667
howardschatz@howardschatz.
com

**Shanghai Daqu Art Design
Co., Ltd**
No. 52, Room 503 Lane 777,
Xihuan Road
Minhang, Shanghai 201199
China
Tel +8621 5494 2726
307480244@qq.com

SJI Associates
www.sjiassociates.com
127 W. 24th St., 2nd Floor
New York, NY 10018
United States
Tel +1 917 412 5787
david@sjiassociates.com

SoFeng Design
www.sofengdesign.com
No. 999 Taihu Ave., Room 209,
R&D Center of Life Aesthetics
High-tech Zone
Suzhou City, Jiangsu Province
215153
China
Tel +0521 6863 0753
shafeng2588@hotmail.com

Stark Designs, LLC
www.jamiestark.com
30 Via Vetti
Laguna Niguel, CA 92677
United States
Tel +1 917 637 0910
stark@starkdesigns.com

Stavitsky Design
www.stavitsky.ru
Chelabinskaya St., 6, 350
Moscow 105568
Russia
Tel +7 965 257 77 26
stavitsky1@yandex.ru

Storm Graphics
www.storm-graphics.jp
2-7-24 2F Hatsukaichi, Hatsu-
kaichi Shi Ken
Hiroshima 738-0013
Japan
Tel +81 90 3172 6996
arashigawa@storm-graphics.
jp

Studio Geray Gencer
www.geraygencer.com
19 Mayıs Cad. Golden Plaza
No. 1 Kat: 10 Şişli
Istanbul 34360
Turkey
Tel +90 533 630 87 84
geraygencer@yahoo.com

STUDIO INTERNATIONAL
www.studio-international.com
Buconjiceva 43
Buconjiceva 43/III
Zagreb HR-10 000
Croatia
Tel +385 1 37 60 171
boris@studio-international.
com

Studio Pekka Loiri
www.posterswithoutborders.
com/Pekka-Loiri
Messitytonkatu 1C 43
Helsinki 00180
Finland
Tel +358 503 512104
pekka.loiri@pp.inet.fi

T9 Brand
www.dawangsun.com
379 S. Pleasant Ave.
Ridgewood, NJ 07450
United States
Tel +1 929 522 9088
dawangsun@hotmail.com

**Taber Calderon Graphic
Design**
414 E. 120th St. 4B
New York, NY 10035
United States
Tel +1 917 282 7742
tabercalderon@hotmail.com

Takashi Akiyama Studio
3-14-35
Shimo-Ochiai
Shinjuku-ku, Tokyo 161-0033
Japan
Tel +81 3 3565 4316
akiyama@t3.rim.or.jp

Tsushima Design
www.tsushima-design.com
1-17 Matsukawa-cho,
Minami-ku
Hiroshima 204 Matsukawa
Heights 204
Japan
Tel +81 08 2567 5586
info@tsushima-design.com

Underline Studio
www.underlinestudio.com
247 Wallace Ave., 2nd Floor
Toronto, Ontario M6H 1V5
Canada
Tel +1 416 341 0475
kristin@underlinestudio.com

Vestígio Design
www.vestigio.com
Rua Chaby Pinheiro, 191
Senhora da Hora, Matosinhos
4460-278
Portugal
Tel +35 19 187 94080
barbosa@vestigio.com

WePlayDesign
weplaydesign.ch
Chemin de l'Ancienne-
Pension 2
Grandvaux 1091
Switzerland
Tel +41 79 474 65 38
hello@weplaydesign.ch

Woosuk University
www.woosuk.ac.kr
Mi-Jung Lee
66 Daehak-ro Gyoseong-ri,
Jincheon-eup, Jincheon-gun
Chungcheongbuk-do, 27841
South Korea
Tel +82 43 531 2806
mijung6@nate.com

**Wuhan Yanzhanglian Design
Consultants**
501 Unit 2, Building 31,
Village 7, District 2
Changqing Huayuan,
Dongxihu District
Wuhan Hubei 430024
China
Tel +86 1300 6186 669
yanzhanglian@163.com

Yossi Lemel
www.yossilemel.com
13 Dubnov St.
Tel Aviv
Israel
Tel +00 972 545 360151
yossilemel1957@gmail.com

SILVER

1/4 studio
Estrada da Circunvalação
12119
Cave Porto 4250-155
Portugal
Tel +351 91 465 6769
jorge.araujo.91@hotmail.com

A2/SW/HK + A2-TYPE
www.a2-type.co.uk
5 Cotton's Gardens
London E2 8DN
United Kingdom
Tel +44 20 7739 4249
henrik@a2swhk.co.uk

anacmyk
http://www.anacmyk.com
Rua de Elísio de Melo No. 28
Sala 11 4000-196
Portugal
Tel +351 966449064
anacmyk@gmail.com

Angry Dog
www.angrydog.com.br
Rua Dias de Toledo, 64, Ap 48
Saúde
São Paulo 04143-030
Brazil
Tel +5511983408517
rafael@angrydog.com.br

Anne M. Giangiulio Design
www.annegiangiulio.com
2601 N. Kansas St.
El Paso, TX 79902
United States
Tel +1 915 222 1134
annegiangiulio@gmail.com

Aquarius
www.aquarius.ba
Bulevar Vojvode Stepe
Stepanovića 183a
Banja Luka Republic of Srpska
78000
Bosnia and Herzegovina
Tel +38751432326
aleksandar.zivanic@aquarius.
ba

Aram Huerta
Mexico
aramazul@hotmail.com

ARSONAL
www.arsonal.com
3524 Hayden Ave.
Culver City, CA 90232
United States
Tel +1 310 815 8824
cynthia@arsonal.com

Atelier Bundi AG
http://atelierbundi.ch
Schlossstrasse 78
Boll Berne CH-3067
Switzerland
Tel +41 79 479 36 94
bundi@atelierbundi.ch

Atelier Ceren Caliskan
Turkey
ceren_caliskan@yahoo.com

Attic Child Press
www.viktorkoen.com
310 E. 23rd St., #11J
New York, NY 10010
United States
Tel +1 212 254 3159
viktor@viktorkoen.com

**Beacon Communications k.k.
(Leo Burnett Tokyo)**
JR Tokyu Meguro Building
3-1-1
Kami-Osaki Shinagawa-ku,
Tokyo 141-0021
Japan
Tel +81 70 3932 9336
atsuko.kubota@beaconcom.
co.jp

Behind the Amusement Park
www.behindtheamusement
park.com
Långa Gatan 12
Stockholm 11521
Sweden
Tel +46 0 73 331 10 09
helene@b-t-a-p.com

BEK Design
www.bek.com.tr
Tesvikiye Caddesi 49/9 Ni-
santasi
Istanbul 34365
Turkey
Tel +212 343 9910
kagan@bek.com.tr

Bob Delevante Studios
www.bobdelevante.com
2503 Fairfax Ave.
Nashville, TN 37212
United States
Tel +1 615 400 0296
bob@bobdelevante.com

Bo Yun Hwang
Cheoin-gu, Yeokbukdong
Myeonggiro 40beongil
G-Well Prugio Apartment 102-
1603 Yongin-si Gyeonggi-do
17056
South Korea
Tel +82 105 028 9976
boyun.hwang0727@gmail.com

Brad Norr Design
www.bradnorrdesign.com
14152 Jardin Ave.
North Hugo, MN 55038
United States
Tel +1 612 298 7599
brad@bradnorrdesign.com

Braley Design
www.braleydesign.com
3469 Lannette Lane
Lexington, KY 40503
United States
Tel +1 415 706 2700
braley@braleydesign.com

BRAND DIRECTORS
www.branddirectors.co.kr
KI Bldg 4F, 515-8 Sinsa-dong,
Gangnam-gu, Seoul, 06035
South Korea
Tel +82 02-512-6538
info@branddirectors.co.kr

Brandient
www.brandient.com
5 Mendeleev St., 3rd Floor
Bucharest 010361
Romania
Tel +40 728702705
mihai.bogdan@brandient.com

Brandtatorship
www.brandtatorship.com
60 Browns Race, Suite 201
Rochester, NY 14614
United States
Tel +1 585 434 2050
jmayernik@brandtatorship.
com

BRED
www.brednation.com
New York
United States
bmcmanus@pace.edu

BSSP
www.bssp.com
20 Liberty Ship Way
Sausalito, CA 94965
United States
Tel +1 415 331 6049
jbutler@bssp.com

**Buitenkant Advertising &
Design**
http://buitenkant.com
260 Ocean Parkway, Suite 6C
Brooklyn, NY 11218
United States
Tel +1 917 684 1286
vavabuitenkant@yahoo.com

Carmit Design Studio
www.creativehotlist.com-
challer
2208 Bettina Ave.
Belmont, CA 94002
United States
Tel +1 650 283 1308
carmit@carmitdesign.com

Centre of Design Research
http://www.cehovin.com
Ulica Milana Majcna 35
Ljubljana SI-1000
Slovenia
Tel +386 40 458 657
eduard.cehovin@siol.net

che.s design institute
www.che-s-design.com
Hyundai-riverstel No.713
738, Yeongdong-daero,
Gangnam-gu
Seoul 06075
South Korea
Tel +82 10 8799 9073
neccoppecco@gmail.com

Chikako Oguma Design
www.chikako-oguma.com
1-10-22-1403 Nakameguro
Meguro-ku
Tokyo 153-0061
Japan
Tel +81 90 6045 2037
koguma75@gmail.com

Chun-Ta Chu
www.behance.net/chuchunta
No.62, Zhongshan Road
North Dist., Hsinchu City 300
Taiwan
Tel +886 919317303
chuchunta@gmail.com

Code Switch
www.codeswitchdesign.com
262 Crescent St.
Northampton, MA 01060
United States
Tel +1 718 310 8966
jansabach@mac.com

Craig Frazier Studio
www.craigfrazier.com
19 Morning Sun Ave.
Mill Valley, CA 94941
United States
Tel +1 415 755 8127
craig@craigfrazier.com

CURIOUS
https://curiouslondon.com
41 Shelton St.
London, WC2H 9HG
United Kingdom
Tel +55 020 7240 6214
Maria@curiouslondon.com

danielguillermo.com
http://danielguillermo.com
321 Harman St., Apt. 1L
Brooklyn, NY 11237
United States
Tel +1 646 620 7410
mail@danielguillermo.com

Danielle Foushée
www.daniellefoushee.com
546 W. Lewis Ave.
Phoenix, AZ 85003
United States
Tel +1 818 613 7459
kdfoushee@yahoo.com

Dankook University
www.dankook.ac.kr/web/
international
Hoon-Dong Chung
College of Arts, 126, Jukjeon,
Suji Yongin Gyeonggi 448-701
South Korea
+82 31 8005 3106
finvox3@naver.com

David Bieloh Design
www.davidbieloh.com
2603 N. Columbia St.
Ellensburg, WA 98926
United States
Tel +1 931 933 3086
dbieloh@gmail.com

Decker Design, Inc.
www.deckerdesign.com
14 W. 23rd St., 3rd Floor
New York, NY 10003
United States
Tel +1 212 633 8588
info@deckerdesign.com

Dennard Lacey & Associates
www.dennardlacey.com
4220 Proton Road,
Suite 150
Dallas, TX 75244
United States
Tel +1 972 233 0430
james@dennardlacey.com

Design Direction, LLC
www.clarkmost.com
1940 S. Badour Road
Midland, MI 48640
United States
Tel +1 989 948 1383
clark@designdirection.com

dGwaltneyArt
www.dgwaltneyart.com
5437 Branchwood Way
Virginia Beach, VA 23464
United States
Tel +1 757 581 1701
dgwaltneyart@gmail.com

Eduardo Davit
www.eduardodavit.com
Av Artigas 336
Colonia 70000
Uruguay
Tel +598 99524217
edudavit@gmail.com

elevate design
www.elevatedesign.org
2600 Roseland Drive
Ann Arbor, MI 48103
United States
Tel +1 734 827 4242
salchow@msu.edu

Elsenbach Design
www.elsenbach-design.de
Südstraße 12
Hückeswagen NRW 42499
Germany
Tel +49 0 219 293 67948
Mail@elsenbach-Design.de

Estudio Pep Carrió
www.pepcarrio.com
C/ Génova, 11, 7ºD
Madrid, 28004
Spain
Tel +34 91 308 0668
info@pepcarrio.com

Evelyne Krall
www.instagram.com/evely
nekrall
Str. Emanoil Gojdu Nr.2 Ap.4
Timis Timisoara 300176
Romania
Tel +407 3685 3212
krall.evelyne@gmail.com

Extra Credit Projects
www.extracreditprojects.com
1250 Taylor Ave. NE.
Grand Rapids, MI 49505
United States
Tel +1 616 454 2955
rob@extracreditprojects.com

Finn Nygaard
www.FinnNygaard.com
Strandvænget 62
Mors 7900
Denmark
Tel +45 48 47 53 10
fn@finnnygaard.com

FJCU
www.fju.edu.tw
No. 510, Zhongzheng Road
Xinzhuang Dist., New Taipei
City 242
Taiwan
aart@mail.fju.edu.tw

Fons Hickmann m23
www.m23.de
Mariannenplatz 23 Gartenhaus
10997 Berlin
Germany
Tel +49 306 951 8501
fons@m23.de

Foto + Film
www.stephenguenther.com
1414 Hinman 1B
Evanston, IL 60201
United States
Tel +1 847 732 2291
stephen.guenther@gmail.com

Goodall Integrated Design
www.goodallintegrated.com
366 Adelaide St. W., Suite 207
Toronto, Ontario M5V 1R9
Canada
Tel +1 416 679 0711
derwyn@goodallintegrated.
com

Gottschalk+Ash Int'l AG
www.ga-z.com
Böcklinstrasse 26
Zurich 8032
Switzerland
Tel +41 44 382 18 50
s.loetscher@gottashzrh.com

Gravdahl Design
www.gravdahldesign.com
Dept. Art & Art History,
Colorado State Univ.
Fort Collins, CO 80523
United States
Tel +1 970 491 5482
john.gravdahl@colostate.edu

Gutsulyak.Studio
www.gutsulyak.studio
Toronto, ON
Canada
Tel +1 416 878 0957
yurko@gutsulyak.studio

**Hiroyuki Matsuishi Design
Office**
www.matsuishi-design.com
Letoit Chuou C201 Koga City,
2-10-20
Fukuoka 811-3103
Japan
Tel +08 05 212 6448
matsuishihiro@gmail.com

Hofmann.to
www.hofmann.to
Weggisgasse 1
Luzern 6003
Switzerland
Tel +41 41 210 55 45
matthias@hofmann.to

Hoyne
www.hoyne.com.au
Level 5 99 Elizabeth St.
Sydney, NSW 2000
Australia
Tel +0419290768
hello@hoyne.com.au

hufax arts
www.facebook.com/HufaxArts
15/F, No.120, Chien-Kuo N.
Road, Sec 2
Taipei City, 104
Taiwan
Tel +886 2 2503015
hufa@ms12.hinet.net

Human Paradise Studio
www.humanparadise.com
No. 38, 3F Lane 140,
Kunyang St., Taipei 11561
Taiwan
Tel +1 8869 3997 6488
humanparadise@mac.com

hyungjookimdesignlab
www.cla.purdue.edu/
academic/rueffschool/ad/vcd
Rueff School of Design, Art,
and Performance
552 West Wood St. W.
Lafayette, IN 47907
United States
Tel +1 765 494 3071
hakim@purdue.edu

hyunjeong yi
www.hyunjeongyi.com
275 E. Green St., Apt. 1438
Pasadena, CA 91101
United States
Tel +1 626 365 2787
hyunjeongyiii@gmail.com

Icon Arts Creative
www.iconartsla.com
10390 Santa Monica Blvd.,
Suite 310
Los Angeles, CA 90025
United States
Tel +1 424 444 4200
contact@iconartsla.com

Imageon Co., LTD.
http://imageon.co.jp
1-10-2-501 Nishihara
Asaminami-Ku
Hiroshima-City Hiroshima
Pref. 7310113
Japan
Tel +81 82 846 1546
fukumoto@imageon.co.jp

Indika
13-17 Laight St., Suite 6-1
New York, NY 10013
United States
ethan@indika.com

Ivan Kashlakov
www.instagram.com/ivanka
shlak
Sofia Sofia 1330
Bulgaria
Tel +897027809
kashlak.art@gmail.com

Jillian Coorey
Kent, OH 44242
United States
jcoorey@kent.edu

Jinu Hong
www.jinuhong.com
New York, NY
United States
jinuhongofficial@gmail.com

**John Sposato Design &
Illustration**
www.johnsposato.carbon
made.com
179 Hudson Terrace
Piermont, NY 10968
United States
Tel +1 845 300 7591
johnsposatodesign@gmail.
com

Jorel Dray
Madison, WI
United States
Tel +1 608 616 3568
joreldray@gmail.com

Josh Ege
www.joshuaege.com
402 Shoreview Drive
Rockwall, TX 75087
United States
Tel +1 214 277 9049
joshua@joshuaege.com

Juliane Petri
www.julianepetri.com
c/ Almudín, 16 Bajo Izq
Valencia 46003
Spain
studio@julianepetri.com

Jun Bum Shin
www.junbumshin.com
4175 NW. Dale Dr.
Corvallis, OR 97330
United States

Kari Piippo
www.piippo.com/kari
Katajamäenkatu 14
Mikkeli 50170
Finland
Tel +358 15 162 187
kari@piippo.com

Keith Kitz Design
www.keithkitz.com
1945 Commonwealth Ave.,
Unit 2
Boston, MA 02135
United States
Tel +1 857 321 0957
keith.kitz@gmail.com

ken-tsai lee design lab
National Taiwan University of
Science and Technology
No. 43號, Section 4, Keelung
Road,
Da'an District, Taipei City, 106
Taiwan
Tel +886 983 086 172
leekentsai1@YAHOO.COM

Khushboo Uday Nayak
www.behance.net/nayakkhu
sh3abc
Savannah College of Art and
Design
516 Drayton St.
Savannah, GA 31401
United States
Knayak20@student.scad.edu

**KINDAI University,
Graphic Art course**
www.facebook.com/ANkiy
oung
Kiyoung An
Sinkamikosaka 228-3,
Higashi-osaka
Osaka 577-0813
Japan
Tel +81 90 9319 9396
aky6815@hotmail.com

Kobi Franco Design
www.kfdesign.co.il
1 Nachal Habsor St., Apt. 42
Tel Aviv 6820129
Israel
Tel +972 544 644034
kobifranco@gmail.com

Krammer Atelier
Austria
jeanpaulkrammer@yahoo.com

Latrice Graphic Design
www.latricegd.com
284 Ames Circle
Huntingdon Valley, PA 19006
United States
Tel + 1 215 512 0708
vlatrice@comcast.net

Leo Lin Design
11F, No. 64, 700th Lane
Chung-Cheng Road
Hsintien, Taipei 231
Taiwan
Tel +886 2 8218 1446
leoposter@yahoo.com.tw

Leroy & Rose
www.leroyandrose.com
1522 Cloverfield Blvd., Suite F
Santa Monica, CA 90404
United States
Tel +1 310 310 8679
michelle@leroyandrose.com

Lisa Winstanley Design
www.lisawinstanley.com
29 Nanyang Ave.
#09-16 639758
Singapore
Tel +65 83437608
lwinstanley@ntu.edu.sg

Los Angeles LGBT Center
www.lalgbtcenter.org
1118 N. McCadden Place
Los Angeles, CA 90038
United States
Tel +1 323 993 8917
tsato@lalgbtcenter.org

Mark Sposato Graphic Design
www.marksposato.com
Brooklyn, NY
United States
Tel +1 845 596 7891
marksposato1@gmail.com

Marlena Buczek Smith
www.marlenabuczek.com
United States
marlenabuczeksmith@gmail.
com

Martin French Studio
www.martinfrench.com
511 NW. Broadway
Portland, OR 97209
United States
Tel +1 503 926 2809
studio@martinfrench.com

Maryland Institute College of Art
www.kwonsoyeon.com
Soyeon Kwon
1300 W. Mt Royal Ave.
Baltimore, MD 21217
United States
Tel +1 443 527 5810
skwon02@mica.edu

May & Co.
www.mayandco.com
6316 Berwyn Lane
Dallas, TX 75214
United States
Tel +1 214 536 0599
dougm@mayandco.com

McCandliss and Campbell
www.mccandlissandcampbell.
com
433 N. Windsor Ave.
Brightwaters NY 11718
United States
Tel +1 631 252 3527
mcandcstudio@gmail.com

Meghan Zavitz
www.behance.net/meghan
zavitz
Texas
United States
meghan.zavitz@mavs.uta.edu

Michael Daiminger Design
Elisabethstrasse 17
Muenchen 80796
Germany
michael@daiminger-net.de

Michael Pantuso Design
www.pantusodesign.com
820 S. Thurlow St.
Hinsdale, IL 60521
United States
Tel +1 312 318 1800
michaelpantuso@me.com

Michael Schwab Studio
www.michaelschwab.com
108 Tamalpa Ave.
San Anselmo, CA 94960
United States
Tel +1 415 257 5792
studio@michaelschwab.com

**Mike Hughes Freelance
Art Direction**
www.hughescreativework.com
Canada
hughescreative@me.com

Mirko Ilic Corp.
www.mirkoilic.com
207 E. 32nd St., 4th Floor
New York, NY 10016
United States
Tel +1 212 481 9737
studio@mirkoilic.com

monokromatic
www.monokromatic.com
Privada 10 "A" Sur 1507 letra
"A" Colonia Motolinía
Puebla, Puebla 72538
Mexico
Tel +044 222 127 1581
knife555@hotmail.com

Mykola Kovalenko Studio
www.mykolakovalenko.eu
Cyprichova 2476/22
Bratislava 831 54
Slovakia
Tel +421 949 852 712
design@mykolakovalenko.eu

Namseoul University
www.sunbi.kr
Byoung il Sun, Department
of Visual Information Design
91 Daehak-ro,
Seonghwan-eup, Seobuk-gu
Cheonan-si,
Chungcheongnam-do
South Korea
Tel +82 105 276 5312
sunbi155@naver.com

Nogami Design Office
www.nogamidesign.com
4-17-9-716 Kikawahigashi
Yodogawa-ku
Osaka 532-0012
Japan
Tel +1 81 90 3033 9317
ndo@kf6.so-net.ne.jp

Olga Severina
www.olgaseverina.com
Los Angeles, CA
United States
posterterritory@gmail.com

Only Child Art
www.andrebarnett.myportfo
lio.com
912 Independence Ave. SE.
Washington, DC 20003
United States
Tel +1 202 577 6814
barnettandre@hotmail.com

Oupas Design (Foco Familia)
www.oupasdesign.com
Rua dos Bragas 85
4050-123 Porto
Portugal
Tel +351 22 509 8174
hello@oupasdesign.com

OUWN
www.ouwn.jp
Kubo Bldg. 501 1-7-4 Ohashi
Meguro-ku
Tokyo 153-0044
Japan
info@ouwn.jp

Palmer+Bohan Design
www.palmerbohan.wixsite.
com/palmerbohan
801 South Blvd., Suite 6
Oak Park, IL 60302
United States
Tel +1 312 388 7263
palmerbohan@gmail.com

Patrycja Longawa
www.patrycja-longawa.com
Lukasiewicza 65/7
Jedlicze 38-460
Poland
patrycja.longawa@op.pl

Pavel Pisklakov
Chelyabinsk
Russia
pavel.pisklakov@gmail.com

PosterTerritory
www.olgaseverina.com
Los Angeles, CA
United States
posterterritory@gmail.com

PytchBlack
www.pytchblack.com
707 W. Magnolia Ave.
Fort Worth, TX 76104
United States
Tel +1 817 570 0915
aryanez@pytchblack.com

Randy Clark
www.randyclark.myportfolio.
com
88 Daxue Road, Ouhai District
Wenzhou, Zhejiang
China
Tel +86 577 5587 0000
randyclarkmfa@icloud.com

Res Eichenberger Design
www.reseichenberger.ch
Postfach 553
Zurich 8053
Switzerland
Tel +41 43 499 83 36
studio@reseichenberger.ch

Rikke Hansen
www.wheelsandwaves.dk
Klovtoftvej 32, Jels
6630 Roedding
Denmark
Tel +45 23 31 35 60
rh@wheelsandwaves.dk

Rose
www.rosedesign.co.uk
The Old School
70 St. Marychurch St.
London SE16 4HZ
United Kingdom
Tel +44 020 7394 2800
hello@rosedesign.co.uk

Saatchi & Saatchi Wellness
www.saatchiwellness.com
375 Hudson Street
New York, NY 10014
United States
Tel +1 646 746 5000
scott_carlton70@mac.com

**Sarah Edmands Martin
Designs**
www.sarahedmandsmartin.
com
211 S. Lincoln St.
Bloomington, IN 47408
United States
Tel +1 301 467 1464
sarahedmandsmartin@gmail.
com

Schatz/Ornstein Studio
www.howardschatz.com
31 W. 21st St.
New York, NY 10010 US
United States
Tel +1 212 334 6667
howardschatz@howardschatz.
com

School of Visual Arts
www.hyupjunglee.com
Hyupjung Lee & Chaoqun
Wang
209 E. 23rd St.
New York, NY 10010
United States
Tel +1 347 859 7012
hlee168@sva.edu; momo_4@
live.cn

Scott Laserow Posters
www.scottlaserowposters.com
1007 Serpentine Lane
Wyncote, PA 19095
United States
Tel +1 215 771 9219
slaserow@temple.edu

Sebastian Aravena
www.roterias.cl
Santiago
Chile
sebas.aravena@gmail.com

**Shangning Wang Graphic
Design**
www.shangningwang.com
New York
United States
shangningwang@gmail.com

SJI Associates
www.sjiassociates.com
127 W. 24th St., 2nd Floor
New York, NY 10018
United States
Tel +1 917 412 5787
david@sjiassociates.com

SoFeng Design
www.sofengdesign.com
No. 999 Taihu Ave., Room 209
R&D Center of Life Aesthetics
High-tech Zone
Suzhou City, Jiangsu Province
215153
China
Tel +0521 6863 0753
shafeng2588@hotmail.com

Spatchurstudio
www.spatchurst.com.au
Noosa Heads, QLD 4567
Australia
Tel +61 7 5449 2988
steven@spatchurst.com.au

Stark Designs, LLC
www.jamiestark.com
30 Via Vetti
Laguna Niguel, CA 92677
United States
Tel +1 917 637 0910
stark@starkdesigns.com

Steiner Graphics
www.renesteiner.com
155 Dalhousie St., Suite 1062
Toronto ON, M5B 2P7
Canada
Tel +1 647 285 1658
rene@steinergraphics.com

studio +fronczek
www.saschafronczek.de
Waldstr. 89 Karlsruhe
Baden-Württemberg 76133
Germany
Tel +491 512 231 3021
mail@saschafronczek.de

Studio AND
2278 15th St., Apt. 4
San Francisco, CA 94114
United States
Tel +1 415 509 7654
usa@and.ch

Studio Eduardo Aires, S.A
www.eduardoaires.com
Rua Alexandre Braga, 94 1
Esquerdo Porto 4000-049
Portugal
Tel +351 22 616 9080
mail@eduardoaires.com

studio lindhorst-emme
www.lindhorst-emme.de
Glogauer Str. 19
1 Hinterhof Links
Berlin, 10999
Germany
Tel +49 0 306 956 4018
mail@lindhorst-emme.de

Studio Pekka Loiri
www.posterswithoutborders.
com/Pekka-Loiri
Messitytonkatu 1C 43
Helsinki 00180
Finland
Tel +358 503 512104
pekka.loiri@pp.inet.fi

STUDY LLC.
www.studyllc.tokyo
1-7-1-202, Wakaba
Tokyo, 160-0011
Japan
eto.t.study@gmail.com

SVIDesign
www.svidesign.com
242 Acklam Road, Studio 124
London W10 5JJ
United Kingdom
Tel +44 207 524 7808
sasha@svidesign.com

T9 Brand
www.dawangsun.com
379 S. Pleasant Ave.
Ridgewood, NJ 07450
United States
Tel +1 929 522 9088
dawangsun@hotmail.com

**Taber Calderon Graphic
Design**
414 E. 120th St. 4B
New York, NY 10035
United States
Tel +1 917 282 7742
tabercalderon@hotmail.com

Takashi Akiyama Studio
3-14-35
Shimo-Ochiai
Shinjuku-ku, Tokyo 161-0033
Japan
Tel +81 33 565 4316
akiyama@t3.rim.or.jp

Tatum Design
www.tatumdesign.com
1747 Reese St., Suite 211
Birmingham, AL 35209
United States
Tel +1 205 978 1179
travis@tatumdesign.com

**Ted Wright Illustration &
Design**
www.tedwright.com
1705 N. Woodlawn Ave.
Ladue, MO 63124
United States
twrightart@aol.com

teiga, studio.
www.xoseteiga.com
Rua Nova de Abaixo, 5 bajo
Pontevedra, Pontevedra 36002
Spain
Tel +34 607 155 211
xoseteiga@gmail.com

**Te Sian Lera Shih's Design
Studio**
www.lera-shih.squarespace.
com
United States
tesian0816@gmail.com

The Refinery
Sherman Oaks Galleria
15301 Ventura Blvd., Bldg. D,
Suite 300
Sherman Oaks, CA 91403
United States
Tel +1 818 843 0004
claire.delouraille@therefinery
creative.com

Thomas Kühnen
www.thomaskuehnen.de
Dorotheenstr. 2
Wuppertal, NRW 42105
Germany
Tel +49 0 172 255 7620
hallo@thomaskuehnen.de

Tivadar Bote Illustration
www.cargocollective.com/tiva
darbote
527 31st St. NW.
Calgary, AB T2N 2V6
Canada
Tel +1 403 703 9683
bote.t@shaw.ca

Toyotsugu Itoh Design Office
www.facebook.com/toyotsu
guoffice
402 Royal Villa Tsurumai
4-17-8 Tsurumai, Showa-ku
Nagoya, Aichi Prefecture
466-0064
Japan
Tel +81 52 731 9747
toyo-ito@ya2.so-net.ne.jp

Traction Factory
www.tractionfactory.com
247 S. Water St.
Milwaukee, WI 53204
United States
Tel +1 414 944 0900
tf_awards@tractionfactory.
com

TRIPLET DESIGN INC.
www.tsuyoshiomori.com
06 Haneginomori, 1-21-23,
Hanegi Setagaya
Tokyo 156-0042
Japan
Tel +81 36 265 7273
tsuyoshi@triplet.jp

Vaughan Creative
www.vaughancreative.com
2001 Blue Ridge Drive
Flower Mound, TX 75028
United States
Tel +1 972 979 2801
veronica.vaughan@verizon.net

Venti caratteruzzi
www.venticaratteruzzi.com
via Regione Siciliana 2507
Palermo 90145
Italy
Tel +39 091 982 0530
carlo@venticaratteruzzi.com

Ventress Design Works
www.ventress.com
1565 N. Shaver St.
Portland, OR 97227
United States
Tel +1 615 8332108
tom@ventress.com

Virgen extra
www.virgen-extra.com
Manzanares 4. 28005
Madrid
Spain
Tel +34 619 007 953
ismael@virgen-extra.com

Virginia Tech
www.meaghand.com
Meaghan A. Dee
Blacksburg, VA 24061
United States
Tel +1 541 632 4426
meaghan.dee@gmail.com

VIS-ART
www.bujny.com
Swietojanska 62/8 Gdynia
Pomorskie 81-393
Poland
Tel +48 602 631 544
studio@bujny.com

White & Case LLP
www.whitecase.com
1221 Avenue of the Americas
New York, NY 10020
United States
Tel +1 646 885 2079
emutlu@whitecase.com

WREC Multimedia Production
Est. Adolfo Loureiro 28, Fl 1,
Flat A Ed. San Keng Garden
Guangdong, Macao SAR
999078
China
Tel +853 6283 8847
eddieakqj10@gmail.com

xihestudio
www.xihestudio.com
7665 Condalia Ave.
Yucca Valley, CA 92284
United States
Tel +1 917 951 6097
hershey.he@hotmail.com

Yijie Zhang
625 Newnham Road,
Upper Mount Gravatt
Brisbane, QLD 4122
Australia
Tel +0431550860
yijiezhang111@outlook.com

Yohei Takahashi
www.yoheitakahashi.com
3-14-26-A-301
Shimoochiai
Shinjuku-ku Tokyo 161-0033
Japan
yohhey219@gmail.com

Yossi Lemel
www.yossilemel.com
13 Dubnov St.
Tel Aviv
Israel
Tel +00 972 545 360151
yossilemel1957@gmail.com

Graphis Titles

New Talent Annual 2021

This was a great collection of talent and creativity, resulting from extraordinary out of the box thinking.

2021
Hardcover: 272 pages
200-plus color illustrations
Trim: 8.5 x 11.75"
ISBN: 978-1-931241-99-1
US $90

Awards: Graphis presents 20 Platinum, 147 Gold, and 398 Silver awards to award-winning work from students and professors.
Platinum-winning Professors: Advertising: Alexi Beltrone, Jay Marsen, Kevin O'Neill, Taylor Shipton, and Mel White. Design: Justin Abadilla, Brent Barson, Rob Clayton, Justin Colt, Jeff Davis, Ann Field, Bill Galyean, Seung-Min Han, Miguel Lee, Dong-Joo Park, Hank Richardson, Paul Rogers, Reneé Seward, Tracey Shiffman, David Stadttmüller, David Tillinghast, and Doug Thomas.
Judges: Carolyn Hadlock, Carmit Haller, Boris Ljubicic, Youhei Ogawa, Sasha Vidakovic, Craig Cutler, and others listed in the book.
Content: This book contains award-winning entries in Design, Advertising, Photography, and Film/Video. We also present A Decade of New Talent, including eight Platinum-winning works from 2011.

Photography Annual 2021

2021
Hardcover: 256 pages
200-plus color illustrations
Trim: 8.5 x 11.75"
ISBN: 978-1-931241-93-9
US $90

Awards: Graphis presents 10 Platinum, 103 Gold, 200 Silver awards, and 84 Honorable Mentions for outstanding talent in photography.
Platinum Winners: Vincent Junier, Jonathan Knowles, Trevett McCandliss, Lennette Newell, and Howard Schatz.
Judges: Vincent Junier of Vincent Junier Photography, Jonathan Knowles of Jonathan Knowles Photography, and Trevett McCandliss of McCandliss and Campbell.
Content: Award-winning work from the judges, and full pages of Platinum, and Gold-winning work. Silver and Honorable Mentions are also presented. Also featured is a retrospective on our Platinum 2011 Photography winners, a list of international photography museums and galleries, and our annual In Memoriam for photography talent that have left us within the past year.

Advertising Annual 2021

As advertising continues to evolve, the Graphis competitions will continue to present exceptionally creative work.

2021
Hardcover: 224 pages
200-plus color illustrations
Trim: 8.5 x 11.75"
ISBN: 978-1-931241-95-3
US $90

Awards: Graphis presents 7 Platinum, 71 Gold, 93 Silver awards, and 11 Honorable Mentions for outstanding talent in advertising.
Platinum Winners: 72andSunny Los Angeles, ARSONAL, The Beacon (Kohler Co), Colin Corcoran, The Designory Inc., FOX Entertainment, INNOCEAN USA, Judd Brand Media, and Young & Laramore.
Judges: David Chandi of Grupo daDa, Silver Cuellar of Tombras, Tony Wu of ARSONAL, and Michael Raso, a freelancer.
Content: Award-winning work from the judges, and full pages of Platinum, and Gold-winning work. Silver and Honorable Mentions are also presented. Also featured are Q&As with our panel of industry-leading, award-winning judges, and our annual In Memoriam for the talent that the advertising community has lost within the past year.

Design Annual 2021

PLATINUM WINNERS:
Carmit Design Studio
Eduardo del Fraile Studio
Fuzhou BY-ENJOY
 Brand Design Co., Ltd.
Journey Group
Leo Lin Design
Michael Pantuso Design
Randy Clark
Ron Taft Design
Shadia Design
Subplot Design Inc.
Tsushima Design
Young & Laramore

2020
Hardcover: 272 pages
200-plus color illustrations
Trim: 8.5 x 11.75"
ISBN: 978-1-931241-94-6
US $90

Awards: Graphis presents 12 Platinum, 125 Gold, 317 Silver awards, and 241 Honorable Mentions for outstanding achievement in design.
Platinum Winners: Randy Clark, Eduardo del Fraile, Carmit Makler Haller, Young Huale, Journey Group, Leo Lin, Shadia Ohanessian, Michael Pantuso, Subplot Design, Ron Taft, Hajime Tsushima, and Young & Laramore.
Judges: All work was judged by a panel of past Platinum and Gold winners, John Fairley, Gavin Hurrell, Erin Mutlu, Alvaro Perez, Diogo Gama Rocha, Jared Welle, and Yin Zhongjun
Content: Award-winning work from the judges, and full-page presentations of Platinum and Gold-winning design work. Silver and Honorable Mentions are also presented, and a list of international design museums are included.

Branding 7

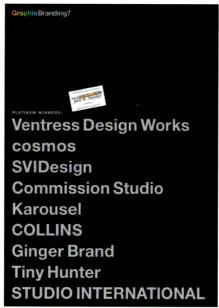

PLATINUM WINNERS:
Ventress Design Works
cosmos
SVIDesign
Commission Studio
Karousel
COLLINS
Ginger Brand
Tiny Hunter
STUDIO INTERNATIONAL

2018
Hardcover: 240 pages
200-plus color illustrations
Trim: 8.5 x 11.75"
ISBN: 978-1-931241-73-1
US $90

Awards: 10 Platinum, 73 Gold, and 194 Silver Awards, totaling nearly 500 winners, along with 124 Honorable Mentions.
Platinum Winners: Tiny Hunter, COLLINS, cosmos, Ventress Design Works, Karousel, SVIDesign, Ginger Brand, Commission Studio, and STUDIO INTERNATIONAL.
Judges: All entries were judged by a panel of highly accomplished, award-winning Branding Designers: Adam Brodsley of Volume Inc., Cristian "Kit" Paul of Brandient, and Sasha Vidakovic of SVIDesign.
Content: Branding designs from New Talent Annual 2018, award-winning designs by the Judges, and Q&As with this year's Platinum Winners, along with some of their additional work.

Nudes 5

2020
Hardcover: 256 pages
200-plus color illustrations
Trim: 10.06 x 13.41"
ISBN: 978-1-931241-84-7
US $90

The fifth volume in this series, Nudes 5 continues to present some of the most refined and creative nudes photography. Just as this genre helped elevate photography into a realm of fine art, one will find that many of the images on these pages deserve to be presented in museums. Award-winning photographers include Erik Almas, Rosanne Olson, Klaus Kampert, Howard Schatz, Phil Marco, Joel-Peter Witkin, and Chris Budgeon, among others.

www.**Graph**is.com

There is no repository of great design
that shows, communicates, and celebrates
graphic design like Graphis.

Randy Clark, *Graphic Design Professor, Wenzhou Kean University*